REASON
IN ART

REASON IN ART

Volume Four of "The Life of Reason"

GEORGE SANTAYANA

ἡ γὰρ νοῦ ἐνέργεια ζωή

DOVER PUBLICATIONS, INC.
NEW YORK

Published in Canada by General Publishing Company, Ltd., 30 Lesmill Road, Don Mills, Toronto, Ontario.
Published in the United Kingdom by Constable and Company, Ltd., 10 Orange Street, London WC2H 7EG.

This Dover edition, first published in 1982, is an unabridged republication of volume four of *The Life of Reason; or The Phases of Human Progress*, originally published by Charles Scribner's Sons, N.Y., in 1905.

Manufactured in the United States of America
Dover Publications, Inc.
180 Varick Street
New York, N.Y. 10014

Library of Congress Cataloging in Publication Data

Santayana, George, 1863-1952.
Reason in art.

(The life of reason ; v. 4)
Reprint. Originally published: New York : Scribner, 1905.
1. Aesthetics. 2. Arts—Philosophy.
I. Title. II. Series: Santayana, George, 1863-1952. Life of reason ; v. 4.
BH39.S258 1982 700'.1 82-7310
ISBN 0-486-24358-3 AACR2

CONTENTS

REASON IN ART

CHAPTER I

THE BASIS OF ART IN INSTINCT AND EXPERIENCE

Man affects his environment, sometimes to good pur-
pose.—Art is plastic instinct conscious of its aims.—It is
automatic.—So are the ideas it expresses.—We are said
to control whatever obeys us.—Utility is a result.—The
useful naturally stable.—Intelligence is docility.—Art is
reason propagating itself.—Beauty an incident in rational

CHAPTER II

RATIONALITY OF INDUSTRIAL ART

Utility is ultimately ideal.—Work wasted and chances
missed.—Ideals must be interpreted, not prescribed.—
The aim of industry is to live well.—Some arts, but no
men, are slaves by nature.—Servile arts may grow spon-
taneous or their products may be renounced.—Art starts
from two potentialities: its material and its problem.—
Each must be definite and congruous with the other.—A
sophism exposed.—Industry prepares matter for the liberal

CHAPTER III

EMERGENCE OF FINE ART

Art is spontaneous action made stable by success.—It
combines utility and automatism.—Automatism funda-
mental and irresponsible.—It is tamed by contact with
the world.—The dance.—Functions of gesture.—Automatic

CHAPTER IV

MUSIC

CHAPTER V

SPEECH AND SIGNIFICATION

CHAPTER VI

POETRY AND PROSE

CHAPTER VII

PLASTIC CONSTRUCTION

CHAPTER VIII

PLASTIC REPRESENTATION

CHAPTER IX

JUSTIFICATION OF ART

CHAPTER X

THE CRITERION OF TASTE

CHAPTER XI

ART AND HAPPINESS

Æsthetic harmonies are parodies of real ones, which in turn would be suffused with beauty, yet prototypes of true perfections.—Pros and cons of detached indulgences.—The happy imagination is one initially in line with things, and brought always closer to them by experience.—Reason is the principle of both art and happiness.—Only a rational society can have sure and perfect arts.—Why art is now empty and unstable.—Anomalous character of the irrational artist.—True art measures and completes happiness.

Pages 216–230

REASON
IN ART

CHAPTER I

THE BASIS OF ART IN INSTINCT AND EXPERIENCE

Man exists amid a universal ferment of being, and not only needs plasticity in his habits and pursuits but finds plasticity also in the sur-

Man affects his environment, sometimes to good purpose.

rounding world. Life is an equilibrium which is maintained now by accepting modification and now by imposing it. Since the organ for all activity is a body in mechanical relation to other material objects, objects which the creature's instincts often compel him to appropriate or transform, changes in his habits and pursuits leave their mark on whatever he touches. His habitat must needs bear many a trace of his presence, from which intelligent observers might infer something about his life and action. These vestiges of action are for the most part imprinted unconsciously and aimlessly on the world. They are in themselves generally useless, like footprints; and yet almost any sign of man's passage might, under certain conditions, interest a man. A footprint could fill Robinson Crusoe with emotion, the devastation wrought by an army's march might prove many

3

things to a historian, and even the disorder in which a room is casually left may express very vividly the owner's ways and character.

Sometimes, however, man's traces are traces of useful action which has so changed natural objects as to make them congenial to his mind. Instead of a footprint we might find an arrow; instead of a disordered room, a well-planted orchard—things which would not only have betrayed the agent's habits, but would have served and expressed his intent. Such propitious forms given by man to matter are no less instrumental in the Life of Reason than are propitious forms assumed by man's own habit or fancy. Any operation which thus humanises and rationalises objects is called art. *Thus, no Art/Craft Dispute*

All art has an instinctive source and a material embodiment. If the birds in building nests felt the

Art is plastic instinct conscious of its aim. utility of what they do, they would be practising an art; and for the instinct to be called rational it would even suffice that their traditional purpose and method should become conscious occasionally. Thus weaving is an art, although the weaver may not be at every moment conscious of its purpose, but may be carried along, like any other workman, by the routine of his art; and language is a rational product, not because it always has a use or meaning, but because it is sometimes felt to have one. Arts are no less automatic than instincts, and usually, as Aristotle observed, less thoroughly purpos-

ive; for instincts, being transmitted by inheritance and imbedded in congenital structure, have to be economically and deeply organised. If they go far wrong they constitute a burden impossible to throw off and impossible to bear. The man harassed by inordinate instincts perishes through want, vice, disease, or madness. Arts, on the contrary, being transmitted only by imitation and teaching, hover more lightly over life. If ill-adjusted they make less havoc and cause less drain. The more superficial they are and the more detached from practical habits, the more extravagant and meaningless they can dare to become; so that the higher products of life are the most often gratuitous. No instinct or institution was ever so absurd as is a large part of human poetry and philosophy, while the margin of ineptitude is much broader in religious myth than in religious ethics.

Arts are instincts bred and reared in the open, creative habits acquired in the light of reason. It is automatic. Consciousness accompanies their formation; a certain uneasiness or desire and a more or less definite conception of what is wanted often precedes their full organisation. That the need should be felt before the means for satisfying it have been found has led the unreflecting to imagine that in art the need produces the discovery and the idea the work. Causes at best are lightly assigned by mortals, and this particular superstition is no worse than any other.

The data—the plan and its execution—as conjoined empirically in the few interesting cases which show successful achievement, are made into a law, in oblivion of the fact that in more numerous cases such conjunction fails wholly or in part, and that even in the successful cases other natural conditions are present, and must be present, to secure the result. In a matter where custom is so ingrained and supported by a constant apperceptive illusion, there is little hope of making thought suddenly exact, or exact language not paradoxical. We must observe, however, that only by virtue of a false perspective do ideas seems to govern action, or is a felt necessity the mother of invention. In truth invention is the child of abundance, and the genius or vital premonition and groping which achieve art, simultaneously achieve the ideas which that art embodies; or, rather, ideas are themselves products of an inner movement which has an automatic extension outwards; and this extension manifests the ideas. Mere craving has no lights of its own to prophesy by, no prescience of what the world may contain that would satisfy, no power of imagining what would allay its unrest. Images and satisfactions have to come of themselves; then the blind craving, as it turns into an incipient pleasure, first recognises its object. The pure will's impotence is absolute, and it would writhe for ever and consume itself in darkness if perception gave it no light and experience no premonition.

Now, a man cannot draw bodily from external perception the ideas he is supposed to create or invent; and as his will or uneasiness, before he creates the satisfying ideas, is by hypothesis without them, it follows that creation or invention is automatic. The ideas come of themselves, being new and unthought-of figments, similar, no doubt, to old perceptions and compacted of familiar materials, but reproduced in a novel fashion and dropping in their sudden form from the blue. However instantly they may be welcomed, they were not already known and never could have been summoned. In the stock example, for instance, of groping for a forgotten name, we know the context in which that name should lie; we feel the environment of our local void; but what finally pops into that place, reinstated there by the surrounding tensions, is itself unforeseen, for it was just this that was forgotten. Could we have invoked the name we should not have needed to do so, having it already at our disposal. It is in fact a palpable impossibility that any idea should call itself into being, or that any act or any preference should be its own ground. The responsibility assumed for these things is not a determination to conceive them before they are conceived (which is a contradiction in terms) but an embrace and appropriation of them once they have appeared. It is thus that ebullitions in parts of our nature become touchstones for the whole; and the inci-

So are the ideas it expresses.

dents within us seem hardly our own work till they
are accepted and incorporated into the main cur-
rent of our being. All invention is tentative, all
art experimental, and to be sought, like salvation,
with fear and trembling. There is a painful preg-
nancy in genius, a long incubation and waiting for
the spirit, a thousand rejections and futile birth-
pangs, before the wonderful child appears, a gift
of the gods, utterly undeserved and inexplicably
perfect. Even this unaccountable success comes
only in rare and fortunate instances. What is
ordinarily produced is so base a hybrid, so lame and
ridiculous a changeling, that we reconcile ourselves
with difficulty to our offspring and blush to be
represented by our fated works.

The propensity to attribute happy events to our
own agency, little as we understand what we mean
We are said to by it, and to attribute only untoward
control what- results to external forces, has its ground
ever obeys us. in the primitive nexus of experience.
What we call ourselves is a certain cycle of vege-
tative processes, bringing a round of familiar im-
pulses and ideas; this stream has a general direc-
tion, a conscious vital inertia, in harmony with
which it moves. Many of the developments within
it are dialectical; that is, they go forward by inner
necessity, like an egg hatching within its shell,
warmed but undisturbed by an environment of
which they are wholly oblivious; and this sort
of growth, when there is adequate consciousness of
it, is felt to be both absolutely obvious and abso-

lutely free. The emotion that accompanies it is pleasurable, but is too active and proud to call itself a pleasure; it has rather the quality of assurance and right. This part of life, however, is only its courageous core; about it play all sorts of incidental processes, allying themselves to it in more or less congruous movement. Whatever peripheral events fall in with the central impulse are accordingly lost in its energy and felt to be not so much peripheral and accidental as inwardly grounded, being, like the stages of a prosperous dialectic, spontaneously demanded and instantly justified when they come.

The sphere of the self's power is accordingly, for primitive consciousness, simply the sphere of what happens well; it is the entire unoffending and obedient part of the world. A man who has good luck at dice prides himself upon it, and believes that to have it is his destiny and desert. If his luck were absolutely constant, he would say he had the *power* to throw high; and as the event would, by hypothesis, sustain his boast, there would be no practical error in that assumption. A will that never found anything to thwart it would think itself omnipotent; and as the psychological essence of omniscience is not to suspect there is anything which you do not know, so the psychological essence of omnipotence is not to suspect that anything can happen which you do not desire. Such claims would undoubtedly be made if experience lent them the least colour; but would even

the most comfortable and innocent assurances of this sort cease to be precarious? Might not any moment of eternity bring the unimagined contradiction, and shake the dreaming god?

Utility, like significance, is an eventual harmony in the arts and by no means their ground. All useful things have been discovered as **Utility is a result.** the Lilliputians discovered roast pig; and the casual feat has furthermore to be supported by a situation favourable to maintaining the art. The most useful act will never be repeated unless its secret remains embodied in structure. Practice and endeavour will not help an artist to remain long at his best; and many a performance is applauded which cannot be imitated. To create the requisite structure two preformed structures are needed: one in the agent, to give him skill and perseverance, and another in the material, to give it the right plasticity. Human progress would long ago have reached its goal if every man who recognised a good could at once appropriate it, and possess wisdom for ever by virtue of one moment's insight. Insight, unfortunately, is in itself perfectly useless and inconsequential; it can neither have produced its own occasion nor now insure its own recurrence. Nevertheless, being proof positive that whatever basis it needs is actual, insight is also an indication that the extant structure, if circumstances maintain it, may continue to operate with the

same moral results, maintaining the vision which
it has once supported.

When men find that by chance they have started
a useful change in the world, they congratulate
The useful nat- themselves upon it and call their per-
urally stable. sistence in that practice a free activ-
ity. And the activity is indeed rational, since it
subserves an end. The happy organisation which
enables us to continue in that rational course is
the very organisation which enabled us to initiate
it. If this new process was formed under exter-
nal influences, the same influences, when they
operate again, will reconstitute the process each
time more easily; while if it was formed quite spon-
taneously, its own inertia will maintain it quietly
in the brain and bring it to the surface whenever
circumstances permit. This is what is called
learning by experience. Such lessons are far from
indelible and are not always at command. Yet
what has once been done may be repeated; repeti-
tion reinforces itself and becomes habit; and a
clear memory of the benefit once attained by for-
tunate action, representing as it does the trace left
by that action in the system, and its harmony with
the man's usual impulses (for the action is felt to
be *beneficial*), constitutes a strong presumption that
the act will be repeated automatically on occa-
sion; *i. e.*, that it has really been learned. Con-
sciousness, which willingly attends to results only,
will judge either the memory or the benefit, or
both confusedly, to be the ground of this readi-

ness to act; and only if some hitch occurs in the machinery, so that rational behaviour fails to takes place, will a surprised appeal be made to material accidents, or to a guilty forgetfulness or indocility in the soul.

The idiot cannot learn from experience at all, because a new process, in his liquid brain, does not **Intelligence is** modify structure; while the fool uses **docility.** what he has learned only inaptly and in frivolous fragments, because his stretches of linked experience are short and their connections insecure. But when the cerebral plasm is fresh and well disposed and when the paths are clear, attention is consecutive and learning easy; a multitude of details can be gathered into a single cycle of memory or of potential regard. Under such circumstances action is the unimpeded expression of healthy instinct in an environment squarely faced. Conduct from the first then issues in progress, and, by reinforcing its own organisation at each rehearsal, makes progress continual. For there will subsist not only a readiness to act and a great precision in action, but if any significant circumstance has varied in the conditions or in the interests at stake, this change will make itself felt; it will check the process and prevent precipitate action. Deliberation or well-founded scruple has the same source as facility—a plastic and quick organisation. To be sensitive to difficulties and dangers goes with being sensitive to opportunities.

Of all reason's embodiments art is therefore the most splendid and complete. Merely to attain

Art is reason propagating itself. categories by which inner experience may be articulated, or to feign analogies by which a universe may be conceived, would be but a visionary triumph if it remained ineffectual and went with no actual remodelling of the outer world, to render man's dwelling more appropriate and his mind better fed and more largely transmissible. Mind grows self-perpetuating only by its expression in matter. What makes progress possible is that rational action may leave traces in nature, such that nature in consequence furnishes a better basis for the Life of Reason; in other words progress is art bettering the conditions of existence. Until art arises, all achievement is internal to the brain, dies with the individual, and even in him spends itself without recovery, like music heard in a dream. Art, in establishing instruments for human life beyond the human body, and moulding outer things into sympathy with inner values, establishes a ground whence values may continually spring up; the thatch that protects from to-day's rain will last and keep out to-morrow's rain also; the sign that once expresses an idea will serve to recall it in future.

Not only does the work of art thus perpetuate its own function and produce a better experience, but the process of art also perpetuates itself, because it is teachable. Every animal learns

something by living; but if his offspring inherit
only what he possessed at birth, they have to learn
life's lessons over again from the beginning, with
at best some vague help given by their parents'
example. But when the fruits of experience exist
in the common environment, when new instru-
ments, unknown to nature, are offered to each in-
dividual for his better equipment, although he
must still learn for himself how to live, he may
learn in a humaner school, where artificial occa-
sions are constantly open to him for expanding his
powers. It is no longer merely hidden inner proc-
esses that he must reproduce to attain his prede-
cessors' wisdom; he may acquire much of it more
expeditiously by imitating their outward habit—
an imitation which, furthermore, they have some
means of exacting from him. Wherever there is
art there is a possibility of training. A father
who calls his idle sons from the jungle to help him
hold the plough, not only inures them to labour
but compels them to observe the earth upturned
and refreshed, and to watch the germination there;
their wandering thought, their incipient rebell-
ions, will be met by the hope of harvest; and
it will not be impossible for them, when their
father is dead, to follow the plough of their own
initiative and for their own children's sake. So
great is the sustained advance in rationality made
possible by art which, being embodied in matter,
is teachable and transmissible by training; for in
art the values secured are recognised the more

easily for having been first enjoyed when ol
people furnished the means to them; while t
maintenance of these values is facilitated by al
external tradition imposing itself contagiously or
by force on each new generation.

Art is action which transcending the body
makes the world a more congenial stimulus to the

Beauty an
incident in
rational art.
soul. All art is therefore useful and
practical, and the notable æsthetic
value which some works of art possess,
for reasons flowing for the most part out of their
moral significance, is itself one of the satisfactions
which art offers to human nature as a whole.
Between sensation and abstract discourse lies a re-
gion of deployed sensibility or synthetic represen-
tation, a region where more is seen at arm's length
than in any one moment could be felt at close
quarters, and yet where the remote parts of experi-
ence, which discourse reaches only through sym-
bols, are recovered and recomposed in something
like their native colours and experienced relations.
This region, called imagination, has pleasures
more airy and luminous than those of sense, more
massive and rapturous than those of intelligence.
The values inherent in imagination, in instant in-
tuition, in sense endowed with form, are called
æsthetic values; they are found mainly in nature
and living beings, but often also in man's artificial
works, in images evoked by language, and in the
realm of sound.

Productions in which an æsthetic value is or is

supposed to be prominent take the name of fine
art; but the work of fine art so defined is almost

Inseparable
from the
others.

always an abstraction from the actual
object, which has many non-æsthetic
functions and values. To separate the
æsthetic element, abstract and dependent as it
often is, is an artifice which is more misleading
than helpful; for neither in the history of art nor
in a rational estimate of its value can the æsthetic
function of things be divorced from the practical
and moral. What had to be done was, by imag-
inative races, done imaginatively; what had to be
spoken or made, was spoken or made fitly, lovingly,
beautifully. Or, to take the matter up on its psy-
chological side, the ceaseless experimentation and
ferment of ideas, in breeding what it had a pro-
pensity to breed, came sometimes on figments that
gave it delightful pause; these beauties were the
first knowledges and these arrests the first hints
of real and useful things. The rose's grace could
more easily be plucked from its petals than the
beauty of art from its subject, occasion, and use.
An æsthetic fragrance, indeed, all things may
have, if in soliciting man's senses or reason they
can awaken his imagination as well; but this mid-
dle zone is so mixed and nebulous, and its limits
are so vague, that it cannot well be treated in
theory otherwise than as it exists in fact—as a
phase of man's sympathy with the world he moves
in. If art is that element in the Life of Reason
which consists in modifying its environment the

better to attain its end, art may be expected to subserve all parts of the human ideal, to increase man's comfort, knowledge, and delight. And as nature, in her measure, is wont to satisfy these interests together, so art, in seeking to increase that satisfaction, will work simultaneously in every ideal direction. Nor will any of these directions be on the whole good, or tempt a well-trained will, if it leads to estrangement from all other interests. The æsthetic good will be accordingly hatched in the same nest with the others, and incapable of flying far in a different air.

CHAPTER II

If there were anything wholly instrumental or merely useful its rationality, such as it was, **Utility is ultimately ideal.** would be perfectly obvious. Such a thing would be exhaustively defined by its result and conditioned exclusively by its expediency. Yet the value of most human arts, mechanical as they may appear, has a somewhat doubtful and mixed character. Naval architecture, for instance, serves a clear immediate purpose. Yet to cross the sea is not an ultimate good, and the ambition or curiosity that first led man, being a land-animal, to that now vulgar adventure, has sometimes found moralists to condemn it. A vessel's true excellence is more deeply conditioned than the ship-wright may imagine when he prides himself on having made something that will float and go. The best battle-ship, or racing yacht, or freight steamer, might turn out to be a worse thing for its specific excellence, if the action it facilitated proved on the whole maleficent, and if war or racing or trade could be rightly condemned by a philosopher. The rationality of ship-building has several sets of conditions: the

18

patron's demands must be first fulfilled; then the
patron's specifications have to be judged by the pur-
pose he in turn has in mind; this purpose itself
has to be justified by his ideal in life, and finally
his ideal by its adequacy to his total or ultimate
nature. Error on any of these planes makes the
ultimate product irrational; and if a finer instinct,
even in the midst of absorbing subsidiary action,
warns a man that he is working against his high-
est good, his art will lose its savour and its most
skilful products will grow hateful, even to his im-
mediate apprehension, infected as they will be by
the canker of folly.

Art thus has its casuistry no less than morals,
and philosophers in the future, if man should at
Work wasted last have ceased to battle with ghosts,
and chances might be called upon to review mate-
missed. rial civilisation from its beginnings,
testing each complication by its known ultimate
fruits and reaching in this way a purified and or-
ganic ideal of human industry, an ideal which edu-
cation and political action might help to embody.
If nakedness or a single garment were shown to
be wholesomer and more agreeable than compli-
cated clothes, weavers and tailors might be notably
diminished in number. If, in another quarter, pop-
ular fancy should sicken at last of its traditional
round of games and fictions, it might discover infi-
nite entertainment in the play of reality and truth,
and infinite novelties to be created by fruitful la-
bour ; so that many a pleasure might be found which

is now clogged by mere apathy and unintelligence. Human genius, like a foolish Endymion, lies fast asleep amid its opportunities, wasting itself in dreams and disinheriting itself by negligence.

Descriptive economy, however, will have to make great progress before the concrete ethics of art can be properly composed. History, conceived hitherto as a barbarous romance, does not furnish sufficient data by which the happiness of life under various conditions may be soberly estimated. Politics has receded into the region of blind impulse and factional interests, and would need to be reconstituted before it could approach again that scientific problem which Socrates and his great disciples would have wished it to solve. Meantime it may not be premature to say something about another factor in practical philosophy, namely, the ultimate interests by which industrial arts and their products have to be estimated. Even before we know the exact effects of an institution

Ideals must be interpreted, not prescribed.

we can fix to some extent the purposes which, in order to be beneficent, it will have to subserve, although in truth such antecedent fixing of aims cannot go far, seeing that every operation reacts on the organ that executes it, thereby modifying the ideal involved. Doubtless the most industrial people would still wish to be happy and might accordingly lay down certain principles which its industry should never transgress, as for instance that production should at any price leave room for lib-

erty, leisure, beauty, and a spirit of general co-
operation and goodwill. But a people once hav-
ing become industrial will hardly be happy if sent
back to Arcadia; it will have formed busy habits
which it cannot relax without tedium; it will have
developed a restlessness and avidity which will
crave matter, like any other kind of hunger.
Every experiment in living qualifies the initial pos-
sibilities of life, and the moralist would reckon
without his host if he did not allow for the change
which forced exercise makes in instinct, adjusting
it more or less to extant conditions originally, per-
haps, unwelcome. It is too late for the highest
good to prescribe flying for quadrupeds or peace
for the sea waves.

What antecedent interest does mechanical art
subserve? What is the initial and commanding
ideal of life by which all industrial developments
are to be proved rational or condemned as vain?
If we look to the most sordid and instrumental
of industries we see that their purpose is to pro-
duce a foreordained result with the minimum of
effort. They serve, in a word, to cheapen commod-
ities. But the value of such an achievement is
clearly not final; it hangs on two underlying ideals,
one demanding abundance in the things produced
and the other diminution in the toil required to
produce them. At least the latter interest may
in turn be analysed further, for to diminish toil
is itself no absolute good; it is a good only when
such diminution in one sphere liberates energies

which may be employed in other fields, so that the total human accomplishment may be greater. Doubtless useful labour has its natural limits, for if overdone any activity may impair the power of enjoying both its fruits and its operation. Yet in so far as labour can become spontaneous and in itself delightful it is a positive benefit; and to its intrinsic value must be added all those possessions or useful dispositions which it may secure. Thus one ideal—to diminish labour—falls back into the other—to diffuse occasions for enjoyment. The aim is not to curtail occupation but rather to render occupation liberal by supplying it with more appropriate objects.

It is then liberal life, fostered by industry and commerce or involved in them, that alone can justify these instrumental pursuits. The aim of industry is to live well. Those philosophers whose ethics is nothing but sentimental physics like to point out that happiness arises out of work and that compulsory activities, dutifully performed, underlie freedom. Of course matter or force underlies everything; but rationality does not accrue to spirit because mechanism supports it; it accrues to mechanism in so far as spirit is thereby called into existence; so that while values derive existence only from their causes, causes derive value only from their results. Functions cannot be exercised until their organs exist and are in operation, so that what is primary in the order of genesis is always last and most dependent in the order

of worth. The primary substance of things is their mere material; their first cause is their lowest instrument. Matter has only the values of the forms which it assumes, and while each stratification may create some intrinsic ideal and achieve some good, these goods are dull and fleeting in proportion to their rudimentary character and their nearness to protoplasmic thrills. Where reason exists life cannot, indeed, be altogether slavish; for any operation, however menial and fragmentary, when it is accompanied by ideal representation of the ends pursued and by felt success in attaining them, becomes a sample and anagram of all freedom. Nevertheless to arrest attention on a means is really illiberal, though not so much by what such an interest contains as by what it ignores. Happiness in a treadmill is far from inconceivable; but for that happiness to be rational the wheel should be nothing less than the whole sky from which influences can descend upon us. There would be meanness of soul in being content with a smaller sphere, so that not everything that was relevant to our welfare should be envisaged in our thoughts and purposes. To be absorbed by the incidental is the animal's portion; to be confined to the instrumental is the slave's. For though within such activity there may be a rational movement, the activity ends in a fog and in mere physical drifting. Happiness has to be begged of fortune or found in mystical indifference: it is not yet subtended by rational art.

The Aristotelian theory of slavery, in making servile action wholly subservient, sins indeed against persons, but not against arts. It sins against persons because there is inconsiderate haste in asserting that

Some arts, but no men, are slaves by nature.

whole classes of men are capable of no activities, except the physical, which justify themselves inherently. The lower animals also have physical interests and natural emotions. A man, if he deserves the name, must be credited with some rational capacity: prospect and retrospect, hope and the ideal portraiture of things, must to some extent employ him. Freedom to cultivate these interests is then his inherent right. As the lion vindicates his prerogative to ferocity and dignity, so every rational creature vindicates his prerogative to spiritual freedom. But a too summary classification of individuals covers, in Aristotle, a just discrimination among the arts. In so far as a man's occupation is merely instrumental and justified only externally, he is obviously a slave and his art at best an evil necessity. For the operation is by hypothesis not its own end; and if the product, needful for some ulterior purpose, had been found ready made in nature, the other and self-justifying activities could have gone on unimpeded, without the arrest or dislocation which is involved in first establishing the needful conditions for right action. If air had to be manufactured, as dwellings must be, or breathing to be learned like speech, mankind would start with an

even greater handicap and would never have come within sight of such goals as it can now pursue. Thus all instrumental and remedial arts, however indispensable, are pure burdens; and progress consists in abridging them as much as is possible without contracting the basis for moral life.

This needful abridgment can take place in two directions. The art may become instinctive, un-conscious of the utility that backs it and conscious only of the solicitation that leads it on. In that measure human nature is adapted to its conditions; lessons long dictated by experience are actually learned and become hereditary habits. So inclination to hunt and fondness for nursing children have passed into instincts in the human race; and what if it were a forced art would be servile, by becoming spontaneous has risen to be an ingredient in ideal life; for sport and maternity are human ideals. In an opposite direction servile arts may be abridged by a lapse of the demand which required them. The servile art of vine-dressers, for instance, would meet such a fate if the course of history, instead of tending to make the vintage an ideal episode and to create worshippers of Bacchus and Priapus, tended rather to bring about a distaste for wine and made the whole industry superfluous. This solution is certainly less happy than the other, insomuch as it suppresses a function instead of taking it up into organic life; yet life to be organic has to be ex-

Servile arts may grow spontaneous or their products may be renounced.

clusive and finite; it has to work out specific tend-
encies in a specific environment; and therefore to
surrender a particular impeded impulse may in-
volve a clear gain, if only a compensating unim-
peded good thereby comes to light elsewhere. If
wine disappeared, with all its humane and sym-
bolic consecrations, that loss might bring an ulti-
mate gain, could some less treacherous friend of
frankness and merriment be thereby brought into
the world.

In practice servile art is usually mitigated by
combining these two methods; the demand sub-
served, being but ill supported, learns to restrain
itself and be less importunate; while at the same
time habit renders the labour which was once un-
willing largely automatic, and even overlays it with
ideal associations. Human nature is happily elas-
tic; there is hardly a need that may not be muffled
or suspended, and hardly an employment that may
not be relieved by the automatic interest with
which it comes to be pursued. To this automatic
interest other palliatives are often added, some-
times religion, sometimes mere dulness and resig-
nation; but in these cases the evil imposed is
merely counterbalanced or forgotten, it is not
remedied. Reflective and spiritual races mini-
mise labour by renunciation, for they find it
easier to give up its fruits than to justify its ex-
actions. Among energetic and self-willed men, on
the contrary, the demand for material progress
remains predominant, and philosophy dwells by

preference on the possibility that a violent and con-
tinual subjection in the present might issue in a
glorious future dominion. This possible result was
hardly realised by the Jews, nor long maintained
by the Greeks and Romans, and it remains to be
seen whether modern industrialism can achieve it.
In fact, we may suspect that success only comes
when a nation's external task happens to coincide
with its natural genius, so that a minimum of its
labour is servile and a maximum of its play is
beneficial. It is in such cases that we find colossal
achievements and apparently inexhaustible ener-
gies. Prosperity is indeed the basis of every ideal
attainment, so that prematurely to recoil from
hardship, or to be habitually conscious of hardship
at all, amounts to renouncing beforehand all
earthly goods and all chance of spiritual greatness.
Yet a chance is no certainty. When glory requires
Titanic labours it often finds itself in the end
buried under a pyramid rather than raised upon a
pedestal. Energies which are not from the begin-
ning self-justifying and flooded with light seldom
lead to ideal greatness.

The action to which industry should minister
is accordingly liberal or spontaneous action; and
this is one condition of rationality in
the arts. But a second condition is
implicit in the first: freedom means
freedom in some operation, ideality
means the ideality of something em-
bodied and material. Activity, achievement, a

Art starts
from two
potentialities:
its material
and its prob-
lem.

passage from prospect to realisation, is evidently essential to life. If all ends were already reached, and no art were requisite, life could not exist at all, much less a Life of Reason. No politics, no morals, no thought would be possible, for all these move towards some ideal and envisage a goal to which they presently pass. The transition is the activity, without which achievement would lose its zest and indeed its meaning; for a situation could never be achieved which had been given from all eternity. The ideal is a concomitant emanation from the natural and has no other possible status. Those human possessions which are perennial and of inalienable value are in a manner potential possessions only. Knowledge, art, love are always largely in abeyance, while power is absolutely synonymous with potentiality. Fruition requires a continual recovery, a repeated re-establishment of the state we enjoy. So breath and nutrition, feeling and thought, come in pulsations; they have only a periodic and rhythmic sort of actuality. The operation may be sustained indefinitely, but only if it admits a certain internal oscillation.

A creature like man, whose mode of being is a life or experience and not a congealed ideality, such as eternal truth might show, must accordingly find something to do; he must operate in an environment in which everything is not already what he is presently to make it. In the actual world this first condition of life is only too amply fulfilled; the real difficulty in man's estate, the

true danger to his vitality, lies not in want of work but in so colossal a disproportion between demand and opportunity that the ideal is stunned out of existence and perishes for want of hope. The Life of Reason is continually beaten back upon its animal sources, and nations are submerged in deluge after deluge of barbarism. Impressed as we may well be by this ancient experience, we should not overlook the complementary truth which under more favourable circumstances would be as plain as the other: namely, that our deepest interest is after all to live, and we could not live if all acquisition, assimilation, government, and creation had been made impossible for us by their foregone realisation, so that every operation was forestalled by the given fact. The distinction between the ideal and the real is one which the human ideal itself insists should be preserved. It is an essential expression of life, and its disappearance would be tantamount to death, making an end to voluntary transition and ideal representation. All objects envisaged either in vulgar action or in the airiest cognition must be at first ideal and distinct from the given facts, otherwise action would have lost its function at the same moment that thought lost its significance. All life would have collapsed into a purposeless datum.

The ideal requires, then, that opportunities should be offered for realising it through action, and that transition should be possible to it from a given state of things. One form of such transi-

tion is art, where the ideal is a possible and more excellent form to be given to some external substance or medium. Art needs to find a material relatively formless which its business is to shape; and this initial formlessness in matter is essential to art's existence. Were there no stone not yet sculptured and built into walls, no sentiment not yet perfectly uttered in poetry, no distance or oblivion yet to be abolished by motion or inferential thought, activity of all sorts would have lost its occasion. Matter, or actuality in what is only potentially ideal, is therefore a necessary condition for realising an ideal at all.

This potentiality, however, in so far as the ideal requires it, is a quite definite disposition. Absolute chaos would defeat life as surely

Each must be definite and congruous with the other.

as would absolute ideality. Activity, in presupposing material conditions, presupposes them to be favourable, so that a movement towards the ideal may actually take place. Matter, which from the point of view of a given ideal is merely its potentiality, is in itself the potentiality of every other ideal as well; it is accordingly responsible to no ideal in particular and proves in some measure refractory to all. It makes itself felt, either as an opportune material or as an accidental hindrance, only when it already possesses definite form and affinities; given in a certain quantity, quality, and order, matter feeds the specific life which, if given otherwise, it would impede or smother altogether.

Art, in calling for materials, calls for materials
plastic to its influence and definitely predisposed
to its ends. Unsuitableness in the data far from
grounding action renders it abortive, and no expe-
A sophism dient could be more sophistical than
exposed that into which theodicy, in its desper-
ate straits, has sometimes been driven, of trying
to justify as conditions for ideal achievement the
very conditions which make ideal achievement im-
possible. The given state from which transition is
to take place to the ideal must support that transi-
tion; so that the desirable want of ideality which
plastic matter should possess is merely relative and
strictly determined. Art and reason find in na-
ture the background they require; but nature, to
be wholly justified by its ideal functions, would
have to subserve them perfectly. It would have
to offer to reason and art a sufficient and favour-
able basis; it would have to feed sense with the
right stimuli at the right intervals, so that art and
reason might continually flourish and be always
moving to some new success. A poet needs emo-
tions and perceptions to translate into language,
since these are his subject-matter and his inspira-
tion; but starvation, physical or moral, will not
help him to sing. One thing is to meet with the
conditions inherently necessary for a given action;
another thing is to meet with obstacles fatal to the
same. A propitious formlessness in matter is no
sort of evil; and evil is so far from being a pro-
pitious formlessness in matter that it is rather

an impeding form which matter has already assumed.

Out of this appears, with sufficient clearness, the rational function which the arts possess.

Industry prepares matter for the liberal arts. They give, as nature does, a form to matter, but they give it a more propitious form. Such success in art is possible only when the materials and organs at hand are in a large measure already well disposed; for it can as little exist with a dull organ as with no organ at all, while there are winds in which every sail must be furled. Art depends upon profiting by a bonanza and learning to sail in a good breeze, strong enough for speed and conscious power but placable enough for dominion and liberty of soul. Then perfection in action can be attained and a self-justifying energy can emerge out of apathy on the one hand and out of servile and wasteful work on the other. Art has accordingly two stages: one mechanical or industrial, in which untoward matter is better prepared, or impeding media are overcome; the other liberal, in which perfectly fit matter is appropriated to ideal uses and endowed with a direct spiritual function. A premonition or rehearsal of these two stages may be seen in nature, where nutrition and reproduction fit the body for its ideal functions, whereupon sensation and cerebration make it a direct organ of mind. Industry merely gives nature that form which, if more thoroughly humane, she might have originally possessed for our benefit; liberal arts

bring to spiritual fruition the matter which either nature or industry has prepared and rendered propitious. This spiritual fruition consists in the activity of turning an apt material into an expressive and delightful form, thus filling the world with objects which by symbolising ideal energies tend to revive them under a favouring influence and therefore to strengthen and refine them.

It remains merely to note that all industry contains an element of fine art and all fine art an element of industry; since every proximate end, in being attained, satisfies the mind and manifests the intent that pursued it; while every operation upon a material, even one so volatile as sound, finds that material somewhat refractory. Before the product can attain its ideal function many obstacles to its transparency and fitness have to be removed. A certain amount of technical and instrumental labour is thus involved in every work of genius, and a certain genius in every technical success.

Each partakes of the other

CHAPTER III

EMERGENCE OF FINE ART

Action which is purely spontaneous is merely tentative. Any experience of success or utility which might have preceded, if it availed **Art is spontaneous action made stable by success.** to make action sure, would avail to make it also intentional and conscious of its ulterior results. Now the actual issue which an action is destined to have, since it is something future and problematical, can exert no influence on its own antecedents; but if any picture of what the issue is likely to be accompanies the heat and momentum of action, that picture being, of all antecedents in the operation, the one most easily remembered and described, may be picked out as essential, and dignified with the name of motive or cause. This will not happen to every prophetic idea; we may live in fear and trembling as easily as with an arrogant consciousness of power. The difference flows from the greater or lesser affinity that happens to exist between expectation and instinct. Action remains always, in its initial phase, spontaneous and automatic; it retains an inwardly grounded and perfectly blind tendency of its own; but this tend-

ency may agree or clash with the motor impulses subtending whatever ideas may at the same time people the fancy. If the blind and the ideal impulses agree, spontaneous action is voluntary and its result intentional; if they clash, the ideas remain speculative and idle, random, ineffectual wishes; while the result, not being referable to any idea, is put down to fate. The sense of power, accordingly, shows either that events have largely satisfied desire, so that natural tendency goes hand in hand with the suggestions of experience, or else that experience has not been allowed to count at all and that the future is being painted *a priori*. In the latter case the sense of power is illusory. Action will then never really issue in the way intended, and even thought will only seem to make progress by constantly forgetting its original direction.

Though life, however, is initially experimental and always remains experimental at bottom, yet experiment fortifies certain tendencies and cancels others, so that a gradual sediment of habit and wisdom is formed in the stream of time. Action then ceases to be merely tentative and spontaneous, and becomes art. Foresight begins to accompany practice and, as we say, to guide it. Purpose thus supervenes on useful impulse, and conscious expression on self-sustaining automatism. Art lies between two extremes. On the one side is purely spontaneous fancy, which would never foresee its own works and scarcely recognise

or value them after they had been created, since
at the next moment the imaginative current would
as likely as not have faced about and might be
making in the opposite direction; and on the other
side is pure utility, which would deprive the work
of all inherent ideality, and render it inexpressive
of anything in man save his necessities. War, for
instance, is an art when, having set itself an ideal
end, it devises means of attaining it; but this ideal
end has for its chief basis some failure in politics
and morals. War marks a weakness and disease
in human society, and its best triumphs are glori-
ous evils—cruel and treacherous remedies, big
with new germs of disease. War is accordingly a
servile art and not essentially liberal; whatever in-
herent values its exercise may have would better
be realised in another medium. Yet out of the
pomp and circumstance of war fine arts may arise
—music, armoury, heraldry, and eloquence. So
utility leads to art when its vehicle acquires in-
trinsic value and becomes expressive. On the
other hand, spontaneous action leads to art when
it acquires a rational function. Thus utterance,
which is primarily automatic, becomes the art of
speech when it serves to mark crises in experi-
ence, making them more memorable and influen-
tial through their artificial expression; but expres-
sion is never art while it remains expressive to no
purpose.

A good way of understanding the fine arts would
be to study how they grow, now out of utility, now

out of automatism. We should thus see more clearly how they approach their goal, which can be nothing but the complete super-position of these two characters. If all practice were art and all art perfect, no action would remain compulsory and not justified inherently, while no creative impulse would any longer be wasteful or, like the impulse to thrum, symptomatic merely and irrelevant to progress. It is by contributing to the Life of Reason and merging into its substance that art, like religion or science, first becomes worthy of praise. Each element comes from a different quarter, bringing its specific excellence and needing its peculiar purification and enlightenment, by co-ordination with all the others; and this process of enlightenment and purification is what we call development in each department. The meanest arts are those which lie near the limit either of utility or of automatic self-expression. They become nobler and more rational as their utility is rendered spontaneous or their spontaneity beneficent.

It combines utility and automatism.

The spontaneous arts are older than the useful, since man must live and act before he can devise instruments for living and acting better. Both the power to construct machines and the end which, to be useful, they would have to serve, need to be given in initial impulse. There is accordingly a vast amount of irresponsible play and loose experiment in art, as in consciousness, before these gropings

Automatism fundamental and irresponsible.

acquire a settled habit and function, and rationality begins. The farther back we go into barbarism the more we find life and mind busied with luxuries; and though these indulgences may repel a cultivated taste and seem in the end cruel and monotonous, their status is really nearer to that of religion and spontaneous art than to that of useful art or of science. Ceremony, for instance, is compulsory in society and sometimes truly oppressive, yet its root lies in self-expression and in a certain ascendency of play which drags all life along into conventional channels originally dug out in irresponsible bursts of action. This occurs inevitably and according to physical analogies. Bodily organs grow automatically and become necessary moulds of life. We must either find a use for them or bear as best we may the idle burden they impose. Of such burdens the barbarian carries the greatest possible sum; and while he paints the heavens with his grotesque mythologies, he encumbers earth with inventions and prescriptions almost as gratuitous. The fiendish dances and shouts, the cruel initiations, mutilations, and sacrifices in which savages indulge, are not planned by them deliberately nor justified in reflection. Men find themselves falling into these practices, driven by a tradition hardly distinguishable from instinct. In its periodic fury the spirit hurries them into wars and orgies, quite as it kindles sudden flaming visions in their brains, habitually so torpid. The spontaneous is the worst of tyrants,

for it exercises a needless and fruitless tyranny in the guise of duty and inspiration. Without mitigating in the least the subjection to external forces under which man necessarily labours, it adds a new artificial subjection to his own false steps and childish errors.

This mental vegetation, this fitful nervous groping, is nevertheless a sign of life, out of which art It is tamed by emerges by discipline and by a gradual contact with application to real issues. An artist is the world. a dreamer consenting to dream of the actual world; he is a highly suggestible mind hypnotised by reality. Even barbaric genius may find points of application in the world. These points will be more numerous the more open the eyes have been, the more docile and intelligent the mind is that gathers and renders back its impressions in a synthetic and ideal form. Intuition will then represent, at least symbolically, an actual situation. Grimace and gesture and ceremony will be modified by a sense of their effect; they will become artful and will transform their automatic expressiveness into ideal expression. They will become significant of what it is intended to communicate and important to know; they will have ceased to be irresponsible exercises and vents for passing feeling, by which feeling is dissipated, as in tears, without being embodied and intellectualised, as in a work of art.

The dance is an early practice that passes after this fashion into an art. A prancing stallion may

transfigure his movements more beautifully than
man is capable of doing; for the springs and limits
of effect are throughout mechanical,
The dance.
and man, in more than one respect,
would have to become a centaur before he could
rival the horse's prowess. Human instinct is very
imperfect in this direction, and grows less happy
the more artificial society becomes; most dances,
even the savage ones, are somewhat ridiculous. A
rudimentary instinct none the less remains, which
not only involves a faculty of heightened and
rhythmic motion, but also assures a direct appre-
ciation of such motion when seen in others. The
conscious agility, *fougue*, and precision which fill
the performer become contagious and delight the
spectator as well. There are indeed dances so
ugly that, like those of contemporary society, they
cannot be enjoyed unless they are shared; they
yield pleasures of exercise only, or at best of move-
ment in unison. But when man was nearer to
the animal and his body and soul were in happier
conjunction, when society, too, was more compul-
sive over the individual, he could lend himself
more willingly and gracefully to being a figure in
the general pageant of the world. The dance
could then detach itself from its early association
with war and courtship and ally itself rather to
religion and art. From being a spontaneous vent
for excitement, or a blind means of producing it,
the dance became a form of discipline and con-
scious social control—a cathartic for the soul; and

this by a quite intelligible transition. Gesture, of which the dance is merely a pervasive use, is an incipient action. It is conduct in the groping

Functions of gesture. stage, before it has lit on its purpose, as can be seen unmistakably in all the gesticulation of love and defiance. In this way the dance is attached to life initially by its physiological origin. Being an incipient act, it naturally leads to its own completion and may arouse in others the beginnings of an appropriate response. Gesture is only less catching and less eloquent than action itself. But gesture, while it has this power of suggesting action and stimulating the response which would be appropriate if the action took place, may be arrested in the process of execution, since it is incipient only; it will then have revealed an intention and betrayed a state of mind. Thus it will have found a function which action itself can seldom fulfil. When an act is done, indications of what it was to be are superfluous; but indications of possible acts are in the highest degree useful and interesting. In this way gesture assumes the rôle of language and becomes a means of rational expression. It remains suggestive and imitable enough to convey an idea, but not enough to precipitate a full reaction; it feeds that sphere of merely potential action which we call thought; it becomes a vehicle for intuition.

Under these circumstances, to tread the measures of a sacred dance, to march with an army, to

bear one's share in any universal act, fills the heart
with a voluminous silent emotion. The massive
suggestion, the pressure of the ambient will, is out
of all proportion to the present call for action.
Infinite resources and definite premonitions are
thus stored up in the soul; and merely to have
moved solemnly together is the best possible
preparation for living afterwards, even if apart,
in the consciousness of a general monition and
authority.

Parallel to this is the genesis and destiny of
music, an art originally closely intertwined with
the dance. The same explosive forces
that agitate the limbs loosen the voice;
hand, foot, and throat mark their wild rhythm
together. Birds probably enjoy the pulsation of
their singing rather than its sound. Even human
music is performed long before it is listened to,
and is at first no more an art than sighing. The
original emotions connected with it are felt by
participation in the performance—a participation
which can become ideal only because, at bottom,
it is always actual. The need of exercise and self-
expression, the force of contagion and unison, bears
the soul along before an artistic appreciation of
music arises; and we may still observe among civil-
ised races how music asserts itself without any æs-
thetic intent, as when the pious sing hymns in com-
mon, or the sentimental, at sea, cannot refrain from
whining their whole homely repertory in the
moonlight. Here as elsewhere, instinct and habit

are phases of the same inner disposition. What has once occurred automatically on a given occasion will be repeated in much the same form when a similar occasion recurs. Thus impulse, reinforced by its own remembered expression, passes into convention. Savages have a music singularly monotonous, automatic, and impersonal; they cannot resist the indulgence, though they probably have little pleasure in it. The same thing happens with customary sounds as with other prescribed ceremonies; to omit them would be shocking and well-nigh impossible, yet to repeat them serves no end further than to avoid a sense of strangeness or inhibition. These automatisms, however, in working themselves out, are not without certain retroactive effects: they leave the system exhausted or relieved, and they have meantime played more or less agreeably on the senses. The music we make automatically we cannot help hearing incidentally; the sensation may even modify the expression, since sensation too has its physical side. The expression is reined in and kept from becoming vagrant, in proportion as its form and occasion are remembered. The automatic performer, being henceforth controlled more or less by reflection and criticism, becomes something of an artist: he trains himself to be consecutive, impressive, agreeable; he begins to compare his improvisation with its subject and function, and thus he develops what is called style and taste.

CHAPTER IV

MUSIC

Sound readily acquires ideal values. It has
power in itself to engross attention and at the
Music is a same time may be easily diversified, so
world apart. as to become a symbol for other things.
Its direct empire is to be compared with that of
stimulants and opiates, yet it presents to the mind,
as these do not, a perception that corresponds, part
by part, with the external stimulus. To hear is
almost to understand. The process we undergo
in mathematical or dialectical thinking is called
understanding, because a natural sequence is there
adequately translated into ideal terms. Logical
connections seem to be internally justified, while
only the fact that we perceive them here and now,
with more or less facility, is attributed to brute
causes. Sound approaches this sort of ideality; it
presents to sense something like the efficacious
structure of the object. It is almost mathemati-
cal; but like mathematics it is adequate only by
being abstract; and while it discloses point by point
one strain in existence, it leaves many other
strains, which in fact are interwoven with it,
wholly out of account. Music is accordingly, like

mathematics, very nearly a world by itself; it contains a whole gamut of experience, from sensuous elements to ultimate intellectual harmonies. Yet this second existence, this life in music, is no mere ghost of the other; it has its own excitements, its quivering alternatives, its surprising turns; the abstract energy of it takes on so much body, that in progression or declension it seems quite as impassioned as any animal triumph or any moral drama.

That a pattering of sounds on the ear should have such moment is a fact calculated to give It justifies itself. pause to those philosophers who attempt to explain consciousness by its utility, or who wish to make physical and moral processes march side by side from all eternity. Music is essentially useless, as life is: but both have an ideal extension which lends utility to its conditions. That the way in which idle sounds run together should matter so much is a mystery of the same order as the spirit's concern to keep a particular body alive, or to propagate its life. Such an interest is, from an absolute point of view, wholly gratuitous; and so long as the natural basis and expressive function of spirit are not perceived, this mystery is baffling. In truth the order of values inverts that of causes; and experience, in which all values lie, is an ideal resultant, itself ineffectual, of the potencies it can conceive. Delight in music is liberal; it makes useful the organs and processes that subserve it. These agencies,

when they support a conscious interest in their operation, give that operation its first glimmering justification, and admit it to the rational sphere. Just so when organic bodies generate a will bent on their preservation, they add a value and a moral function to their equilibrium. In vain should we ask for what purpose existences arise, or become important; that purpose, to be such, must already ·have been important to some existence; and the only question that can be asked or answered is what recognised importance, what ideal values, actual existences involve.

We happen to breathe, and on that account are interested in breathing; and it is no greater marvel It is vital and that, happening to be subject to intransient. tricate musical sensations, we should be in earnest about these too. The human ear discriminates sounds with ease; what it hears is so diversified that its elements can be massed without being confused, or can form a sequence having a character of its own, to be appreciated and remembered. The eye too has a field in which clear distinctions and relations appear, and for that reason is an organ favourable to intelligence; but what gives music its superior emotional power is its rhythmic advance. Time is a medium which appeals more than space to emotion. Since life is itself a flux, and thought an operation, there is naturally something immediate and breathless about whatever flows and expands. The visible world offers itself to our regard with

a certain lazy indifference. "Peruse me," it seems to say, "if you will. I am here; and even if you pass me by now and later find it to your advantage to resurvey me, I may still be here." The world of sound speaks a more urgent language. It insinuates itself into our very substance, and it is not so much the music that moves us as we that move with it. Its rhythms seize upon our bodily life, to accelerate or to deepen it; and we must either become inattentive altogether or remain enslaved.

This imperious function in music has lent it functions which are far from æsthetic. Song can Its physical be used to keep in unison many men's affinities. efforts, as when sailors sing as they heave; it can make persuasive and obvious sentiments which, if not set to music, might seem absurd, as often in love songs and in psalmody. It may indeed serve to prepare the mind for any impression whatever, and render the same more intense when it comes. Music was long used before it was loved or people took pains to refine it. It would have seemed as strange in primitive times to turn utterance into a fine art as now to make æsthetic paces out of mourning or childbirth. Primitive music is indeed a wail and a parturition; magical and suggestive as it may be, for long ages it never bethinks itself to be beautiful. It is content to furnish a contagious melancholy employment to souls without a language and with little interest in the real world. Bar-

baric musicians, singing and playing together
more or less at random, are too much carried away
by their performance to conceive its effect; they
cry far too loud and too unceasingly to listen. A
contagious tradition carries them along and con-
trols them, in a way, as they improvise; the as-
sembly is hardly an audience; all are performers,
and the crowd is only a stimulus that keeps every
one dancing and howling in emulation. This un-
considered flow of early art remains present, more
or less, to the end. Instead of vague custom we
have schools, and instead of swaying multitudes
academic example; but many a discord and man-
nerism survive simply because the musician is so
suggestible, or so lost in the tumult of production,
as never to reconsider what he does, or to perceive
its wastefulness.

Nevertheless an inherent value exists in all
emitted sounds, although barbaric practice and
theory are slow to recognise it. Each tone has its
quality, like jewels of different water; every ca-
dence has its vital expression, no less inherent in
it than that which comes in a posture or in a
thought. Everything audible thrills merely by
sounding, and though this perceptual thrill be at
first overpowered by the effort and excitement of
action, yet it eventually fights its way to the top.
Participation in music may become perfunctory
or dull for the great majority, as when hymns are
sung in church; a mere suggestion of action will
doubtless continue to colour the impression re-

ceived, for a tendency to act is involved in per-
ception; but this suggestion will be only an over-
tone or echo behind an auditory feeling. Some
performers will be singled out from the crowd;
those whom the public likes to hear will be asked
to continue alone; and soon a certain suasion will
be exerted over them by the approval or censure
of others, so that consciously or unconsciously they
will train themselves to please.

The musical quality of sounds has a simple
physical measure for its basis; and the rate of
Physiology vibration is complicated by its sweep or
of music. loudness, and by concomitant sounds.
What a rich note is to a pure and thin one, that
a chord is to a note; nor is melody wholly differ-
ent in principle, for it is a chord rendered piece-
meal. Time intervenes, and the harmony is de-
ployed; so that in melody rhythm is added, with
its immense appeal, to the cumulative effect al-
ready secured by rendering many notes together.
The heightened effect which a note gets by figur-
ing in a phrase, or a phrase in a longer passage,
comes of course from the tensions established and
surviving in the sensorium—a case, differently
shaded, of chords and overtones. The difference
is only that the more emphatic parts of the mel-
ody survive clearly to the end, while the detail,
which if perceived might now clash, is largely
lost, and out of the preceding parts perhaps noth-
ing but a certain swing and potency is present at
the close. The mind has been raked and set

vibrating in an unusual fashion, so that the *finale* comes like a fulfilment after much premonition and desire, whereas the same event, unprepared for, might hardly have been observed. The whole technique of music is but an immense elaboration of this principle. It deploys a sensuous harmony by a sort of dialectic, suspending and resolving it, so that the parts become distinct and their relation vital.

Such elaboration often exceeds the synthetic power of all but the best trained minds. Both in scope and in articulation musical fac-

Limits of musical sensibility.

ulty varies prodigiously. There is no fixed limit to the power of sustaining a given conscious process while new features appear in the same field; nor is there any fixed limit to the power of recovering, under changed circumstances, a process that was formerly suspended. A whole symphony might be felt at once, if the musician's power of sustained or cumulative hearing could stretch so far. As we all survey two notes and their interval in one sensation (actual experience being always transitive and pregnant, and its terms ideal), so a trained mind might survey a whole composition. This is not to say that time would be transcended in such an experience; the apperception would still have duration and the object would still have successive features, for evidently music not arranged in time would not be music, while all sensations with a recognisable character occupy more than an instant in passing.

But the passing sensation, throughout its lapse, presents some experience; and this experience, taken at any point, may present a temporal sequence with any number of members, according to the synthetic and analytic power exerted by the given mind. What is tedious and formless to the inattentive may seem a perfect whole to one who, as they say, takes it all in; and similarly what is a frightful deafening discord to a sense incapable of discrimination, for one who can hear the parts may break into a celestial chorus. A musical education is necessary for musical judgment. What most people relish is hardly music; it is rather a drowsy revery relieved by nervous thrills.

The degree to which music should be elaborated depends on the capacity possessed by those it addresses. There are limits to every

The value of music is relative to them. man's synthetic powers, and to stretch those powers to their limit is exhausting. Excitement then becomes a debauch; it leaves the soul less capable of habitual harmony. Especially is such extreme tension disastrous when, as in music, nothing remains to be the fruit of that mighty victory; the most pregnant revelation sinks to an illusion and is discredited when it cannot maintain its inspiration in the world's presence. Everything has its own value and sets up its price; but others must judge if that price is fair, and sociability is the condition of all rational excellence. There is therefore a limit to right complexity in music, a limit set not by the

nature of music itself, but by its place in human economy. This limit, though clear in principle, is altogether variable in practice; duly cultivated people will naturally place it higher than the unmusical would. In other words, popular music needs to be simple, although elaborate music may be beautiful to the few. When elaborate music is the fashion among people to whom all music is a voluptuous mystery, we may be sure that what they love is. voluptuousness or fashion, and not music itself.

Beneath its hypnotic power music, for the musician, has an intellectual essence. Out of simple

Wonders of musical structure. chords and melodies, which at first catch only the ear, he weaves elaborate compositions that by their form appeal also to the mind. This side of music resembles a richer versification; it may be compared also to mathematics or to arabesques. A moving arabesque that has a vital dimension, an audible mathematics, adding sense to form, and a versification that, since it has no subject-matter, cannot do violence to it by its complex artifices—these are types of pure living, altogether joyful and delightful things. They combine life with order, precision with spontaneity; the flux in them has become rhythmical and its freedom has passed into a rational choice, since it has come in sight of the eternal form it would embody. The musician, like an architect or goldsmith working in sound, but freer than they from material trammels, can

expand for ever his yielding labyrinth; every step
opens up new vistas, every decision—how unlike
those made in real life!—multiplies opportunities,
and widens the horizon before him, without pre-
venting him from going back at will to begin
afresh at any point, to trace the other possible
paths leading thence through various magic land-
scapes. Pure music is pure art. Its extreme ab-
straction is balanced by its entire spontaneity, and,
while it has no external significance, it bears no
internal curse. It is something to which a few
spirits may well surrender themselves, sure that
in a liberal commonwealth they will be thanked
for their ideal labour, the fruits of which many
may enjoy. Such excursions into ultra-mundane
regions, where order is free, refine the mind and
make it familiar with perfection. By analogy an
ideal form comes to be conceived and desiderated
in other regions, where it is not produced so read-
ily, and the music heard, as the Pythagoreans
hoped, makes the soul also musical.

It must be confessed, however, that a world of
sounds and rhythms, all about nothing, is a by-
world and a mere distraction for a political animal.
Its substance is air, though the spell of it may have
moral affinities. Nevertheless this ethereal art may
be enticed to earth and married with what is mor-
tal. Music interests humanity most when it is wed-
ded to human events. The alliance comes about
through the emotions which music and life arouse
in common. For sound, in sweeping through the

body and making felt there its kinetic and poten-
tial stress, provokes no less interest than does any
Its inherent other physical event or premonition.
emotions. Music can produce emotion as directly
as can fighting or love. If in the latter instances
the body's whole life may be in jeopardy, this fact
is no explanation of our concern; for many a dan-
ger is not felt and there is no magic in the body's
future condition, that it should now affect the soul.
What touches the soul is the body's condition at
the moment; and this is altered no less truly by
a musical impression than by some protective or
reproductive act. If emotions accompany the lat-
ter, they might as well accompany the former;
and in fact they do. Nor is music the only idle
cerebral commotion that enlists attention and pre-
sents issues no less momentous for being quite
imaginary; dreams do the same, and seldom can
the real crises of life so absorb the soul, or prompt
it to such extreme efforts, as can delirium in sick-
ness, or delusion in what passes for health.

There is perhaps no emotion incident to human
life that music cannot render in its abstract me-
dium by suggesting the pang of it; though of
course music cannot describe the complex situa-
tion which lends earthly passions their specific
colour. It is by fusion with many suggested
emotions that sentiment grows definite; this fusion
can hardly come about without ideas intervening,
and certainly it could never be sustained or ex-
pressed without them. Occasions define feelings;

we can convey a delicate emotion only by deli-
cately describing the situation which brings it
on. Music, with its irrelevant medium,

In growing
specific they
remain un-
earthly.

can never do this for common life,
and the passions, as music renders
them, are always general. But music
has its own substitute for conceptual dis-
tinctness. It makes feeling specific, nay, more
delicate and precise than association with things
could make it, by uniting it with musical form.
We may say that besides suggesting abstractly
all ordinary passions, music creates a new realm
of form far more subtly impassioned than is
vulgar experience. Human life is confined to
a dramatic repertory which has already be-
come somewhat classical and worn, but music has
no end of new situations, shaded in infinite ways;
it moves in all sorts of bodies to all sorts of
adventures. In life the ordinary routine of des-
tiny beats so emphatic a measure that it does not
allow free play to feeling; we cannot linger on any-
thing long enough to exhaust its meaning, nor can
we wander far from the beaten path to catch new
impressions. But in music there are no mortal
obligations, no imperious needs calling us back to
reality. Here nothing beautiful is extravagant,
nothing delightful unworthy. Musical refine-
ment finds no limit but its own instinct, so that a
thousand shades of what, in our blundering words,
we must call sadness or mirth, find in music their
distinct expression. Each phrase, each composi-

tion, articulates perfectly what no human situa-
tion could embody. These fine emotions are
really new; they are altogether musical and unex-
ampled in practical life; they are native to the
passing cadence, absolute postures into which it
throws the soul.

There is enough likeness, however, between
musical and mundane feeling for the first to be
They merge
with common
emotions, and
express such
as find no ob-
ject in nature. used in entertaining the second. Hence
the singular privilege of this art: to
give form to what is naturally inar-
ticulate, and express those depths of
human nature which can speak no lan-
guage current in the world. Emotion is prima-
rily about nothing, and much of it remains about
nothing to the end. What rescues a part of our
passions from this pathological plight, and gives
them some other function than merely to be, is the
ideal relevance, the practical and mutually rep-
resentative character, which they sometimes ac-
quire. All experience is pathological if we con-
sider its ground; but a part of it is also rational if
we consider its import. The words I am now writ-
ing have a meaning not because at this moment
they are fused together in my animal soul as a
dream might fuse them, however incongruous the
situation they depict might be in waking life;
they are significant only if this moment's product
can meet and conspire with some other thought
speaking of what elsewhere exists, and uttering an
intuition that from time to time may be actually

recovered. The art of distributing interest among the occasions and vistas of life so as to lend them a constant worth, and at the same time to give feeling an ideal object, is at bottom the sole business of education; but the undertaking is long, and much feeling remains unemployed and unaccounted for. This objectless emotion chokes the heart with its dull importunity; now it impedes right action, now it feeds and fattens illusion. Much of it radiates from primary functions which, though their operation is half known, have only base or pitiful associations in human life; so that they trouble us with deep and subtle cravings, the unclaimed *Hinterland* of life. When music, either by verbal indications or by sensuous affinities, or by both at once, succeeds in tapping this fund of suppressed feeling, it accordingly supplies a great need. It makes the dumb speak, and plucks from the animal heart potentialities of expression which might render it, perhaps, even more than human.

By its emotional range music is appropriate to all intense occasions: we dance, pray, and mourn to music, and the more inadequate words or external acts are to the situation, the more grateful music is. As the only bond between music and life is emotion, music is out of place only where emotion itself is absent. If it breaks in upon us in the midst of study or business it becomes an interruption or alternative to our activity, rather than an expression of it; we must either remain

inattentive or pass altogether into the realm of
sound (which may be unemotional enough) and
become musicians for the nonce. Music brings its
sympathetic ministry only to emotional moments;
there it merges with common existence, and is a
welcome substitute for descriptive ideas, since it
co-operates with us and helps to deliver us from
dumb subjection to influences which we should
not know how to meet otherwise. There is often
in what moves us a certain ruthless persistence,
together with a certain poverty of form; the power
felt is out of proportion to the interest awakened,
and attention is kept, as in pain, at once strained
and idle. At such a moment music is a blessed

**Music lends
elementary
feelings an
intellectual
communi-
cable form.**
resource. Without attempting to re-
move a mood that is perhaps inevitable,
it gives it a congruous filling. Thus
the mood is justified by an illustration
or expression which seems to offer some
objective and ideal ground for its existence; and
the mood is at the same time relieved by absorp-
tion in that impersonal object. So entertained,
the feeling settles. The passion to which at first
we succumbed is now tamed and appropriated.
We have digested the foreign substance in giving
it a rational form: its energies are merged in that
strength by which we freely operate.

In this way the most abstract of arts serves the
dumbest emotions. Matter which cannot enter
the moulds of ordinary perception, capacities
which a ruling instinct usually keeps under, flow

suddenly into this new channel. Music is like those branches which some trees put forth close to the ground, far below the point where the other boughs separate; almost a tree by itself, it has nothing but the root in common with its parent. Somewhat in this fashion music diverts into an abstract sphere a part of those forces which abound beneath the point at which human understanding grows articulate. It flourishes on saps which other branches of ideation are too narrow or rigid to take up. Those elementary substances the musician can spiritualise by his special methods, taking away their reproach and redeeming them from blind intensity.

There is consequently in music a sort of Christian piety, in that it comes not to call the just but sinners to repentance, and understands the spiritual possibilities in outcasts from the respectable world. If we look at things absolutely enough, and from their own point of view, there can be no doubt that each has its own ideal and does not question its own justification. Lust and frenzy, revery or despair, fatal as they may be to a creature that has general ulterior interests, are not perverse in themselves: each searches for its own affinities, and has a kind of inertia which tends to maintain it in being, and to attach or draw in whatever is propitious to it. Feelings are as blameless as so many forms of vegetation; they can be poisonous only to a different life. They are all

All essences are in themselves good, even the passions.

primordial motions, eddies which the universal flux makes for no reason, since its habit of falling into such attitudes is the ground-work and exemplar for nature and logic alike. That such strains should exist is an ultimate datum; justification cannot be required of them, but must be offered to each of them in turn by all that enters its particular orbit. There is no will but might find a world to disport itself in and to call good, and thereupon boast to have created that in which it found itself expressed. But such satisfaction has been denied to the majority; the equilibrium of things has at least postponed their day. Yet they are not altogether extinguished, since the equilibrium of things is mechanical and results from no preconcerted harmony such as would have abolished everything contrary to its own perfection. Many ill-suppressed possibilities endure in matter, and peep into being through the crevices, as it were, of the dominant world. Weeds they are called by the tyrant, but in themselves they are aware of being potential gods. Why should not every impulse expand in a congenial paradise? Why should each, made evil now only by an adventitious appellation or a contrary fate, not vindicate its own ideal? If there is a piety towards things deformed, because it is not they that are perverse, but the world that by its laws and arbitrary standards decides to treat them as if they were, how much more should there be a piety towards things altogether lovely, when it is only space and

matter that are wanting for their perfect real-
isation?

Philosophers talk of self-contradiction, but there
is evidently no such thing, if we take for the self
what is really vital, each propulsive, definite strain
of being, each nucleus for estimation and for
pleasure and pain. Each impulse may be contra-
dicted, but not by itself; it may find itself opposed,
in a theatre which it has entered it knows not how,
by violent personages that it has never wished
to encounter. The environment it calls for is
congenial with it; and by that environ-
ment it could never be thwarted or
condemned. The lumbering course of
events may indeed involve it in ruin,
and a mind with permanent interests to defend
may at once rule out everything inconsistent with
possible harmonies; but such rational judgments
come from outside and represent a compromise
struck with material forces. Moral judgments
and conflicts are possible only in the mind that
represents many interests synthetically: in nature,
where primary impulses collide, all conflict is
physical and all will innocent. Imagine some in-
gredient of humanity loosed from its oppressive
environment in human economy: it would at once
vegetate and flower into some ideal form, such as
we see exuberantly displayed in nature. If we
can only suspend for a moment the congested
traffic in the brain, these initial movements will
begin to traverse it playfully and show their

*Each impulse
calls for a
possible con-
genial world.*

paces, and we shall live in one of those plausible worlds which the actual world has made impossible.

Man possesses, for example, a native capacity for joy. There are moments, in friendship or in solitude, when joy is realised; but the occasions are often trivial and could never justify in reflection the feelings that then happen to bubble up. Nor can pure joy be long sustained: cross-currents of lassitude or anxiety, distracting incidents, irrelevant associations, trouble its course and make it languish, turning it before long into dulness or melancholy. Language cannot express a joy that shall be full and pure; for to keep the purity nothing would have to be named which carried the least suggestion of sadness with it, and, in the world that human language refers to, such a condition would exclude every situation possible. " O joy, O joy," would be the whole ditty : hence some dialecticians, whose experience is largely verbal, think whatever is pure necessarily thin.

Literature incapable of expressing pure feelings.

That feeling should be so quickly polluted is, however, a superficial and earthly accident. Spirit is clogged by what it flows through, but at its springs it is both limpid and abundant. There is matter enough in joy for many a universe, though the actual world has not a single form quite fit to embody it, and its too rapid syllables are excluded from the current hexameter. Music, on the contrary, has a more flexible measure ; its prosody ad-

mits every word. Its rhythms can explicate every emotion, through all degrees of complexity and **Music may** volume, without once disavowing it. **do so.** Thus unused matter, which is not less fertile than that which nature has absorbed, comes to fill out an infinity of ideal forms. The joy condemned by practical exigencies to scintillate for a moment uncommunicated, and then, as it were, to be buried alive, may now find an abstract art to embody it and bring it before the public; formed into a rich and constant object called a musical composition. So art succeeds in vindicating the forgotten regions of spirit: a new spontaneous creation shows how little authority or finality the given creation has.

What is true of joy is no less true of sorrow, which, though it arises from failure in some natural ideal, carries with it a sentimental ideal of its own. Even confusion can find in music an expression and a catharsis. That death or change should grieve does not follow from the material nature of these phenomena. To change or to disappear might be as normal a tendency as to move; and it actually happens, when nothing ideal has been attained, that *not to be thus* is the whole law **Instability the** of being. There is then a nameless **soul of matter.** satisfaction in passing on; which is the virtual ideal of pain and mere willing. Death and change acquire a tragic character when they invade a mind which is not ready for them in all its parts, so that those elements in it which are

still vigorous, and would maintain somewhat
longer their ideal identity, suffer violence at the
hands of the others, already mastered by decay
and willing to be self-destructive. Thus a man
whose physiological complexion involves more
poignant emotion than his ideas can absorb—one
who is sentimental—will yearn for new objects
that may explain, embody, and focus his dumb
feelings; and these objects, if art can produce
them, will relieve and glorify those feelings in the
act of expressing them. Catharsis is nothing more.

There would be no pleasure in expressing pain,
if pain were not dominated through its expression.
To know how just a cause we have for grieving is
already a consolation, for it is already a shift from
feeling to understanding. By such consideration
of a passion, the intellectual powers turn it into
Peace the tri- subject-matter to operate upon. All
umph of spirit. utterance is a feat, all apprehension a
discovery; and this intellectual victory, sounding
in the midst of emotional struggles, hushes some
part of their brute importunity. It is at once sub-
lime and beneficent, like a god stilling a tempest.
Melancholy can in this way be the food of art; and
it is no paradox that such a material may be beau-
tiful when a fit form is imposed upon it, since a
fit form turns anything into an agreeable object;
its beauty runs as deep as its fitness, and stops
where its adaptation to human nature begins to
fail. Whatever can interest may prompt to expres-
sion, as it may have satisfied curiosity; and the

mind celebrates a little triumph whenever it can
formulate a truth, however unwelcome to the flesh,
or discover an actual force, however unfavourable
to given interests. As meditation on death and
on life make equally for wisdom, so the expression
of sorrow and joy make equally for beauty. Medi-
tation and expression are themselves congenial
activities with an intrinsic value which is not les-
sened if what they deal with could have been abol-
ished to advantage. If once it exists, we may
understand and interpret it; and this reaction will
serve a double purpose. At first, in its very act,
it will suffuse and mollify the unwelcome experi-
ence by another, digesting it, which is welcome;
and later, by the broader adjustment which it will
bring into the mind, it will help us to elude or
confront the evils thus laid clearly before us.

Catharsis has no such effect as a sophistical op-
timism wishes to attribute to it; it does not show
us that evil is good, or that calamity and crime are
things to be grateful for: so forced an apology
for evil has nothing to do with tragedy or wis-
dom; it belongs to apologetics and an artificial
theodicy. Catharsis is rather the consciousness of
how evil evils are, and how besetting; and how pos-
sible goods lie between and involve serious renun-
ciations. To understand, to accept, and to use
the situation in which a mortal may find himself is
the function of art and reason. Such mastery is
desirable in itself and for its fruits; it does not
make itself responsible for the chaos of goods and

evils that it supervenes upon. Whatever writhes
in matter, art strives to give form to; and however
unfavourable the field may be for its activity, it
does what it can there, since no other field exists in
which it may labour.

Sad music pleases the melancholy because it is
sad and other men because it is music. When a
Refinement is composer attempts to reproduce com-
true strength. plex conflicts in his score he will please
complex or disordered spirits for expressing their
troubles, but other men only for the order and
harmony he may have brought out of that chaos.
The chaos in itself will offend, and it is no part of
rational art to produce it. As well might a physi-
cian poison in order to give an antidote, or maim
in order to amputate. The subject matter of art
is life, life as it actually is; but the function of art
is to make life better. The depth to which an
artist may find current experience to be sunk in
discord and confusion is not his special concern;
his concern is, in some measure, to lift experience
out. The more barbarous his age, the more dras-
tic and violent must be his operation. He will
have to shout in a storm. His strength must
needs, in such a case, be very largely physical and
his methods sensational. In a gentler age he may
grow nobler, and blood and thunder will no longer
seem impressive. Only the weak are obliged to
be violent; the strong, having all means at com-
mand, need not resort to the worst. Refined art
is not wanting in power if the public is refined

also. And as refinement comes only by experience, by comparison, by subordinating means to ends and rejecting what hinders, it follows that a refined mind will really possess the greater volume, as well as the subtler discrimination. Its ecstasy without grimace, and its submission without tears, will hold heaven and earth better together—and hold them better apart—than could a mad imagination.

CHAPTER V

SPEECH AND SIGNIFICATION

Music rationalises sound, but a more momentous rationalising of sound is seen in language. Language is one of the most useful of things, yet the greater part of it still remains (what it must all have been in the beginning) useless and without ulterior significance. The musical side of language is its primary and elementary side. Man is endowed with vocal organs so plastic as to emit a great variety of delicately varied sounds; and by good fortune his ear has a parallel sensibility, so that much vocal expression can be registered and confronted by auditory feeling. It has been said that man's preeminence in nature is due to his possessing hands; his modest participation in the ideal world may similarly be due to his possessing tongue and ear. For when he finds shouting and vague moaning after a while fatiguing, he can draw a new pleasure from uttering all sorts of labial, dental, and gutteral sounds. Their rhythms and oppositions can entertain him, and he can begin to use his lingual gamut to designate the whole range of his perceptions and passions.

Sounds well fitted to be symbols.

Here we touch upon one of the great crises in creation. As nutrition at first established itself in the face of waste, and reproduction in the face of death, so representation was able, by help of vocal symbols, to confront that dispersion inherent in experience, which is something in itself ephemeral. Merely to associate one thing with another brings little gain; and merely to have added a vocal designation to fleeting things—a designation which of course would have been taken for a part of their essence—would in itself have encumbered phenomena without rendering them in any way more docile to the will. But the encumbrance in this instance proved to be a wonderful preservative and means of comparison. It actually gave each moving thing its niche and cenotaph in the eternal. For the universe of vocal sounds was a field, like that of colour or number, in which the elements showed relations and transitions easy to dominate. It was a key-board over which attention could run back and forth, eliciting many implicit harmonies. Henceforth when various sounds had been idly associated with various things, and identified with them, the things could, by virtue of their names, be carried over mentally into the linguistic system; they could be manipulated there ideally, and vicariously preserved in representation. Needless to say that the things themselves remained unchanged all the while in their efficacy and mechanical succession, just as they remain unchanged in those respects when they pass for

the mathematical observer into their measure or
symbol; but as this reduction to mathematical form
makes them calculable, so their earlier reduction
to words rendered them comparable and memo-
rable, first enabling them to figure in discourse
at all.

Language had originally no obligation to sub-
serve an end which we may sometimes measure it

Language has a structure independent of things. by now, and depute to be its proper
function, namely, to stand for things
and adapt itself perfectly to their struc-
ture. In language as in every other
existence idealism precedes realism, since it must
be a part of nature living its own life before it can
become a symbol for the rest and bend to external
control. The vocal and musical medium is, and
must always remain, alien to the spatial. What
makes terms correspond and refer to one another
is a relation eternally disparate from the relation
of propinquity or derivation between existences.
Yet when sounds were attached to an event or
emotion, the sounds became symbols for that dis-
parate fact. The net of vocal relations caught
that natural object as a cobweb might catch a fly,
without destroying or changing it. The object's
quality passed to the word at the same time that
the word's relations enveloped the object; and thus
a new weight and significance was added to sound,
previously nothing but a dull music. A conflict
at once established itself between the drift proper
to the verbal medium and that proper to the des-

ignated things; a conflict which the whole history
of language and thought has embodied and which
continues to this day.

Suppose an animal going down to a frozen river
which he had previously visited in summer. Marks
Words, re-
maining iden-
tical, serve to
identify things
that change. of all sorts would awaken in him an
old train of reactions; he would doubt-
less feel premonitions of satisfied thirst
and the splash of water. On finding,
however, instead of the fancied liquid, a mass of
something like cold stone, he would be discon-
certed. His active attitude would be pulled up
short and contradicted. In his fairyland of faith
and magic the old river would have been simply
annihilated, the dreamt-of water would have
become a vanished ghost, and this ice for the mo-
ment the hard reality. He would turn away and
live for a while on other illusions. When this
shock was overgrown by time and it was summer
again, the original habit might, however, reassert
itself once more. If he revisited the stream, some
god would seem to bring back something from an
old familiar world; and the chill of that temporary
estrangement, the cloud that for a while had made
the good invisible, would soon be gone and for-
gotten.

If we imagine, on the contrary, that this ani-
mal could speak and had from the first called his
haunt *the river*, he would have repeated its name
on seeing it even when it was frozen, for he had
not failed to recognise it in that guise. The varia-

tion afterwards noticed, upon finding it hard,
would seem no total substitution, but a *change;* for
it would be the same river, once flowing, that was
now congealed. An identical word, covering all
the identical qualities in the phenomena and serv-
ing to abstract them, would force the inconsistent
qualities in those phenomena to pass for accidents;
and the useful proposition could at once be framed
that the same river may be sometimes free and
sometimes frozen.

This proposition is true, yet it contains much
that is calculated to offend a scrupulous dialec-
tician. Its language and categories are
Language the
dialectical gar- not purely logical, but largely physical
ment of facts. and representative. The notion that
what changes nevertheless endures is a remarkable
hybrid. It arises when rigid ideal terms are im-
posed on evanescent existence. Feelings, taken
alone, would show no identities; they would be lost
in changing, or be woven into the infinite feeling
of change. Notions, taken alone, would allow no
lapse, but would merely lead attention about from
point to point over an eternal system of relations.
Power to understand the world, logical or scien-
tific mastery of existence, arises only by the forced
and conventional marriage of these two essences,
when the actual flux is ideally suspended and an
ideal harness is loosely flung upon things. For
this purpose words are an admirable instrument.
They have dialectical relations based on an ideal
import, or tendency to definition, which makes

their essence their signification; yet they can be freely bandied about and applied for a moment to the ambiguous things that pass through existence.

Had men been dumb, an exchange and circulation of images need not have been wanting, and

Words are wise men's counters. associations might have arisen between ideals in the mind and corresponding reactive habits in the body. What words add is not power of discernment or action, but a medium of intellectual exchange. Language is like money, without which specific relative values may well exist and be felt, but cannot be reduced to a common denominator. And as money must have a certain intrinsic value of its own in order that its relation to other values may be stable, so a word, by which a thing is represented in discourse, must be a part of that thing's context, an ingredient in the total apparition it is destined to recall. Words, in their existence, are no more universal than gold by nature is a worthless standard of value in other things. Words are a material accompaniment of phenomena, at first an idle accompaniment, but one which happens to subserve easily a universal function. Some other element in objects might conceivably have served for a common denominator between them; but words, just by virtue of their adventitious, detachable status, and because they are so easily compared and manipulated in the world of sound, were singularly well fitted for this office. They are not vague, as any common quality abstracted from

things would necessarily become; and though
vagueness is a quality only too compatible with
perception, so that vague ideas can exist without
end, this vagueness is not what makes them uni-
versal in their functions. It is one thing to per-
ceive an ill-determined form and quite another to
attribute to it a precise general predicate. Words,
distinct in their own category and perfectly recog-
nisable, can accordingly perform very well the
function of embodying a universal; for they can
be identified in turn with many particulars and
yet remain throughout particular themselves.

The psychology of nominalism is undoubtedly
right where it insists that every image is particular
Nominalism and every term, in its existential aspect,
right in a *flatum vocis;* but nominalists should
psychology.
and realism have recognised that images may have
in logic any degree of vagueness and generality
when measured by a conceptual standard. A
figure having obviously three sides and three cor-
ners may very well be present to the mind when
it is impossible to say whether it is an equilateral
or a rectangular triangle. Functional or logical
universality lies in another sphere altogether, being
a matter of intent and not of existence. When we
say that " universals alone exist in the mind " we
mean by " mind " something unknown to Berke-
ley; not a bundle of psychoses nor an angelic sub-
stance, but quick intelligence, the faculty of dis-
course. Predication is an act, understanding a
spiritual and transitive operation: its existential

basis may well be counted in psychologically and reduced to a stream of immediate presences; but its meaning can be caught only by another meaning, as life only can exemplify life. Vague or general images are as little universal as sounds are; but a sound better than a flickering abstraction can serve the intellect in its operation of comparison and synthesis. Words are therefore the body of discourse, of which the soul is understanding.

The categories of discourse are in part merely representative, in part merely grammatical, and

Literature moves between the extremes of music and denotation. in part attributable to both spheres. Euphony and phonetic laws are principles governing language without any reference to its meaning; here speech is still a sort of music. At the other extreme lies that ultimate form of prose which we see in mathematical reasoning or in a telegraphic style, where absolutely nothing is rhetorical and speech is denuded of every feature not indispensable to its symbolic rôle. Between these two extremes lies the broad field of poetry, or rather of imaginative or playful expression, where the verbal medium is a medium indeed, having a certain transparency, a certain reference to independent facts, but at the same time elaborates the fact in expressing it, and endows it with affinities alien to its proper nature. A pun is a grotesque example of such diremption, where ambiguities belonging only to speech are used to suggest impossible substitutions in ideas. Less frankly, language habitu-

ally wrests its subject-matter in some measure from its real context and transfers it to a represented and secondary world, the world of logic and reflection. Concretions in existence are subsumed, when named, under concretions in discourse. Grammar lays violent hands upon experience, and everything becomes a prey to wit and fancy, a material for fiction and eloquence. Man's intellectual progress has a poetic phase, in which he imagines the world; and then a scientific phase, in which he sifts and tests what he has imagined.

In what measure do inflection and syntax represent anything in the subject-matter of discourse? In what measure are they an independent play of expression, a quasi-musical, quasi-mathematical veil interposed between reflection and existence? One who knows only languages of a single family can give but a biassed answer to this question. There are doubtless many approaches to correct symbolism in language, which grammar may have followed up at different times in strangely different ways. That the medium in every art has a

Sound and object, in their sensuous presence, may have affinity.

character of its own, a character limiting its representative value, may perhaps be safely asserted, and this intrinsic character in the medium antedates and permeates all representation. Phonetic possibilities and phonetic habits belong, in language, to this indispensable vehicle; what the throat and lips can emit easily and distinguishably, and what sequences can appeal to the ear and

be retained, depend alike on physiological conditions; and no matter how convenient or inconvenient these conditions may be for signification, they will always make themselves felt and may sometimes remain predominant. In poetry they are still conspicuous. Euphony, metre, and rhyme colour the images they transmit and add a charm wholly extrinsic and imputed. In this immersion of the message in the medium and in its intrinsic movement the magic of poetry lies; and the miracle grows as there is more or less native analogy between the medium's movement and that of the subject-matter.

Both language and ideas involve processes in the brain. The two processes may be wholly disparate if we regard their objects only and forget their seat, as Athena is in no way linked to an elephant's tusk; yet in perception all processes are contiguous and exercise a single organism, in which they may find themselves in sympathetic or antipathetic vibration. On this circumstance hangs that subtle congruity between subject and vehicle which is otherwise such a mystery in expression. If to think of Athena and to look on ivory are congruous physiological processes, if they sustain or heighten each other, then to represent Athena in ivory will be a happy expedient, in which the very nature of the medium will already be helping us forward. Scent and form go better together, for instance, in the violet or the rose than in the hyacinth or the poppy: and being better compacted

for human perception they seem more expressive
and can be linked more unequivocally with other
sources of feeling. So a given vocal sound may
have more or less analogy to the thing it is used
to signify; this analogy may be obvious, as in ono-
matopœia, or subtle, as when short, sharp sounds
go with decision, or involved rhythms and vague
reverberations with a floating dream. What seems
exquisite to one poet may accordingly seem vapid
to another, when the texture of experience in the
two minds differs, so that a given composition
rustles through one man's fancy as a wind might
through a wood, but finds no sympathetic response
in the other organism, nerved as it may be, per-
haps, to precision in thought and action.

The structure of language, when it passes beyond
the phonetic level, begins at once to lean upon ex-
Syntax posi- istences and to imitate the structure of
tively repre- things. We distinguish the parts of
sentative. speech, for instance, in subservience to
distinctions which we make in ideas. The feeling
or quality represented by an adjective, the relation
indicated by a verb, the substance or concretion
of qualities designated by a noun, are diversities
growing up in experience, by no means attributable
to the mere play of sound. The parts of speech
are therefore representative. Their inflection is
representative too, since tenses mark important
practical differences in the distribution of the
events described, and cases express the respective
rôles played by objects in the operation. " I struck

him and he will strike me," renders in linguistic
symbols a marked change in the situation; the
variation in phrase is not rhetorical. Language
here, though borrowed no doubt from ancestral
poetry, has left all revery far behind, and has been
submerged in the Life of Reason.

The medium, however, constantly reasserts
itself. An example may be found in gender,
which, clearly representative in a meas-

Yet it viti-
ates what it ure, cuts loose in language from all
represents. genuine representation and becomes a
feature in abstract linguistic design, a formal
characteristic in expression. Contrasted senti-
ments permeate an animal's dealings with his own
sex and with the other; nouns and adjectives rep-
resent this contrast by taking on masculine and
feminine forms. The distinction is indeed so im-
portant that wholly different words—man and
woman, bull and cow—stand for the best-known
animals of different sex; while adjectives, where
declension is extinct, as in English, often take on
a connotation of gender and are applied to one sex
only—as we say a beautiful woman, but hardly a
beautiful man. But gender in language extends
much farther than sex, and even if by some subtle
analogy all the masculine and feminine nouns in
a language could be attached to something suggest-
ing sex in the objects they designate, yet it can
hardly be maintained that the elaborate concor-
dance incident upon that distinction is representa-
tive of any felt quality in the things. So remote

an analogy to sex could not assert itself pervasively.
Thus Horace says:

> Quis *multa* gracilis te puer in *rosa*
> perfusis liquidis urget odoribus
> *grato*, Pyrrha, sub *antro?*

Here we may perceive why the rose was instinc-
tively made feminine, and we may grant that the
bower, though the reason escape us, was somehow
properly masculine; but no one would urge that a
profusion of roses was also intrinsically feminine,
or that the *pleasantness* of a bower was ever spe-
cifically masculine to sense. The epithets *multa*
and *grato* take their gender from the nouns, even
though the quality they designate fails to do so.
Their gender is therefore non-representative and
purely formal; it marks an intra-linguistic accom-
modation. The medium has developed a syntacti-
cal structure apart from any intrinsic significance
thereby accruing to its elements.. Artificial con-
cordance in gender does not express gender: it
merely emphasises the grammatical links in the
phrases and makes greater variety possible in the
arrangement of words.

This example may prepare us to understand a
general principle: that language, while essentially
significant viewed in its function, is
Difficulty in subduing a living medium. indefinitely wasteful, being mechanical
and tentative in its origin. It over-
loads itself, and being primarily music,
and a labyrinth of sounds, it develops an articula-

tion and method of its own, which only in the end,
and with much inexactness, reverts to its function
of expression. How great the possibilities of ef-
fect are in developing a pure medium we can best
appreciate in music; but in language a similar de-
velopment goes on while it is being applied to rep-
resenting things. The organ is spontaneous, the
function adventitious and superimposed. Rhetoric
and utility keep language going, as centrifugal and
centripetal forces keep a planet in its course.
Euphony, verbal analogy, grammatical fancy,
poetic confusion, continually drive language afield,
in its own tangential direction; while the business
of life, in which language is employed, and the
natural lapse of rhetorical fashions, as continually
draw it back towards convenience and exacti-
tude.

Between music and bare symbolism language
has its florid expansion. Until music is subordi-
nated, speech has little sense; it can
hardly tell a story or indicate an object
unequivocally. Yet if music were left
behind altogether, language would pass into a sort
of algebra or vocal shorthand, without literary
quality; it would become wholly indicative and
record facts without colouring them ideally. This
medium and its intrinsic development, though
they make the bane of reproduction, make the
essence of art; they give representation a new and
specific value such as the object, before represen-
tation, could not have possessed. Consciousness

**Language
foreshortens
experience.**

itself is such a medium in respect to diffuse existence, which it foreshortens and elevates into synthetic ideas. Reason, too, by bringing the movement of events and inclinations to a head in single acts of reflection, thus attaining to laws and purposes, introduces into life the influence of a representative medium, without which life could never pass from a process into an art. Language acquires scope in the same way, by its kindly infidelities; its metaphors and syntax lend experience perspective. Language vitiates the experience it expresses, but thereby makes the burden of one moment relevant to that of another. The two experiences, identified roughly with the same concretion in discourse, are pronounced similar or comparable in character. Thus a proverb, by its verbal pungency and rhythm, becomes more memorable than the event it first described would ever have been if not translated into an epigram and rendered, so to speak, applicable to new cases; for by that translation the event has become an idea.

To turn events into ideas is the function of literature. Music, which in a certain sense is a mass of pure forms, must leave its " ideas " imbedded in their own medium—they are musical ideas—and cannot impose them on any foreign material, such as human affairs. Science, on the contrary, seeks to disclose the bleak anatomy of existence, stripping off as much as possible the veil of prejudice and words. Literature takes a middle course and

tries to subdue music, which for its purposes would
be futile and too abstract, into conformity with
general experience, making music
thereby significant. Literary art in the
end rejects all unmeaning flourishes, all
complications that have no counterpart in things
or no use in expressing their relations; at the same
time it aspires to digest that reality to which it
confines itself, making it over into ideal substance
and material for the mind. It looks at things with
an incorrigibly dramatic eye, turning them into
permanent unities (which they never are) and
almost into persons, grouping them by their imagi-
native or moral affinities and retaining in them
chiefly what is incidental to their being, namely,
the part they may chance to play in man's adven-
tures.

*It is a per-
petual myth-
ology.*

Such literary art demands a subject-matter other
than the literary impulse itself. The literary man
is an interpreter and hardly succeeds, as the musi-
cian may, without experience and mastery of
human affairs. His art is half genius and half
fidelity. He needs inspiration; he must wait for
automatic musical tendencies to ferment in his
mind, proving it to be fertile in devices, compari-
sons, and bold assimilations. Yet inspiration
alone will lead him astray, for his art is relative
to something other than its own formal impulse;
it comes to clarify the real world, not to encum-
ber it; and it needs to render its native agility
practical and to attach its volume of feeling to

what is momentous in human life. Literature has
its piety, its conscience; it cannot long forget,
without forfeiting all dignity, that it serves a bur-
dened and perplexed creature, a human animal
struggling to persuade the universal Sphinx to pro-
pose a more intelligible riddle. Irresponsible and
trivial in its abstract impulse, man's simian chatter
becomes noble as it becomes symbolic; its represen-
tative function lends it a serious beauty, its utility
endows it with moral worth.

These relations, in determining the function of
language, determine the ideal which its structure
should approach. Any sort of gram-
mar and rhetoric, the most absurd and
inapplicable as well as the most descrip-
tive, can be spontaneous; fit organisms
are not less natural than those that are unfit.
Felicitous genius is so called because it meets ex-
perience half-way. A genius which flies in the op-
posite direction, though not less fertile internally,
is externally inept and is called madness. Inepti-
tude is something which language needs to shake
off. Better surrender altogether some verbal cate-
gories and start again, in that respect, with a clean
slate, than persist in any line of development that
alienates thought from reality. The language of
birds is excellent in its way, and those ancient sages
who are reported to have understood it very likely
had merely perceived that it was not meant to be
intelligible; for it is not to understand nature to
reduce her childishly to a human scale. Man, who

*It may be
apt or inapt,
with equal
richness.*

is merged in universal nature at the roots of his being, is not without profound irrational intuitions by which he can half divine her secret processes; and his heart, in its own singing and fluttering, might not wholly misinterpret the birds. But human discourse is not worth having if it is mere piping, and helps not at all in mastering things; for man is intelligent, which is another way of saying that he aspires to envisage in thought what he is dealing with in action. Discourse that absolved itself from that observant duty would not be cognitive; and in failing to be cognitive it would fail to redeem the practical forces it ignored from their brute externality, and to make them tributary to the Life of Reason. Thus its own dignity and continued existence depend on its learning to express momentous facts, facts important for action and happiness; and there is nothing which so quickly discredits itself as empty rhetoric and dialectic, or poetry that wanders in dim and private worlds. If pure music, even with its immense sensuous appeal, is so easily tedious, what a universal yawn must meet the verbiage which develops nothing but its own irridescence. Absolute versification and absolute dialectic may

Absolute language a possible but foolish art. have their place in society; they give play to an organ that has its rights like any other, and that, after serving for a while in the economy of life, may well claim a holiday in which to disport itself irresponsibly among the fowls of the air and the lilies of the field.

But the exercise is trivial; and if its high priests go through their mummeries with a certain unction, and pretend to be wafted by them into a higher world, the phenomenon is neither new nor remarkable. Language is a wonderful and pliant medium, and why should it not lend itself to imposture? A systematic abuse of words, as of other things, is never without some inner harmony or propriety that makes it prosper; only the man who looks beyond and sees the practical results awakes to the villainy of it. In the end, however, those who play with words lose their labour, and pregnant as they feel themselves to be with new and wonderful universes, they cannot humanise the one in which they live and rather banish themselves from it by their persistent egotism and irrelevance.

CHAPTER VI

POETRY AND PROSE

There is both truth and illusion in the saying that primitive poets are sublime. Genesis and the Iliad (works doubtless backed by a long tradition) are indeed sublime. Primitive men, having perhaps developed language before the other arts, used it with singular directness to describe the chief episodes of life, which was all that life as yet contained. They had frank passions and saw things from single points of view. A breath from that early world seems to enlarge our natures, and to restore to language, which we have sophisticated, all its magnificence and truth. But there is more, for (as we have seen) language is spontaneous; it constitutes an act before it registers an observation. It gives vent to emotion before it is adjusted to things external and reduced, as it were, to its own echo rebounding from a refractory world. The lion's roar, the bellowing of bulls, even the sea's cadence has a great sublimity. Though hardly in itself poetry, an animal cry, when still audible in human language, renders it also the unanswerable, the ultimate voice of nature. Nothing can so pierce the soul as the

87

uttermost sigh of the body. There is no utterance so thrilling as that of absolute impulse, if absolute impulse has learned to speak at all. An intense, inhospitable mind, filled with a single idea, in which all animal, social, and moral interests are fused together, speaks a language of incomparable force. Thus the Hebrew prophets, in their savage concentration, poured into one torrent all that their souls possessed or could dream of. What other men are wont to pursue in politics, business, religion, or art, they looked for from one wave of national repentance and consecration. Their age, swept by this ideal passion, possessed at the same time a fresh and homely vocabulary; and the result was an eloquence so elemental and combative, so imaginative and so bitterly practical, that the world has never heard its like. Such single-mindedness, with such heroic simplicity in words and images, is hardly possible in a late civilisation. Cultivated poets are not unconsciously sublime.

The sublimity of early utterances should not be hailed, however, with unmixed admiration. It is a sublimity born of defect or at least of disproportion. The will asserts itself magnificently; images, like thunderclouds, seem to cover half the firmament at once. But such a will is sadly inexperienced; it has hardly tasted or even conceived any possible or high satisfactions. Its lurid firmament is poor in stars. To throw the whole mind upon something is not

<div style="margin-left:2em; font-style:italic">Its exclusiveness and narrowness.</div>

so great a feat when the mind has nothing else to throw itself upon. Every animal when goaded becomes intense; and it is perhaps merely the apathy in which mortals are wont to live that keeps them from being habitually sublime in their sentiments. The sympathy that makes a sheep hasten after its fellows, in vague alarm or in vague affection; the fierce premonitions that drive a bull to the heifer; the patience with which a hen sits on her eggs; the loyalty which a dog shows to his master—what thoughts may not all these instincts involve, which it needs only a medium of communication to translate into poetry?

Man, though with less wholeness of soul, enacts the same dramas. He hears voices on all occasions; he incorporates what little he observes of nature into his verbal dreams; and as each new impulse bubbles to the surface he feels himself on the verge of some inexpressible heaven or hell. He needs but to abandon himself to that seething chaos which perpetually underlies conventional sanity—a chaos in which memory and prophecy, vision and impersonation, sound and sense, are inextricably jumbled together—to find himself at once in a magic world, irrecoverable, largely unmeaning, terribly intricate, but, as he will conceive, deep, inward, and absolutely real. He will have reverted, in other words, to crude experience, to primordial illusion. The movement of his animal or vegetative mind will be far from delightful; it will be unintelligent and unintelligible; nothing

in particular will be represented therein; but it
will be a movement in the soul and for the
soul, as exciting and compulsive as the soul's
volume can make it. In this muddy torrent words
also may be carried down; and if these words are
by chance strung together into a cadence, and are
afterwards written down, they may remain for a
memento of that turbid moment. Such words we
may at first hesitate to call poetry, since very likely
they are nonsense; but this nonsense will have
some quality—some rhyme or rhythm—that makes
it memorable (else it would not have survived);
and moreover the words will probably show,
in their connotation and order, some sympathy
with the dream that cast them up. For the
•man himself, in whom such a dream may be part-
ly recurrent, they may consequently have a con-
siderable power of suggestion, and they may
even have it for others, whenever the rhythm and
incantation avail to plunge them also into a sim-
ilar trance.

Memorable nonsense, or sound with a certain
hypnotic power, is the really primitive and radical
form of poetry. Nor is such poetry yet
extinct: children still love and compose
it, and every genuine poet, on one side
of his genius, reverts to it from explicit
speech. As all language has acquired its mean-
ing, and did not have it in the beginning, so the
man who launches a new locution, the poet who
creates a symbol, must do so without knowing

Rudimentary poetry an incantation or charm.

what significance it may eventually acquire, and
conscious at best only of the emotional back-
ground from which it emerged. Pure poetry is
pure experiment; and it is not strange that nine-
tenths of it should be pure failure. For it matters
little what unutterable things may have originally
gone together with a phrase in the dreamer's mind;
if they were not uttered and the phrase cannot
call them back, this verbal relic is none the richer
for the high company it may once have kept. Ex-
pressiveness is a most accidental matter. What a
line suggests at one reading, it may never suggest
again even to the same person. For this reason,
among others, poets are partial to their own com-
positions; they truly discover there depths of mean-
ing which exist for nobody else. Those readers
who appropriate a poet and make him their own
fall into a similar illusion; they attribute to him
what they themselves supply, and whatever he
reels out, lost in his own personal revery, seems
to them, like *sortes biblicæ,* written to fit their
own case.

Justice has never been done to Plato's remark-
able consistency and boldness in declaring that
Inspiration poets are inspired by a divine madness
irresponsible. and yet, when they transgress rational
bounds, are to be banished from an ideal republic,
though not without some marks of Platonic re-
gard. Instead of fillets, a modern age might as-
sign them a coterie of flattering dames, and instead
of banishment, starvation; but the result would be

the same in the end. A poet is inspired because
what occurs in his brain is a true experiment in
creation. His apprehension plays with words and
their meanings as nature, in any spontaneous
variation, plays with her own structure. A me-
chanical force shifts the kaleidoscope; a new direc-
tion is given to growth or a new gist to significa-
tion. This inspiration, moreover, is mad, being
wholly ignorant of its own issue; and though it
has a confused fund of experience and verbal
habit on which to draw, it draws on this fund
blindly and quite at random, consciously possessed
by nothing but a certain stress and pregnancy and
the pains, as it were, of parturition. Finally the
new birth has to be inspected critically by the pub-
lic censor before it is allowed to live; most probably
it is too feeble and defective to prosper in the com-
mon air, or is a monster that violates some primary
rule of civic existence, tormenting itself to disturb
others.

Plato seems to have exaggerated the havoc
which these poetic dragons can work in the world.

Plato's dis-
criminating
view.
They are in fact more often absurd
than venomous, and no special legisla-
tion is needed to abolish them. They
soon die quietly of universal neglect. The poetry
that ordinarily circulates among a people is poetry
of a secondary and conventional sort that propa-
gates established ideas in trite metaphors. Popu-
lar poets are the parish priests of the Muse, re-
tailing her ancient divinations to a long since

converted public. Plato's quarrel was not so much with poetic art as with ancient myth and emotional laxity: he was preaching a crusade against the established church. For naturalistic deities he wished to substitute moral symbols; for the joys of sense, austerity and abstraction. To proscribe Homer was a marked way of protesting against the frivolous reigning ideals. The case is much as if we should now proscribe the book of Genesis, on account of its mythical cosmogony, or in order to proclaim the philosophic truth that the good, being an adequate expression to be attained by creation, could not possibly have preceded it or been its source. We might admit at the same time that Genesis contains excellent images and that its poetic force is remarkable; so that if serious misunderstanding could be avoided the censor might be glad to leave it in everybody's hands. Plato in some such way recognised that Homer was poetical and referred his works, mischievous as they might prove incidentally, to divine inspiration. Poetic madness, like madness in prophecy or love, bursts the body of things to escape from it into some ideal; and even the Homeric world, though no model for a rational state, was a cheerful heroic vision, congenial to many early impulses and dreams of the mind.

Homer, indeed, was no primitive poet; he was a consummate master, the heir to generations of discipline in both life and art. This appears in his perfect prosody, in his limpid style, in his sense

for proportion, his abstentions, and the frank pathos of his portraits and principles, in which there is nothing gross, subjective, or arbitrary. The inspirations that came to him never carried him into crudeness or absurdity. Every modern poet, though the world he describes may be more refined in spots and more elaborate, is less advanced in his art; for art is made rudimentary not by its date but by its irrationality. Yet even if Homer had been primitive he might well have been inspired, in the same way as a Bacchic frenzy or a mystic trance; the most blundering explosions may be justified antecedently by the plastic force that is vented in them. They may be expressive, in **Explosive and pregnant expression.** the physical sense of this ambiguous word; for, far as they may be from conveying an idea, they may betray a tendency and prove that something is stirring in the soul. Expressiveness is often sterile; but it is sometimes fertile and capable of reproducing in representation the experience from which it sprang. As a tree in the autumn sheds leaves and seeds together, so a ripening experience comes indifferently to various manifestations, some barren and without further function, others fit to carry the parent experience over into another mind, and give it a new embodiment there. Expressiveness in the former case is dead, like that of a fossil; in the latter it is living and efficacious, recreating its original. The first is idle self-manifestation, the second rational art.

Self-manifestation, so soon as it is noted and accepted as such, seems to present the same marvel as any ideal success. Such self-manifestation is incessant, many-sided, unavoidable; yet it seems a miracle when its conditions are looked back upon from the vantage ground of their result. By reading spirit out of a work we turn it into a feat of inspiration. Thus even the crudest and least coherent utterances, when we suspect some soul to be groping in them, and striving to address us, become oracular; a divine afflatus breathes behind their gibberish and they seem to manifest some deep intent. The miracle of creation or inspiration consists in nothing but this, that an external effect should embody an inner intention. The miracle, of course, is apparent only, and due to an inverted and captious point of view. In truth the tendency that executed the work was what first made its conception possible; but this conception, finding the work responsive in some measure to its inner demand, attributes that response to its own magic prerogative. Hence the least stir and rumble of formative processes, when it generates a soul, makes itself somehow that soul's interpreter; and dim as the spirit and its expression may both remain, they are none the less in profound concord, a concord which wears a miraculous providential character when it is appreciated without being understood.

Primitive poetry is the basis of all discourse.

Natural history of inspiration.

If we open any ancient book we come at once upon an elaborate language, and on divers conventional

Expressions to be understood must be recreated, and so changed.

concepts, of whose origin and history we hear nothing. We must read on, until by dint of guessing and by confronting instances we grow to understand those symbols. The writer was himself heir to a linguistic tradition which he made his own by the same process of adoption and tentative use by which we, in turn, interpret his phrases: he understood what he heard in terms of his own experience, and attributed to his predecessors (no matter what their incommunicable feelings may have been) such ideas as their words generated in his own thinking. In this way expressions continually change their sense; they can communicate a thought only by diffusing a stimulus, and in passing from mouth to mouth they will wholly reverse their connotation, unless some external object or some recurring human situation gives them a constant standard, by which private aberrations may be checked. Thus in the first phrase of Genesis, " In the beginning God created the heavens and the earth," the words have a stable meaning only in so far as they are indicative and bring us back to a stable object. What " heavens " and " earth " stand for can be conveyed by gestures, by merely pointing up and down; but beyond that sensuous connotation their meaning has entirely changed since they were here written; and no two minds, even to-day, will respond to these

familiar words with exactly the same images. "Beginning" and "created" have a superficial clearness, though their implications cannot be defined without precipitating the most intricate metaphysics, which would end in nothing but a proof that both terms were ambiguous and unthinkable. As to the word "God," all mutual understanding is impossible. It is a floating literary symbol, with a value which, if we define it scientifically, becomes quite algebraic. As no experienced object corresponds to it, it is without fixed indicative force, and admits any sense which its context in any mind may happen to give it. In the first sentence of Genesis its meaning, we may safely say, is "a masculine being by whom heaven and earth were created." To fill out this implication other instances of the word would have to be gathered, in each of which, of course, the word would appear with a new and perhaps incompatible meaning.

Whenever a word appears in a radically new context it has a radically new sense: the expression in which it so figures is a poetic figment, a fresh literary creation. Such invention is sometimes perverse, sometimes humorous, sometimes sublime; that is, it may either buffet old associations without enlarging them, or give them a plausible but impossible twist, or enlarge them to cover, with unexpected propriety, a much wider or more momentous experience. The force of experience in

Expressions may be recast perversely, humorously, or sublimely.

any moment—if we abstract from represented values—is emotional; so that for sublime poetry what is required is to tap some reservoir of feeling. If a phrase opens the flood-gates of emotion, it has made itself most deeply significant. Its discursive range and clearness may not be remarkable; its emotional power will quite suffice. For this reason again primitive poetry may be sublime: in its inchoate phrases there is affinity to raw passion and their very blindness may serve to bring that passion back. Poetry has body; it represents the volume of experience as well as its form, and to express volume a primitive poet will rely rather on rhythm, sound, and condensed suggestion than on discursive fulness or scope.

The descent from poetry to prose is in one sense a progress. When use has worn down a poetic **The nature** phrase to its external import, and ren- **of prose.** dered it an indifferent symbol for a particular thing, that phrase has become prosaic; it has also become, by the same process, transparent and purely instrumental. In poetry feeling is transferred by contagion; in prose it is communicated by bending the attention upon determinate objects; the one stimulates and the other informs. Under the influence of poetry various minds radiate from a somewhat similar core of sensation, from the same vital mood, into the most diverse and incommunicable images. Interlocutors speaking prose, on the contrary, pelt and besiege one another with a peripheral attack; they come into

contact at sundry superficial points and thence push their agreement inwards, until perhaps a practical coincidence is arrived at in their thought. Agreement is produced by controlling each mind externally, through a series of checks and little appeals to possible sensation; whereas in poetry the agreement, where it exists, is vague and massive; there is an initial fusion of minds under hypnotic musical influences, from which each listener, as he awakes, passes into his own thoughts and interpretations. In prose the vehicle for communication is a conventional sign, standing in the last analysis for some demonstrable object or controllable feeling. By marshalling specific details a certain indirect suasion is exercised on the mind, as nature herself, by continual checks and denials, gradually tames the human will. The elements of prose are always practical, if we run back and reconstruct their primitive essence, for at bottom every experience is an original and not a copy, a nucleus for ideation rather than an object to which ideas may refer. It is when these stimulations are shaken together and become a system of mutual checks that they begin to take on ideally a rhythm borrowed from the order in which they actually recurred. Then a prophetic or representative movement arises in thought. Before this comes about, experience remains a constantly renovated dream, as poetry to the end conspires to keep it. For poetry, while truly poetical, never loses sight of initial feelings and underlying appeals; it

is incorrigibly transcendental, and takes every present passion and every private dream in turn for the core of the universe. By creating new signs, or by recasting and crossing those which have become conventional, it keeps communication massive and instinctive, immersed in music, and inexhaustible by clear thought.

Lying is a privilege of poets because they have not yet reached the level on which truth and error are discernible. Veracity and signifi-
cance are not ideals for a primitive mind; we learn to value them as we learn to live, when we discover that the spirit cannot be wholly free and solipsistic. To have to distinguish fact from fancy is so great a violence to the inner man that not only poets, but theologians and philosophers, still protest against such a distinction. They urge (what is perfectly true for a rudimentary creature) that facts are mere conceptions and conceptions full-fledged facts; but this interesting embryonic lore they apply, in their intellectual weakness, to retracting or undermining those human categories which, though alone fruitful or applicable in life, are not congenial to their half-formed imagination. Retreating deeper into the inner chaos, they bring to bear the whole momentum of an irresponsible dialectic to frustrate the growth of representative ideas: In this they are genuine, if somewhat belated, poets, experimenting anew with solved problems, and fancying how creation might have

It is more advanced and responsible than poetry.

moved upon other lines. The great merit that
prose shares with science is that it is responsible.
Its conscience is a new and wiser imagination, by
which creative thought is rendered cumulative and
progressive; for a man does not build less boldly
or solidly if he takes the precaution of building
in baked brick. Prose is in itself meagre and bodi-
less, merely indicating the riches of the world.
Its transparency helps us to look through it to the
issue, and the signals it gives fill the mind with
an honest assurance and a prophetic art far nobler
than any ecstasy.

As men of action have a better intelligence than
poets, if only their action is on a broad enough
stage, so the prosaic rendering of ex-
Maturity
brings love perience has the greater value, if only
of practical the experience rendered covers enough
truth. human interests. Youth and aspira-
tion indulge in poetry; a mature and masterful
mind will often despise it, and prefer to express
itself laconically in prose. It is clearly proper
that prosaic habits should supervene in this way
on the poetical; for youth, being as yet little fed
by experience, can find volume and depth only in
the soul; the half-seen, the supra-mundane, the
inexpressible, seem to it alone beautiful and worthy
of homage. Time modifies this sentiment in two
directions. It breeds lassitude and indifference
towards impracticable ideals, originally no less
worthy than the practicable. Ideals which cannot
be realised, and are not fed at least by partial real-

isations, soon grow dormant. Life-blood passes to
other veins; the urgent and palpitating interests of
life appear in other quarters. While things im-
possible thus lose their serious charm, things
actual reveal their natural order and variety; these
not only can entertain the mind abstractly, but they
can offer a thousand material rewards in observa-
tion and action. In their presence, a private
dream begins to look rather cheap and hysterical.
Not that existence has any dignity or prerogative
in the presence of will, but that will itself, being
elastic, grows definite and firm when it is fed by
success; and its formed and expressible ideals then
put to shame the others, which have remained
vague for want of practical expression. Mature
interests centre on soluble problems and tasks
capable of execution; it is at such points that the
ideal can be really served. The individual's dream
straightens and reassures itself by merging with
the dream of humanity. To dwell, as irrational
poets do, on some private experience, on some
emotion without representative or ulterior value,
then seems a waste of time. Fiction becomes less
interesting than affairs, and poetry turns into a
sort of incompetent whimper, a childish fore-
shortening of the outspread world.

On the other hand, prose has a great defect,
which is abstractness. It drops the volume of ex-
perience in finding bodiless algebraic symbols by
which to express it. The verbal form, instead of
transmitting an image, seems to constitute it, in

so far as there is an image suggested at all; and the ulterior situation is described only in the sense

Pure prose would tend to efface itself. that a change is induced in the hearer which prepares him to meet that situation. Prose seems to be a use of language in the service of material life. It would tend, in that case, to undermine its own basis; for in proportion as signals for action are quick and efficacious they diminish their sensuous stimulus and fade from consciousness. Were language such a set of signals it would be something merely instrumental, which if made perfect ought to be automatic and unconscious. It would be a buzzing in the ears, not a music native to the mind. Such a theory of language would treat it as a necessary evil and would look forward hopefully to the extinction of literature, in which it would recognise nothing ideal. There is of course no reason to deprecate the use of vocables, or of any other material agency, to expedite affairs; but an art of speech, if it is to add any ultimate charm to life, has to supervene upon a mere code of signals. Prose, could it be purely representative, would be ideally superfluous. A literary prose accordingly owns a double allegiance, and its life is amphibious. It must convey intelligence, but intelligence clothed in a language that lends the message an intrinsic value, and makes it delightful to apprehend apart from its importance in ultimate theory or practice. Prose is in that measure a fine art. It might be called poetry that had become per-

vasively representative, and was altogether faithful
to its rational function.

We may therefore with good reason distinguish
prosaic form from prosaic substance. A novel, a

**Form alone,
or substance
alone, may be
poetical.**
satire, a book of speculative philosophy,
may have a most prosaic exterior; every
phrase may convey its idea economi-
cally; but the substance may neverthe-
less be poetical, since these ideas may be irrele-
vant to all ulterior events, and may express
nothing but the imaginative energy that called
them forth. On the other hand, a poetic vehicle in
which there is much ornamental play of language
and rhythm may clothe a dry ideal skeleton. So
those tremendous positivists, the Hebrew prophets,
had the most prosaic notions about the goods
and evils of life. So Lucretius praised, I
will not say the atoms merely, but even fecundity
and wisdom. The motives, to take another ex-
ample, which Racine attributed to his personages,
were prosaically conceived; a physiologist could not
be more exact in his calculations, for even love may
be made the mainspring in a clock-work of emo-
tions. Yet that Racine was a born poet appears
in the music, nobility, and tenderness of his me-
dium; he clothed his intelligible characters in
magical and tragic robes; the aroma of sentiment
rises like a sort of pungent incense between them
and us, and no dramatist has ever had so sure a
mastery over transports and tears.

In the medium a poet is at home; in the world

he tries to render, he is a child and a stranger.
Poetic notions are false notions; in so far as their
function is representative they are viti-
ated by containing elements not pres-
ent in things. Truth is a jewel which
should not be painted over; but it may be set
to advantage and shown in a good light. The
poetic way of idealising reality is dull, bungling,
and impure; a better acquaintance with things ren-
ders such flatteries ridiculous. That very effort
of thought by which opaque masses of experience
were first detached from the flux and given a cer-
tain individuality, seeks to continue to clarify
them until they become as transparent as pos-
sible. To resist this clarification, to love the
chance incrustations that encumber human ideas,
is a piece of timid folly, and poetry in this respect
is nothing but childish confusion. Poetic appre-
hension is a makeshift, in so far as its cognitive
worth is concerned; it is exactly, in this respect,
what myth is to science. Approaching its subject-
matter from a distance, with incongruous cate-
gories, it translates it into some vague and mis-
leading symbol rich in emotions which the object
as it is could never arouse and is sure presently to
contradict. What lends these hybrid ideas their
temporary eloquence and charm is their congruity
with the mind that breeds them and with its early
habits. Falsification, or rather clouded vision,
gives to poetry a more human accent and a readier
welcome than to truth. In other words, it is the

Poetry has its place in the medium.

medium that asserts itself; the apperceptive powers indulge their private humours, and neglect the office to which they were assigned once for all by their cognitive essence.

That the medium should so assert itself, however, is no anomaly, the cognitive function being

It is the best medium possible. an ulterior one to which ideas are by no means obliged to conform. Apperception is itself an activity or art, and like all others terminates in a product which is a good in itself, apart from its utilities. If we abstract, then, from the representative function which may perhaps accrue to speech, and regard it merely as an operation absorbing energy and occasioning delight, we see that poetic language is language at its best. Its essential success consists in fusing ideas in charming sounds or in metaphors that shine by their own brilliance. Poetry is an eloquence justified by its spontaneity, as eloquence is a poetry justified by its application. The first draws the whole soul into the situation, and the second puts the whole situation before the soul.

Is there not, we may ask, some ideal form of discourse in which apperceptive life could be en-

Might it not convey what it is best to know? gaged with all its volume and transmuting power, and in which at the same time no misrepresentation should be involved? Transmutation is not erroneous when it is intentional; misrepresentation does not please for being false, but only because

truth would be more congenial if it resembled such a fiction. Why should not discourse, then, have nothing but truth in its import and nothing but beauty in its form? With regard to euphony and grammatical structure there is evidently nothing impossible in such an ideal; for these radical beauties of language are independent of the subject-matter. They form the body of poetry; but the ideal and emotional atmosphere which is its soul depends on things external to language, which no perfection in the medium could modify. It might seem as if the brilliant substitutions, the magic suggestions essential to poetry, would necessarily vanish in the full light of day. The light of day is itself beautiful; but would not the loss be terrible if no other light were ever suffered to shine?

The Life of Reason involves sacrifice. What forces yearn for the ideal, being many and incom-

A rational poetry would exclude much now thought poetical.

patible, have to yield and partly deny themselves in order to attain any ideal at all. There is something sad in all possible attainment so long as the rational virtue (which wills such attainment) is not pervasive; and even then there is limitation to put up with, and the memory of many a defeat. Rational poetry is possible and would be infinitely more beautiful than the other; but the charm of unreason, if unreason seem charming, it certainly could not preserve. In what human fancy demands, as at present constituted, there are irra-

tional elements. The given world seems insufficient; impossible things have to be imagined, both to extend its limits and to fill in and vivify its texture. Homer has a mythology without which experience would have seemed to him undecipherable; Dante has his allegories and his mock science; Shakespeare has his romanticism; Goethe his symbolic characters and artificial machinery. All this lumber seems to have been somehow necessary to their genius; they could not reach expression in more honest terms. If such indirect expression could be discarded, it would not be missed; but while the mind, for want of a better vocabulary, is reduced to using these symbols, it pours into them a part of its own life and makes them beautiful. Their loss is a real blow, while the incapacity that called for them endures; and the soul seems to be crippled by losing its crutches.

There are certain adaptations and abbreviations of reality which thought can never outgrow. **All apperception modifies its object.** Thought is representative; it enriches each soul and each moment with premonitions of surrounding existences. If discourse is to be significant it must transfer to its territory and reduce to its scale whatever objects it deals with: in other words, thought has a point of view and cannot see the world except in perspective. This point of view is not, for reason, locally or naturally determined; sense alone is limited in that material fashion, being seated in the body and looking thence centrifugally upon things

in so far as they come into dynamic relations with
that body. Intelligence, on the contrary, sallies
from that physical stronghold and consists pre-
cisely in shifting and universalising the point of
view, neutralising all local, temporal, or personal
conditions. Yet intelligence, notwithstanding, has
its own centre and point of origin, not explicitly
in space or in a natural body, but in some specific
interest or moral aim. It translates animal life
into moral endeavour, and what figured in the first
as a local existence figures in the second as a
specific good. Reason accordingly has its essential
bias, and looks at things as they affect the par-
ticular form of life which reason expresses; and
though all reality should be ultimately swept by
the eye of reason, the whole would still be surveyed
by a particular method, from a particular starting-
point, for a particular end; nor would it take much
shrewdness to perceive that this nucleus for dis-
course and estimation, this ideal life, corresponds
in the moral world to that animal body which gave
sensuous experience its seat and centre; so that
rationality is nothing but the ideal function or
aspect of natural life. Reason is universal in its
outlook and in its sympathies: it is the faculty of
changing places ideally and representing alien
points of view; but this very self-transcendence
manifests a certain special method in life, an equi-
librium which a far-sighted being is able to estab-
lish between itself and its comprehended condi-
tions. Reason remains to the end essentially

human and, in its momentary actuality, necessarily personal.

We have here an essential condition of discourse which renders it at bottom poetical. Selection and

Reason has its own bias and method.

applicability govern all thinking, and govern it in the interests of the soul. Reason is itself a specific medium; so that prose can never attain that perfect transparency and mere utility which we were attributing to it. We should not wish to know "things in themselves," even if we were able. What it concerns us to know about them is merely the service or injury they are able to do us, and in what fashion they can affect our lives. To know this would be, in so far, truly to know them; but it would be to know them through our own faculties and through their supposed effects; it would be to know them by their appearance. A singular proof of the frivolous way in which philosophers often proceed, when they think they are particularly profound, is seen in this puzzle, on which they solemnly ask us to fix our thoughts: How is it possible to know reality, if all we can attain in experience is but appearance? The meaning of knowledge, which is an intellectual and living thing, is here forgotten, and the notion of sensation, or bodily possession, is substituted for it; so what we are really asked to consider is how, had we no understanding, we should be able to understand what we endure. It is by conceiving what we endure to be the appearance of something beyond us, that we reach knowl-

edge that something exists beyond us, and that it plays in respect to us a determinate rôle. There could be no knowledge of reality if what conveyed that knowledge were not felt to be appearance; nor can a medium of knowledge better than appearance be by any possibility conceived. To have such appearances is what makes realities knowable. Knowledge transcends sensation by relating it to other sensation, and thereby rising to a supersensuous plane, the plane of principles and causes by which sensibles are identified in character and distributed in existence. These principles and causes are what we call the intelligible or the real world; and the sensations, when they have been so interpreted and underpinned, are what we call experience.

If a poet could clarify the myths he begins with, so as to reach ultimate scientific notions of nature and life, he would still be dealing with vivid feeling and with its imaginative expression. The prosaic landscape before him would still be a work of art, painted on the human brain by human reason. If he found that landscape uninteresting, it would be because he was not really interested in life; if he found it dull and unpoetical, he would be manifesting his small capacity and childish whims. Tragic, fatal, intractable, he might well feel that the truth was; but these qualities have never been absent from that half-mythical world through which poets, for want of a rational edu-

Rational poetry would envelop exact knowledge in ultimate emotions.

cation, have hitherto wandered. A rational poet's vision would have the same moral functions which myth was asked to fulfil, and fulfilled so treacherously; it would employ the same ideal faculties which myth expressed in a confused and hasty fashion. More detail would have been added, and more variety in interpretation. To deal with so great an object, and retain his mastery over it, a poet would doubtless need a robust genius. If he possessed it, and in transmuting all existence falsified nothing, giving that picture of everything which human experience in the end would have drawn, he would achieve an ideal result. In prompting mankind to imagine, he would be helping them to live. His poetry, without ceasing to be a fiction in its method and ideality, would be an ultimate truth in its practical scope. It would present in graphic images the total efficacy of real things. Such a poetry would be more deeply rooted in human experience than is any casual fancy, and therefore more appealing to the heart. Such a poetry would represent more thoroughly than any formula the concrete burden of experience; it would become the most trustworthy of companions. The images it had worked out would confront human passion more intelligibly than does the world as at present conceived, with its mechanism half ignored and its ideality half invented; they would represent vividly the uses of nature, and thereby make all natural situations seem so many incentives to art.

Rational poetry is not wholly unknown. When Homer mentions an object, how does he render it poetical? First, doubtless, by the euphony of its name or the sensuous glow of some epithet coupled with it. Sometimes, however, even this ornamental epithet is not merely sensuous; it is very likely a patronymic, the name of some region or some mythical ancestor. In other words, it is a signal for widening our view and for conceiving the object, not only vividly and with pause, but in an adequate historic setting. Macbeth tells us that his dagger was " unmannerly breeched in gore." Achilles would not have amused himself with such a metaphor, even if breeches had existed in his day, but would rather have told us whose blood, on other occasions, had stained the same blade, and perhaps what father or mother had grieved for the slaughtered hero, or what brave children remained to continue his race. Shakespeare's phrase is ingenious and fanciful; it dazzles for a moment, but in the end it seems violent and crude. What Homer would have said, on the contrary, being simple and true, might have grown, as we dwelt upon it, always more noble, pathetic, and poetical. Shakespeare, too, beneath his occasional absurdities of plot and diction, ennobles his stage with actual history, with life painted to the quick, with genuine human characters, politics, and wisdom; and surely these are not the elements that do least credit to his genius. In every poet, in-

<div style="margin-left:2em"><small>An illustration.</small></div>

deed, there is some fidelity to nature, mixed with that irrelevant false fancy with which poetry is sometimes identified; and the degree in which a poet's imagination dominates reality is, in the end, the exact measure of his importance and dignity.

Before prosaic objects are descried, the volume and richness needful for poetry lie in a blurred and undigested chaos; but after the common world has emerged and has called on prose to describe it, the same volume and richness may be recovered; and a new and clarified poetry may arise through synthesis. Scope is a better thing than suggestion, and more truly poetical. It has expressed what suggestion pointed to and felt in the bulk: it possesses what was yearned for. A real thing, when all its pertinent natural associates are discerned, touches wonder, pathos, and beauty on every side; the rational poet is one who, without feigning anything unreal, perceives these momentous ties, and presents his subject loaded with its whole fate, missing no source of worth which is in it, no ideal influence which it may have. Homer remains, perhaps, the greatest master in this art. The world he glorified by showing in how many ways it could serve reason and beauty was but a simple world, and an equal genius in these days might be distracted by the Babel about him, and be driven, as poets now are, into incidental dreams. Yet the ideal of mastery and idealisation remains

Volume can be found in scope better than in suggestion.

the same, if any one could only attain it: mastery,
to see things as they are and dare to describe them
ingenuously; idealisation, to select from this real-
ity what is pertinent to ultimate interests and can
speak eloquently to the soul.

CHAPTER VII

PLASTIC CONSTRUCTION

We have seen how arts founded on exercise and automatic self-expression develop into music,

Automatic expression often leaves traces in the outer world. poetry, and prose. By an indirect approach they come to represent outer conditions, till they are interwoven in a life which has in some measure gone out to meet its opportunities and learned to turn them to an ideal use. We have now to see how man's reactive habits pass simultaneously into art in a wholly different region. Spontaneous expression, such as song, comes when internal growth in an animal system vents itself, as it were, by the way. At the same time animal economy has playful manifestations concerned with outer things, such as burrowing or collecting objects. These practices are not less spontaneous than the others, and no less expressive; but they seem more external because the traces they leave on the environment are more clearly marked.

To change an object is the surest and most glorious way of changing a perception. A shift in posture may relieve the body, and in that way satisfy,

but the new attitude is itself unstable. Its pleas-
antness, like its existence, is transient, and scarcely
is a movement executed when both its occasion and
its charm are forgotten. Self-expression by exer-
cise, in spite of its pronounced automatism, is
therefore something comparatively passive and in-
glorious. A man has hardly *done* anything when
he has laughed or yawned. Even the inspired
poet retains something of this passivity: his work
is not his, but that of a restless, irresponsible spirit
passing through him, and hypnotising him for its
own ends. Of the result he has no profit, no glory,
and little understanding. So the mystic also posi-
tively gloats on his own nothingness, and puts his
whole genuine being in a fancied instrumentality
and subordination to something else. Far more
virile and noble is the sense of having actually
done something, and left at least the temporary
stamp of one's special will on the world. To chop
a stick, to catch a fly, to pile a heap of sand, is a
satisfying action; for the sand stays for a while in
its novel arrangement, proclaiming to the sur-
rounding level that we have made it our instru-
ment, while the fly will never stir nor the stick
grow together again in all eternity. If the im-
pulse that has thus left its indelible mark on
things is constant in our own bosom, the world
will have been permanently improved and human-
ised by our action. Nature cannot but be more
favourable to those ideas which have once found
an efficacious champion.

Plastic impulses find in this way an immediate sanction in the sense of victory and dominion Such effects which they carry with them; it is so fruitful. evident a proof of power in ourselves to see things and animals bent out of their habitual form and obedient instead to our idea. But a far weightier sanction immediately follows. Man depends on things for his experience, yet by automatic action he changes these very things so that it becomes possible that by his action he should promote his welfare. He may, of course, no less readily precipitate his ruin. The animal is more subject to vicissitudes than the plant, which makes no effort to escape them or to give chase to what it feeds upon. The greater perils of action, however, are in animals covered partly by fertility, partly by adaptability, partly by success. The mere possibility of success, in a world governed by natural selection, is an earnest of progress. Sometimes, in impressing the environment, a man will improve it: which is merely to say that a change may sometimes fortify the impulse which brought it about. As soon as this retroaction is perceived and the act is done with knowledge of its ensuing benefits, plastic impulse becomes art, and the world begins actually to change in obedience to reason.

One respect, for instance, in which man depends on things is for the æsthetic quality of his perceptions. If he happens, by a twist of the hand, to turn a flowering branch into a wreath, thereby

making it more interesting, he will have discovered
a decorative art and initiated himself auspiciously
into the practice of it. Experimentation may fol-
low, and whenever the new form given to the ob-
ject improves it—*i. e.*, increases its interest for the
eye—the experimenter will triumph and will con-
gratulate himself on his genius. The garland so
arranged will be said to express the taste it
satisfies; insight and reason will be mythically
thought to have guided the work by which they
are sustained in being. It is no small harmony,
however, that they should be sustained by it. The
consonances man introduces into nature will fol-
low him wherever he goes. It will no longer be
necessary that nature should supply them spon-
taneously, by a rare adventitious harmony with
his demands. His new habit will habitually rear-
range her chance arrangements, and his path will
be marked by the beauties he has strewn it with.
So long as the same plastic impulse continues
operative it will be accompanied by knowledge
and criticism of its happy results. Self-criticism,
being a second incipient artistic impulse, con-
trasting itself with the one which a work embod-
ies, may to some extent modify the next perform-
ance. If life is drawn largely into this deepening
channel, physical proficiency and its ideal sanc-
tions will develop more or less harmoniously into
what is called a school of art.

The first felt utilities by which plastic instinct
is sanctioned are of course not distinctly æsthetic,

much less distinctly practical; they are magical.
A stone cut into some human or animal semblance

Magic author- fascinates the savage eye much more
ity of man's than would a useful tool or a beautiful
first creations. idol. The man wonders at his own
work, and petrifies the miracle of his art into
miraculous properties in its product. Primitive
art is incredibly conservative; its first creations,
having once attracted attention, monopolise it
henceforth and nothing else will be trusted to work
the miracle. It is a sign of stupidity in general to
stick to physical objects and given forms apart
from their ideal functions, as when a child cries
for a broken doll, even if a new and better one is
at hand to replace it. Inert associations establish
themselves, in such a case, with that part of a
thing which is irrelevant to its value—its material
substance or perhaps its name. Art can make no
progress in such a situation. A man remains in-
corrigibly unhappy and perplexed, cowed, and
helpless, because not intelligent enough to readjust
his actions; his idol must be the self-same hered-
itary stock, or at least it must have the old sanc-
tified rigidity and stare. Plastic impulse, as yet
sporadic, is overwhelmed by a brute idolatrous
awe at mere existence and actuality. What is,
what has always been, what chance has associated
with one person, alone seems acceptable or con-
ceivable.

Idolatry is by no means incident to art; art,
on the contrary, is a release from idolatry. A

cloud, an animal, a spring, a stone, or the whole
heaven, will serve the pure idolater's purpose to
perfection; these things have existence
and a certain hypnotic power, so that he
may make them a focus for his dazed
contemplation. When the mind takes to gener-
alities it finds the same fascination in Being or in
the Absolute, something it needs no art to discover.
The more indeterminate, immediate, and unutter-
able the idol is, the better it induces panic self-
contraction and a reduction of all discourse to the
infinite intensity of zero. When idolaters pass
from trying to evoke the Absolutely Existent to
apostrophising the sun or an ithyphallic bull they
have made an immense progress in art and religion,
for now their idols represent some specific and
beneficent function in nature, something pro-
pitious to ideal life and to its determinate expres-
sion. Isaiah is very scornful of idols made with
hands, because they have no physical energy. He
forgets that perhaps they represent something, and
so have a spiritual dignity which things living and
powerful never have unless they too become rep-
resentative and express some ideal. Isaiah's con-
ception of Jehovah, for instance, is itself a poetic
image, the work of man's brain; and the innocent
worship of it would not be idolatry, if that con-
ception represented something friendly to human
happiness and to human art. The question merely
is whether the sculptor's image or the prophet's
stands for the greater interest and is a more ade-

**Art brings
relief from
idolatry.**

quate symbol for the good. The noblest art will be the one, whether plastic or literary or dialectical, which creates figments most truly representative of what is momentous in human life. Similarly the least idolatrous religion would be the one which used the most perfect art, and most successfully abstracted the good from the real.

Conservatism rules also in those manufactures which are tributary to architecture and the smaller **Inertia in** plastic arts. Utility makes small head- **technique.** way against custom, not only when custom has become religion, but even when it remains inert and without mythical sanction. To admit or trust anything new is to overcome that inertia which is a general law in the brain no less than elsewhere, and which may be distinguished in reflection into a technical and a social conservatism. Technical conservatism appears, for instance, in a man's handwriting, which is so seldom improved, even when admitted, perhaps, to be execrable. Every artist has his tricks of execution, every school its hereditary, irrational processes. These refractory habits are to blame for the rare and inimitable quality of genius; they impose excellence on one man and refuse it to a million. A happy physiological structure, by creating a mannerism under the special circumstances favourable to expression, may lift a man, perhaps inferior in intelligence, to heights which no insight can attain with inferior organs. As a voice is necessary for singing, so a certain quickness of eye and hand

is needed for good execution in the plastic arts. The same principle goes deeper. Conception and imagination are themselves automatic and run in grooves, so that only certain forms in certain combinations will ever suggest themselves to a given designer. Every writer's style, too, however varied within limits, is single and monotonous compared with the ideal possibilities of expression. Genius at every moment is confined to the idiom it is creating.

Social inertia is due to the same causes working in the community at large. The fancy, for instance, of building churches in the shape of a cross has largely determined Christian architecture. Builders were prevented by a foregone suggestion in themselves and by their patrons' demands from conceiving any alternative to that convention. Early pottery, they say, imitates wicker-work, and painted landscape was for ages not allowed to exist without figures, although even the old masters show plainly enough in their backgrounds that they could love landscape for its own sake. When one link with humanity has been rendered explicit and familiar, people assume that by no other means can humanity be touched at all; even if at the same time their own heart is expanding to the highest raptures in a quite different region. The severer Greeks reprobated music without words; Saint Augustine complained of chants that rendered the sacred text unintelligible; the Puritans regarded

Inertia in appreciation.

elaborate music as diabolical, little knowing how soon some of their descendants would find religion in nothing else. A stupid convention still looks on material and mathematical processes as somehow distressing and ugly, and systems of philosophy, artificially mechanical, are invented to try to explain natural mechanism away; whereas in no region can the spirit feel so much at home as among natural causes, or realise so well its universal affinities, or so safely enlarge its happiness. Mechanism is the source of beauty. It is not necessary to look so high as the stars to perceive this truth: the action of an animal's limbs or the movement of a waterfall will prove it to any one who has eyes and can shake himself loose from verbal prejudices, those débris of old perceptions which choke all fresh perception in the soul. Irrational hopes, irrational shames, irrational decencies, make man's chief desolation. A slight knocking of fools' heads together might be enough to break up the ossifications there and start the blood coursing again through possible channels. Art has an infinite range; nothing shifts so easily as taste and yet nothing so persistently avoids the directions in which it might find most satisfaction.

Since construction grows rational slowly and by indirect pressure, we may expect that its most **Adventitious** superficial merits will be the first appre- **effects appre-** ciated. Ultimate beauty in a building **ciated first.** would consist, of course, in responding simultaneously to all the human faculties

affected: to the eye, by the building's size, form, and colour; to the imagination, by its fitness and ideal expression. Of all grounds for admiration those most readily seized are size, elaboration, splendour of materials, and difficulties or cost involved. Having built or dug in the conventional way a man may hang before his door some trophy of battle or the chase, bearing witness to his prowess; just as people now, not thinking of making their rooms beautiful, fill them with photographs of friends or places they have known, to suggest and reburnish in their minds their interesting personal history, which even they, unstimulated, might tend to forget. That dwelling will seem best adorned which contains most adventitious objects; bare and ugly will be whatever is not concealed by something else. Again, a barbarous architect, without changing his model, may build in a more precious material; and his work will be admired for the evidence it furnishes of wealth and wilfulness. As a community grows luxurious and becomes accustomed to such display, it may come to seem strange and hideous to see a wooden plate or a pewter spoon. A beautiful house will need to be in marble and the sight of plebeian brick will banish all satisfaction.

Less irrational, and therefore less vulgar, is the wonder aroused by great bulk or difficulty in the work. Exertions, to produce a great result, even if it be material, must be allied to perseverance and intelligent direction. Roman bridges and

aqueducts, for instance, gain a profound emotional power when we see in their monotonous arches a symbol of the mightiest enterprise in history, and in their decay an evidence of its failure. Curiosity is satisfied, historic imagination is stimulated, tragic reflection is called forth. We cannot refuse admiration to a work so full of mind, even if no great plastic beauty happens to distinguish it. It is at any rate beautiful enough, like the sea or the skeleton of a mountain. We may rely on the life it has made possible to add more positive charms and clothe it with imaginative functions. Modern engineering works often have a similar value; the force and intelligence they express merge in an æsthetic essence, and the place they hold in a portentous civilisation lends them an almost epic dignity. New York, since it took to doing business in towers, has become interesting to look at from the sea; nor is it possible to walk through the overshadowed streets without feeling a pleasing wonder. A city, when enough people swarm in it, is as fascinating as an ant-hill, and its buildings, whatever other charms they may have, are at least as curious and delightful as sea-shells or birds' nests. The purpose of improvements in modern structures may be economic, just as the purpose of castles was military; but both may incidentally please the contemplative mind by their huge forms and human associations.

Of the two approaches which barbaric architecture makes to beauty—one through ornamenta-

tion and the other through mass—the latter is in
general the more successful. An engineer fights
with nature hand to hand; he is less

Approach to beauty through useful structure. easily extravagant than a decorator; he
can hardly ever afford to be absurd.
He becomes accordingly more rap-
idly civilised and his work acquires, in spite of
itself, more rationality and a more permanent
charm. A self-sustaining structure, in art as in
life, is the only possible basis for a vital ideal.
When the framework is determined, when it is
tested by trial and found to stand and serve, it
will gradually ingratiate itself with the observer;
affinities it may have in his memory or appercep-
tive habits will come to light; they will help him
to assimilate the new vision and will define its æs-
thetic character. Whatever beauty its lines may
have will become a permanent possession and
whatever beauties they exclude will be rejected by
a faithful artist, no matter how sorely at first they
may tempt him. Not that these excluded beau-
ties would not be really beautiful; like fashions,
they would truly please in their day and very likely
would contain certain absolute excellences of form
or feeling which an attentive eye could enjoy at
any time. Yet if appended to a structure they
have no function in, these excellences will hardly
impose themselves on the next builder. Being
adventitious they will remain optional, and since
fancy is quick, and exotic beauties are many, there
will be no end to the variations, in endless direc-

tions, which art will undergo. Caprice will fol-
low caprice and no style will be developed.

A settled style is perhaps in itself no desider-
atum. A city that should be a bazaar of all pos-
Failure of sible architectures, adding a multitude
adapted styles. of new inventions to samples of every
historical style, might have a certain interest; yet
carnival can hardly be enjoyed all the year round
and there is a certain latent hideousness in mas-
querades in spite of their glitter. Not only are
the effects juxtaposed incongruous, but each apart
is usually shallow and absurd. A perruque can-
not bring back courtly manners, and a style of
architecture, when revived, is never quite genuine;
adaptations have to be introduced and every adap-
tation, the bolder it is, runs the greater risk of
being extravagant. Nothing is more pitiable than
the attempts people make, who think they have
an exquisite sensibility, to live in a house all of
one period. The connoisseur, like an uncritical
philosopher, boasts to have patched his dwelling
perfectly together, but he has forgotten himself, its
egregious inhabitant. Nor is he merely a blot in
his own composition; his presence secretly infects
and denaturalises everything in it. Ridiculous
himself in such a setting, he makes it ridiculous
too by his æsthetic pose and appreciations; for
the objects he has collected or reproduced were
once used and prized in all honesty, when life and
inevitable tradition had brought them forth, while
now they are studied and exhibited, relics of a dead

past and evidences of a dead present. Historic remains and restorations might well be used as one uses historic knowledge, to serve some living interest and equip the mind for the undertakings of the hour. An artist may visit a museum but only a pedant can live there. Ideas that have long been used may be used still, if they remain ideas and have not been congealed into memories. Incorporated into a design that calls for them, traditional forms cease to be incongruous, as words that still have a felt meaning may be old without being obsolete. All depends on men subserving an actual ideal and having so firm and genuine an appreciation of the past as to distinguish at once what is still serviceable in it from what is already ghostly and dead.

An artist may be kept true to his style either by ignorance of all others or by love of his own. This fidelity is a condition of prog-

Not all structure beautiful, nor all beauty structural. ress. When he has learned to appreciate whatever is æsthetically appreciable in his problem, he can go on to refine his construction, to ennoble, and finally to decorate it. As fish, flesh, and fowl have specific forms, each more or less beautiful and adorned, so every necessary structure has its specific character and its essential associations. Taking his cue from these, an artist may experiment freely; he may emphasise the structure in the classic manner and turn its lines into ornament, adding only what may help to complete and unite its suggestions.

This puritanism in design is rightly commended, but its opposite may be admirable too. We may admit that nudity is the right garment for the gods, but it would hardly serve the interests of beauty to legislate that all mortals should always go naked. The veil that conceals natural imperfections may have a perfection of its own. Maxims in art are pernicious; beauty is here the only commandment. And beauty is a free natural gift. When it has appeared, we may perceive that its influence is rational, since it both expresses and fosters a harmony of impressions and impulses in the soul; but to take any mechanism whatever, and merely because it is actual or necessary to insist that it is worth exhibiting, and that by divine decree it shall be pronounced beautiful, is to be quite at sea in moral philosophy.

Beauty is adventitious, occasional, incidental, in human products no less than in nature. Works of art are automatic figments which nature fashions through man. It is impossible they should be wholly beautiful, as it is impossible that they should offer no foothold or seed-plot for beauty at all. Beauty is everywhere potential and in a way pervasive because existence itself presupposes a modicum of harmony, first within the thing and then between the thing and its environment. Of this environment the observer's senses are in this case an important part. Man can with difficulty maintain senses quite out of key with the stimuli furnished by the outer world. They would then be useless

burdens to his organism. On the other side, even artificial structures must be somehow geometrical or proportional, because only such structures hold physically together. Objects that are to be esteemed by man must further possess or acquire some function in his economy; otherwise they would not be noticed nor be so defined as to be recognisable. Out of these physical necessities beauty may grow; but an adjustment must first take place between the material stimulus and the sense it affects. Beauty is something spiritual and, being such, it rests not on the material constitution of each existence taken apart, but on their conspiring ideally together, so that each furthers the other's endeavour. Structure by itself is no more beautiful than existence by itself is good. They are only potentialities or conditions of excellence.

An architect, when his main structure is uninteresting, may have recourse to a subsidiary construction. The façade, or a part of it, or the interior may still have a natural form that lends itself to elaboration. This beautiful feature may be developed so as to ignore or even conceal the rest; then the visible portion may be entirely beautiful, like the ideal human figure, though no pledges be given concerning the anatomy within. Many an Italian palace has a false front in itself magnificent. We may chance to observe, however, that it overtops its backing, perhaps an amorphous rambling pile in

Structures designed for display.

quite another material. What we admire is not so much a façade as a triumphal gateway, set up in front of the house to be its ambassador to the world, wearing decidedly richer apparel than its master can afford at home. This was not vanity in the Italians so much as civility to the public, to whose taste this flattering embassy was addressed. However our moral sense may judge the matter, it is clear that two separate monuments occupied the architect in such cases, if indeed inside and outside were actually designed by the same hand. Structure may appear in each independently and may be frankly enough expressed. The most beautiful façades, even if independent of their building, are buildings themselves, and since their construction is decorative there is the greater likelihood that their decoration should be structural.

In relation to the house, however, the façade in such an extreme case would be an abstract ornament; and so, though the ornament be structural within its own lines, we have reverted to the style of building where construction is one thing and decoration another. Applied ornament has an indefinite range and there would be little profit in reasoning about it. Philosophy can do little more at this point than expose the fallacies into which dogmatic criticism is apt to fall. Everything is true decoration which truly adorns, and everything adorns which enriches the impression and pleasantly entertains the eye. There is a decorative im-

pulse as well as a sense for decoration. As I sit
idle my stick makes meaningless marks upon the
sand; or (what is nearer to the usual origin of
ornament) I make a design out of somebody's ini-
tials, or symbolise fantastically something lying in
my thoughts. We place also one thing upon
another, the better to see and to think of two
things at once.

To love decoration is to enjoy synthesis: in other
words, it is to have hungry senses and unused
Appeal made powers of attention. This hunger, when
by decoration. it cannot well be fed by recollecting
things past, relishes a profusion of things simul-
taneous. Nothing is so much respected by unin-
telligent people as elaboration and complexity.
They are simply dazed and overawed at seeing at
once so much more than they can master. To
overwhelm the senses is, for them, the only way of
filling the mind. It takes cultivation to appre-
ciate in art, as in philosophy, the consummate value
of what is simple and finite, because it has found
its pure function and ultimate import in the world.
What is just, what is delicately and silently ad-
justed to its special office, and thereby in truth
to all ultimate issues, seems to the vulgar some-
thing·obvious and poor. What astonishes them is
the crude and paradoxical jumble of a thousand
suggestions in a single view. As the mystic yearns
for an infinitely glutted consciousness that feels
everything at once and is not put to the incon-
venience of any longer thinking or imagining, so

the barbarian craves the assault of a myriad sensations together, and feels replete and comfortable when a sort of infinite is poured into him without ideal mediation. As ideal mediation is another name for intelligence, so it is the condition of elegance. Intelligence and elegance naturally exist together, since they both spring from a subtle sense for absent and eventual processes. They are sustained by experience, by nicety in foretaste and selection. Before ideality, however, is developed, volume and variety must be given bodily or they cannot be given at all. At that earlier stage a furious ornamentation is the chief vehicle for beauty.

That the ornate may be very beautiful, that in fact what is to be completely beautiful needs to **Its natural rights.** be somehow rich, is a fact of experience which further justifies the above analysis. For sensation is the matter of ideas; all representation is such only in its function; in its existence it remains mere feeling. Decoration, by stimulating the senses, not only brings a primary satisfaction with it, independent of any that may supervene, but it furnishes an element of effect which no higher beauty can ever render unwelcome or inappropriate, since any higher beauty, in moving the mind, must give it a certain sensuous and emotional colouring. Decoration is accordingly an independent art, to be practised for its own sake, in obedience to elementary plastic instincts. It is fundamental in

design, for everything structural or significant produces in the first instance some sensuous impression and figures as a spot or pattern in the field of vision. The fortunate architect is he who has, for structural skeleton in his work, a form in itself decorative and beautiful, who can carry it out in a beautiful material, and who finally is suffered to add so much decoration as the eye may take in with pleasure, without losing the expression and lucidity of the whole.

It is impossible, however, to imagine beforehand what these elements should be or how to combine them. The problem must exist before its solution can be found. The forms of good taste and beauty which a man can think of or esteem are limited by the scope of his previous experience. It would be impossible to foresee or desire a beauty which had not somehow grown up of itself and been recognised receptively. A satisfaction cannot be conceived ideally when neither its organ nor its occasion has as yet arisen. That ideal conception, to exist, would have to bring both into play. The fine arts are butter to man's daily bread; there is no conceiving or creating them except as they spring out of social exigencies. Their types are imposed by utility: their ornamentation betrays the tradition that happens to envelop and diversify them; their expression and dignity are borrowed from the company they keep in the world.

The Greek temple, for instance, if we imagine it in its glory, with all its colour and furniture,

was a type of human art at its best, where decoration, without in the least restricting itself, took

Its alliance with structure in Greek architecture.

naturally an exquisitely subordinate and pervasive form: each detail had its own splendour and refinement, yet kept its place in the whole. Structure and decoration were alike traditional and imposed by ulterior practical or religious purposes; yet, by good fortune and by grace of that rationality which unified Greek life, they fell together easily into a harmony such as imagination could never have devised had it been invited to decree pleasure-domes for non-existent beings. Had the Greek gods been hideous, their images and fable could not so readily have beautified the place where they were honoured; and had the structural theme and uses of the temple been more complicated, they would not have lent themselves so well to decoration without being submerged beneath it.

In some ways the ideal Gothic church attained a similar perfection, because there too the structure remained lucid and predominant, while it was enriched by many necessary appointments —altars, stalls, screens, chantries—which, while really the *raison d'être* of the whole edifice, æsthetically regarded, served for its ornaments. It may be doubted, however, whether Gothic construction was well grounded enough in utility to be a sound and permanent basis for beauty; and the extreme instability of Gothic style, the feverish inconstancy of architects straining after effects

never, apparently, satisfactory when achieved,
shows that something was wrong and artificial in
the situation. The structure, in be-

Relations of
the two in
Gothic art.
coming an ornament, ceased to be any-
thing else, and could be discarded by
any one whose fancy preferred a different image.

For this reason a building like the cathedral
of Amiens, where a structural system is put through
consistently, is far from representing mediæval art
in its full and ideal essence; it is rather an inciden-
tal achievement, a sport in which an adventitious
interest is, for a moment, emphasised overwhelm-
ingly. Intelligence here comes to the fore, and a
sort of mathematical virtuosity: but it was not
mathematical virtuosity nor even intelligence to
which, in Christian art, the leading rôle properly
belonged. What structural elucidation did for
church architecture was much like what scholastic
elucidation did for church dogma: it insinuated
a logic into the traditional edifice which was far
from representing its soul or its genuine value.
The dialectic introduced, might be admirable in
itself, in its lay and abstruse rationality; but it
could not be applied to the poetic material in hand
without rendering it absurd and sterile. The
given problem was scientifically carried out, but
the given problem was itself fantastic. To vault
at such heights and to prop that vault with ex-
ternal buttresses was a gratuitous undertaking.
The result was indeed interesting, the ingenuity
and method exhibited were masterly in their way;

yet the result was not proportionate in beauty to the effort required; it was after all a technical and a vain triumph.

The true magic of that very architecture lay not in its intelligible structure but in the bewildering incidental effects which that structure permitted. The part in such churches is better than the symmetrical whole; often incompleteness and accretions alone give grace or expression to the monument. A cross vista where all is wonder, a side chapel where all is peace, strike the key-note here; not that punctilious and wooden repetition of props and arches, as a builder's model might boast to exhibit them. Perhaps the most beautiful Gothic interiors are those without aisles, if what we are considering is their proportion and majesty; elsewhere the structure, if perceived at all, is too artificial and strange to be perceived intuitively and to have the glow of a genuine beauty. There is an over-ingenious mechanism, redeemed by its colour and the thousand intervening objects, when these have not been swept away. Glazed and painted as Gothic churches were meant to be, they were no doubt exceedingly gorgeous. When we admire their structural scheme we are perhaps nursing an illusion like that which sentimental classicists once cherished when they talked about the purity of white marble statues and the ideality of their blank and sightless eyes. What we treat as a supreme quality may have been a mere means to mediæval builders, and a mechani-

The marginal note reads: *The result here romantic.*

cal expedient: their simple hearts were set on making their churches, for God's glory and their own, as large, as high, and as rich as possible. After all, an uninterrupted tradition attached them to Byzantium; and it was the sudden passion for stained glass and the goldsmith's love of intricate fineness—which the Saracens also had shown—that carried them in a century from Romanesque to flamboyant. The structure was but the inevitable underpinning for the desired display. If these sanctuaries, in their spoliation and ruin, now show us their admirable bones, we should thank nature for that rational skeleton, imposed by material conditions on an art which in its life-time was goaded on only by a pious and local emulation, and wished at all costs to be sumptuous and astonishing.

It was rather in another direction that groping mediæval art reached its most congenial triumphs. The mediæval artist. That was an age, so to speak, of epidemic privacy; social contagion was irresistible, yet it served only to make each man's life no less hard, narrow, and visionary than that of every one else. Like bees in a hive, each soul worked in its separate cell by the same impulse as every other. Each was absorbed in saving itself only, but according to a universal prescription. This isolation in unanimity appears in those patient and childlike artists who copied each his leaf or flower, or imagined each his curious angels and devils, taking what was told of them so much

to heart that his rendering became deeply individual. The lamp of sacrifice—or perhaps rather of ignorance—burned in every workshop; much labour was wasted in forgetfulness of the function which the work was to perform, yet a certain pathos and expression was infused into the detail, on which all invention and pride had to be lavished. Carvings and statues at impossible elevations, minute symbols hidden in corners, the choice for architectural ornament of animal and vegetable forms, copied as attentively and quaintly as possible—all this shows how abstractedly the artist surrendered himself to the given task. He dedicated his genius like the widow's mite, and left the universal composition to Providence.

Nor was this humility, on another side, wholly pious and sacrificial. The Middle Ages were, in their way, merry, sturdy, and mischievous. A fresh breath, as of convalescence, breathed through their misery. Never was spring so green and lovely as when men greeted it in a cloistered garden, with hearts quite empty and clean, only half-awakened from a long trance of despair. It mattered little at such a moment where a work was to figure or whether any one should ever enjoy it. The pleasure and the function lay here, in this private revelation, in this playful dialogue between a bit of nature and a passing mood. When a Greek workman cut a volute or a moulding, he was not asked to be a poet; he was merely a scribe, writing out what some master had composed before

him. The spirit of his art, if that was called forth
consciously at all, could be nothing short of intel-
ligence. Those lines and none other, he would
say to himself, are requisite and sufficient: to do
less would be unskilful, to do more would be per-
verse. But the mediæval craftsman was irrespon-
sible in his earnestness. The whole did not con-
cern him, for the whole was providential and
therefore, to the artist, irrelevant. He was only
responsible inwardly, to his casual inspiration, to
his individual model, and his allotted block of
stone. With these he carried on, as it were, an
ingenuous dialectic, asking them questions by a
blow of the hammer, and gathering their oracular
answers experimentally from the result. Art, like
salvation, proceeded by a series of little miracles;
it was a blind work, half stubborn patience, half
unmerited grace. If the product was destined to
fill a niche in the celestial edifice, that was God's
business and might be left to him: what concerned
the sculptor was to-day's labour and joy, with the
shrewd wisdom they might bring after them.

Gothic ornament was accordingly more than or-
nament; it was sculpture. To the architect sculp-
Representation ture and painting are only means of
introduced. variegating a surface; light and shade,
depth and elaboration, are thereby secured and aid
him in distributing his masses. For this reason
geometrical or highly conventionalised ornament
is all the architect requires. If his decorators
furnish more, if they insist on copying natural

forms or illustrating history, that is their own affair. Their humanity will doubtless give them, as representative artists, a new claim on human regard, and the building they enrich in their pictorial fashion will gain a new charm, just as it would gain by historic associations or by the smell of incense clinging to its walls. When the arts superpose their effects the total impression belongs to none of them in particular; it is imaginative merely or in the broadest sense poetical. So the monumental function of Greek sculpture, and the interpretations it gave to national myths, made every temple a storehouse of poetic memories. In the same way every great cathedral became a pious story-book. Construction, by admitting applied decoration, offers a splendid basis and background for representative art. It is in their decorative function that construction and representation meet; they are able to conspire in one ideal effect by virtue of the common appeal which they unwittingly make to the senses. If construction were not decorative it could never ally itself imaginatively to decoration; and decoration in turn would never be willingly representative if the forms which illustration requires were not decorative in themselves.

Illustration has nevertheless an intellectual function by which it diverges altogether from decoration and even, in the narrowest sense of the word, from art: for the essence of illustration lies neither in use nor in beauty. The illustrator's

impulse is to reproduce and describe given ob-
jects. He wishes in the first place to force ob-
servers—overlooking all logical scru-

Transition
to illustra-
tion.
ples—to call his work by the name of
its subject matter; and then he wishes
to inform them further, through his representa-
tion, and to teach them to apprehend the real ob-
ject as, in its natural existence, it might never
have been apprehended. His first task is to trans-
late the object faithfully into his special medium;
his second task, somewhat more ambitious, is so to
penetrate into the object during that process of
translation that this translation may become at the
same time analytic and imaginative, in that it sig-
nalises the object's structure and emphasises its
ideal suggestions. In such reproduction both hand
and mind are called upon to construct and build
up a new apparition; but here construction has
ceased to be chiefly decorative or absolute in order
to become representative. The æsthetic element in
art has begun to recede before the intellectual; and
sensuous effects, while of course retained and still
studied, seem to be impressed into the service of
ideas.

CHAPTER VIII

PLASTIC REPRESENTATION

Imitation is a fertile principle in the Life of Reason. We have seen that it furnishes the only

Psychology of imitation. rational sanction for belief in any fellow mind; now we shall see how it creates the most glorious and interesting of plastic arts. The machinery of imitation is obscure but its prevalence is obvious, and even in the present rudimentary state of human biology we may perhaps divine some of its general features. In a motor image the mind represents prophetically what the body is about to execute: but all images are more or less motor, so that no idea, apparently, can occupy the mind unless the body has received some impulse to enact the same. The plastic instinct to reproduce what is seen is therefore simply an uninterrupted and adequate seeing; these two phenomena, separable logically and divided in Cartesian psychology by an artificial chasm, are inseparable in existence and are, for natural history, two parts of the same event. That an image should exist for consciousness is, abstractly regarded, a fact which neither involves motion nor constitutes knowledge; but that natural relation

144

to ulterior events which endows that image with a cognitive function identifies it at the same time with the motor impulse which accompanies the idea. If the image involved no bodily attitude and prophesied no action it would refer to no eventual existence and would have no practical meaning. Even if it *meant* to refer to something ulterior it would, under those circumstances, miss its aim, seeing that no natural relation connected it with any object which could support or verify its asseverations. It might *feel* significant, like a dream, but its significance would be vain and not really self-transcendent; for it is in the world of events that logic must find application, if it cares for applicability at all. This needful bond between ideas and the further existences they forebode is not merely a logical postulate, taken on trust because the ideas in themselves assert it; it is a previous and genetic bond, proper to the soil in which the idea flourishes and a condition of its existence. For the idea expresses unawares a present cerebral event of which the ulterior event consciously looked to is a descendant or an ancestor; so that the ripening of that idea, or its prior history, leads materially to the fact which the idea seeks to represent ideally.

In some such fashion we may come to conceive how imitative art is simply the perfection and fulfilment of sensation. The act of apperception in which a sensation is reflected upon and understood is already an internal reproduction. The

object is retraced and gone over in the mind, not
without quite perceptible movements in the limbs,
Sustained sen- which sway, as it were, in sympathy
sation involves with the object's habit. Presumably
reproduction. this incipient imitation of the ob-
ject is the physical basis for apperception itself;
the stimulus, whatever devious courses it may pur-
sue, reconstitutes itself into an impulse to render
the object again, as we acquire the accent which
we often hear. This imitation sometimes has the
happiest results, in that the animal fights with one
that fights, and runs after one that runs away from
him. All this happens initially, as we may still
observe in ourselves, quite without thought of
eventual profit; although if chase leads to contact,
and contact stimulates hunger or lust, movements
important for preservation will quickly follow.
Such eventual utilities, however, like all utilities,
are supported by a prodigious gratuitous vitality,
and long before a practical or scientific use of
sensation is attained its artistic force is in full
operation. If art be play, it is only because all
life is play in the beginning. Rational adjust-
ments to truth and to benefit supervene only occa-
sionally and at a higher level.

Imitation cannot, of course, result in a literal
repetition of the object that suggests it. The copy
is secondary; it does not iterate the model by cre-
ating a second object on the same plane of reality,
but reproduces the form in a new medium and
gives it a different function. In these latter cir-

cumstances lies the imitative essence of the second image: for one leaf does not imitate another nor

Imitative art repeats with intent to repeat, and in a new material.

is each twin the other's copy. Like sensibility, imitation remodels a given being so that it becomes, in certain formal respects, like another being in its environment. It is a response and an index, by which note is taken of a situation or of its possible developments. When a man involuntarily imitates other men, he does not become those other persons; he is simply modified by their presence in a manner that allows him to conceive their will and their independent existence, not without growing similar to them in some measure and framing a genuine representation of them in his soul. He enacts what he understands, and his understanding consists precisely in knowing that he is re-enacting something which has its collateral existence elsewhere in nature. An element in the percipient repeats the total movement and tendency of the person perceived. The imitation, though akin to what it imitates, and reproducing it, lies in a different medium, and accordingly has a specific individuality and specific effects. Imitation is far more than similarity, nor does its ideal function lie in bringing a flat and unmeaning similarity about. It has a representative and intellectual value because in reproducing the forms of things it reproduces them in a fresh substance to a new purpose.

If I imitate mankind by following their fashions,

I add one to the million and improve nothing: but if I imitate them under proper inhibitions and in the service of my own ends, I really understand them, and, by representing what I do not bodily become, I preserve and enlarge my own being and make it relevant ideally to what it physically depends upon. Assimilation is a way of drifting through the flux or of letting it drift through oneself; representation, on the contrary, is a principle of progress. To grow by accumulating passions and fancies is at best to grow in bulk: it is to become what a colony or a hydra might be. But to make the accretions which time brings to your being representative of what you are not, and do not wish to be, is to grow in dignity. It is to be wise and prepared. It is to survey a universe without ceasing to be a mind.

A product of imitative sensibility is accordingly on a higher plane than the original existences it introduces to one another—the ignorant individual and the unknown world. Imitation in softening the body into physical adjustment stimulates the mind to ideal representation. This is the case even when the stimulus is a contagious influence or habit, though the response may then be slavish and the representation vague. Sheep jumping a wall after their leader doubtless feel that they are not alone; and though their action may have no purpose it probably has a felt sanction and reward. Men also think they invoke an authority

Imitation leads to adaptation and to knowledge.

when they appeal to the *quod semper et ubique et ab omnibus,* and a conscious unanimity is a human if not a rational joy. When, however, the stimulus to imitation is not so pervasive and touches chiefly a single sense, when what it arouses is a movement of the hand or eye retracing the object, then the response becomes very definitely cognitive. It constitutes an observation of fact, an acquaintance with a thing's structure amounting to technical knowledge; for such a survey leaves behind it a power to reconstitute the process it involved. It leaves an efficacious idea. In an idle moment, when the information thus acquired need not be put to instant use, the new-born faculty may work itself out spontaneously. The sound heard is repeated, the thing observed is sketched, the event conceived is acted out in pantomime. Then imitation rounds itself out; an uninhibited sensation has become an instinct to keep that sensation alive, and plastic representation has begun.

The secret of representative genius is simple enough. All hangs on intense, exhaustive, rehearsed sensation. To paint is a way **How the artist is inspired and** of letting vision work; nor should the **irresponsible.** amateur imagine that while he lacks technical knowledge he can have in his possession all the ideal burden of an art. His reaction will be personal and adventitious, and he will miss the artist's real inspiration and ignore his genuine successes. You may instruct a poet about literature, but his allegiance is to emotion. You may

offer the sculptor your comparative observations on style and taste; he may or may not care to listen, but what he knows and loves is the human body. Critics are in this way always one stage behind or beyond the artist; their operation is reflective and his is direct. In transferring to his special medium what he has before him his whole mind is lost in the object; as the marksman, to shoot straight, looks at the mark. How successful the result is, or how appealing to human nature, he judges afterwards, as an outsider might, and usually judges ill; since there is no life less apt to yield a broad understanding for human affairs or even for the residue of art itself, than the life of a man inspired, a man absorbed, as the genuine artist is, in his own travail. But into this travail, into this digestion and reproduction of the thing seen, a critic can hardly enter. Having himself the ulterior office of judge, he must not hope to rival nature's children in their sportiveness and intuition.

In an age of moral confusion, these circumstances may lead to a strange shifting of rôles. The critic, feeling that something in the artist has escaped him, may labour to put himself in the artist's place. If he succeeded, the result would only be to make him a biographer; he would be describing in words the very intuitions which the artist had rendered in some other medium. To understand how the artist felt, however, is not criticism; criticism is an investigation of what the

work is good for. Its function may be chiefly to awaken certain emotions in the beholder, to deepen in him certain habits of apperception; but even this most æsthetic element in a work's operation does not borrow its value from the possible fact that the artist also shared those habits and emotions. If he did, and if they are desirable, so much the better for him; but his work's value would still consist entirely in its power to propagate such good effects, whether they were already present in him or not. All criticism is therefore moral, since it deals with benefits and their relative weight. Psychological penetration and reconstructed biography may be excellent sport; if they do not reach historic truth they may at least exercise dramatic talent. Criticism, on the other hand, is a serious and public function; it shows the race assimilating the individual, dividing the immortal from the mortal part of a soul.

Representation naturally repeats those objects which are most interesting in themselves. Even the medium, when a choice is possible, **Need of knowing and loving the subject rendered.** is usually determined by the sort of objects to be reproduced. Instruments lose their virtue with their use and a medium of representation, together with its manipulation, is nothing but a vehicle. It is fit if it makes possible a good rendition. All accordingly hangs on what life has made interesting to the senses, on what presents itself persuasively to the artist for imitation; and living arts exist only while

well-known, much-loved things imperatively de-
mand to be copied, so that their reproduction has
some honest non-æsthetic interest for mankind.
Although subject matter is often said to be indif-
ferent to art, and an artist, when his art is sec-
ondary, may think of his technique only, nothing
is really so poor and melancholy as art that is in-
terested in itself and not in its subject. If any
remnant of inspiration or value clings to such a
performance, it comes from a surviving taste for
something in the real world. Thus the literature
that calls itself purely æsthetic is in truth prurient;
without this half-avowed weakness to play upon,
the coloured images evoked would have had noth-
ing to marshall or to sustain them.

A good way to understand schools and styles
and to appreciate their respective functions and
Public inter- successes is to consider first what re-
ests determine gion of nature preoccupied the age in
the subject of
art, and the which they arose. Perception can cut
subject the the world up into many patterns, which
medium. it isolates and dignifies with the name
of things. It must distinguish before it can re-
produce and the objects which attention distin-
guishes are of many strange sorts. Thus the
single man, the hero, in his acts of prowess or in
his readiness, may be the unit and standard in dis-
course. It will then be his image that will pre-
occupy the arts. For such a task the most ade-
quate art is evidently sculpture, for sculpture is
the most complete of imitations. In no other art

can apprehension render itself so exhaustively and with such recuperative force. Sculpture retains form and colour, with all that both can suggest, and it retains them in their integrity, leaving the observer free to resurvey them from any point of view and drink in their quality exhaustively.

The movement and speech which are wanting, the stage may be called upon to supply; but it can-

Reproduction by acting ephemeral. not supply them without a terrible sacrifice, for it cannot give permanence to its expression. Acting is for this reason an inferior art, not perhaps in difficulty and certainly not in effect, but inferior in dignity, since the effort of art is to keep what is interesting in existence, to recreate it in the eternal, and this ideal is half frustrated if the representation is itself fleeting and the rendering has no firmer subsistence than the inspiration that gave it birth. By making himself, almost in his entirety, the medium of his art, the actor is morally diminished, and as little of him remains in his work, when this is good, as of his work in history. He lends himself without interest, and after being Brutus at one moment and Falstaff at another, he is not more truly himself. He is abolished by his creations, which nevertheless cannot survive him.

Being so adequate a rendering of its object, sculpture demands a perfect mastery over it and **High demands of sculpture.** is correspondingly difficult. It requires taste and training above every other art; for not only must the material form be repro-

duced, but its motor suggestions and moral expression must be rendered; things which in the model itself are at best transitory, and which may never be found there if a heroic or ideal theme is proposed. The sculptor is obliged to have caught on the wing attitudes momentarily achieved or vaguely imagined; yet these must grow firm and harmonious under his hand. Nor is this enough; for sculpture is more dependent than other arts on its model. If the statue is to be ideal, *i. e.*, if it is to express the possible motions and vital character of its subject, the model must itself be refined. Training must have cut in the flesh those lines which are to make the language and eloquence of the marble. Trivial and vulgar forms, such as modern sculpture abounds in, reflect an undisciplined race of men, one in which neither soul nor body has done anything well, because the two have done nothing together. The frame has remained gross or awkward, while the face has taken on a tense expression, betraying loose and undignified habits of mind. To carve such a creature is to perpetuate a caricature. The modern sculptor is stopped short at the first conception of a figure; if he gives it its costume, it is grotesque; if he strips it, it is unmeaning and pitiful.

Greece was in all these respects a soil singularly favourable to sculpture. The success there It is essen- achieved was so conspicuous that two tially obsolete. thousand years of essential superfluity have not availed to extirpate the art. Plastic im-

pulse is indeed immortal, and many a hand, even
without classic example, would have fallen to mod-
elling. In the middle ages, while monumental
sculpture was still rudely reminiscent, ornamental
carving arose spontaneously. Yet at every step
the experimental sculptor would run up against
disaster. What could be seen in the streets, while
it offered plenty of subjects, offered none that
could stimulate his talent. His patrons asked only
for illustration and applied ornament; his models
offered only the smirk and sad humour of a stunted
life. Here and there his statues might attain a
certain sweetness and grace, such as painting might
perfectly well have rendered; but on the whole
sculpture remained decorative and infantile.

The Renaissance brought back technical freedom
and a certain inspiration, unhappily a retrospective
and exotic one. The art cut praiseworthy capers
in the face of the public, but nobody could teach
the public itself to dance. If several great tem-
peraments, under the auspices of fashion, could
then call up a magic world in which bodies still
spoke a heroic language, that was a passing
dream. Society could not feed such an artificial
passion, nor the schools transmit an arbitrary per-
sonal style that responded to nothing permanent
in social conditions. Academies continued to
offer prizes for sculpture, the nude continued to
be seen in studios, and equestrian or other rhetori-
cal statues continued occasionally to be erected in
public squares. Heroic sculpture, however, in

modern society, is really an anomaly and confesses as much by being a failure. No personal talent avails to rescue an art from laboured insignificance when it has no steadying function in the moral world, and must waver between caprice and convention. Where something modest and genuine peeped out was in portraiture, and also at times in that devotional sculpture in wood which still responded to a native interest and consequently kept its sincerity and colour. Pious images may be feeble in the extreme, but they have not the weakness of being merely æsthetic. The purveyor of church wares has a stated theme; he is employed for a purpose; and if he has enough technical resource his work may become truly beautiful: which is not to say that he will succeed if his conceptions are without dignity or his style without discretion. There are good *Mater dolorosas;* there is no good *Sacred Heart.*

It may happen, however, that people are not interested in subjects that demand or allow reproduction in bulk. The isolated figure or simple group may seem cold apart from its natural setting. In rendering an action you may need to render its scene, if it is the circumstance that gives it value rather than the hero. You may also wish to trace out the action through a series of episodes with many figures. In the latter case you might have recourse to a bas-relief, which, although durable, is usually a thankless work; there is little in it that might not be conveyed in a drawing with distinct-

When men see groups and backgrounds they are natural painters.

ness. As some artists, like Michael Angelo, have carried the sculptor's spirit into painting, many more, when painting is the prevalent and natural art, have produced carved pictures. It may be said that any work is essentially a picture which is conceived from a single quarter and meant to be looked at only in one light. Objects in such a case need not be so truly apperceived and appropriated as they would have to be in true sculpture. One aspect suffices: the subject presented is not so much constructed as dreamt.

The whole history of painting may be strung on this single thread—the effort to reconstitute im-

Evolution of painting.

pressions, first the dramatic impression and then the sensuous. A summary and symbolic representation of things is all that at first is demanded; the point is to describe something pictorially and recall people's names and actions. It is characteristic of archaic painting to be quite discursive and symbolic; each figure is treated separately and stuck side by side with the others upon a golden ground. The painter is here smothered in the recorder, in the annalist; only those perceptions are allowed to stand which have individual names or chronicle facts mentioned in the story. But vision is really more sensuous and rich than report, if art is only able to hold vision in suspense and make it explicit. When painting is still at this stage, and is employed on hieroglyphics, it may reach the maximum of decorative splendour. Whatever sensuous glow finer representations may later acquire will be not sensuous merely,

but poetical; Titians, Murillos, or Turners are *colourists in representation,* and their canvases would not be particularly warm or luminous if they represented nothing human or mystical or atmospheric. A stained-glass window or a wall of tiles can outdo them for pure colour and decorative magic. Leaving decoration, accordingly, to take care of itself and be applied as sense may from time to time require, painting goes on to elaborate the symbols with which it begins, to make them symbolise more and more of what their object contains. A catalogue of persons will fall into a group, a group will be fused into a dramatic action. Conventional as the separate figures may still be, their attitudes and relations will reconstitute the dramatic impression. The event will be rendered in its own language; it will not, to be recognised, have to appeal to words. Thus a symbolic crucifixion is a crucifixion only because we know by report that it is; a plastic crucifixion would first teach us, on the contrary, what a real crucifixion might be. It only remains to supply the aerial medium and make dramatic truth sensuous truth also.

To work up a sensation intellectually and re-awaken all its passionate associations is to reach a

Sensuous and dramatic adequacy approached.
new and more exciting sensation which we call emotion or thought. As in poetry there are two stages, one pregnant and prior to prose and another posterior and synthetic, so in painting we have not

only a reversion to sense but an ulterior synthesis of the sensuous, its interpretation in a dramatic or poetic vision. Archaic painting, with its abstract rendering of separate things, is the prose of design. It would not be beautiful at all but for its colour and technical feeling—that expression of candour and satisfaction which may pervade it, as it might a Latin rhyme. To correct this thinness and dislocation, to restore life without losing significance, painting must proceed to accumulate symbol upon symbol, till the original impression is almost restored, but so restored that it contains all the articulation which a thorough analysis had given it. Such painting as Tintoretto's or Paolo Veronese's records impressions as a cultivated sense might receive them. It glows with visible light and studies the sensuous appearance, but it contains at the same time an intelligent expression of all those mechanisms, those situations and passions, with which the living world is diversified. It is not a design in spots, meant merely to outdo a sunset; it is a richer dream of experience, meant to outshine the reality.

In order to reconstitute the image we may take an abstract representation or hieroglyphic and gradually increase its depth and its scope. As the painter becomes aware of what at first he had ignored, he adds colour to outline, modelling to colour, and finally an observant rendering of tints and values. This process gives back to objects their texture and atmosphere, and the space in

which they lie. From a representation which is statuesque in feeling and which renders figures by furnishing a visible inventory of their parts and attributes, the artist passes to considering his figures more and more as parts of a whole and as moving in an ambient ether. They tend accordingly to lose their separate emphasis, in order to be like flowers in a field or trees in a forest. They become elements, interesting chiefly by their interplay, and shining by a light which is mutually reflected.

When this transformation is complete the painting is essentially a landscape. It may not represent precisely the open country; it may even depict an interior, like Velasquez's Meninas. But the observer, even in the presence of men and artificial objects, has been overcome by the medium in which they swim. He is seeing the air and what it happens to hold. He is impartially recreating from within all that nature puts before him, quite as if his imagination had become their diffused material substance. Whatever individuality and moral value these bits of substance may have they acquire for him, as for nature, incidentally and by virtue of ulterior relations consequent on their physical being. If this physical being is wholly expressed, the humanity and morality involved will be expressed likewise, even if expressed unawares. Thus a profound and omnivorous reverie overflows the mind; it devours its objects or is absorbed into them, and

Essence of landscape-painting.

the mood which this active self-alienation brings
with it is called the spirit of the scene, the senti-
ment of the landscape.

Perception and art, in this phase, easily grow
mystical; they are readily lost in primordial phys-
ical sympathies. Although at first a certain articu-
lation and discursiveness may be retained in the
picture, so that the things seen in their atmos-
phere and relations may still be distinguished
clearly, the farther the impartial absorption in
them goes, the more what is inter-individual rises
and floods the individual over. All becomes light
and depth and air, and those particular objects
threaten to vanish which we had hoped to make
luminous, breathing, and profound. The initi-
ated eye sees so many nameless tints and sur-
faces, that it can no longer select any creative
limits for things. There cease to be fixed out-
lines, continuous colours, or discrete existences in
nature.

An artist, however, cannot afford to forget that
even in such a case units and divisions would have
Its threatened to be introduced by him into his work.
dissolution. A man, in falling back on immediate
reality, or immediate appearance, may well feel his
mind's articulate grammar losing its authority, but
that grammar must evidently be reasserted if from
the immediate he ever wishes to rise again to ar-
ticulate mind; and art, after all, exists for the
mind and must speak humanly. If we crave some-
thing else, we have not so far to go: there is always

the infinite about us and the animal within us to absolve us from human distinctions.

Moreover, it is not quite true that the immediate has no real diversity. It evidently suggests the ideal terms into which we divide it, and it sustains our apprehension itself, with all the diversities this may create. To what I call right and left, light and darkness, a real opposition must correspond in any reality which is at all relevant to my experience; so that I should fail to integrate my impression, and to absorb the only reality that concerns me, if I obliterated those points of reference which originally made the world figured and visible. Space remains absolutely dark, for all the infinite light which we may declare to be radiating through it, until this light is concentrated in one body or reflected from another; and a landscape cannot be so much as vaporous unless mists are distinguishable in it, and through them some known object which they obscure. In a word, landscape is always, in spite of itself, a collection of particular representations. It is a mass of hieroglyphics, each the graphic symbol for some definite human sensation or reaction; only these symbols have been extraordinarily enriched and are fused in representation, so that, like instruments in an orchestra, they are merged in the voluminous sensation they constitute together, a sensation in which, for attentive perception, they never cease to exist.

Impatience of such control as reality must

always exercise over representation may drive

Reversion to pure decorative design. painting back to a simpler function. When a designer, following his own automatic impulse, conventionalises a form, he makes a legitimate exchange, substituting fidelity to his apperceptive instincts for fidelity to his external impressions. When a landscape-painter, revolting against a tedious discursive style, studies only masses of colour and abstract systems of lines, he retains something in itself beautiful, although no longer representative, perhaps, of anything in nature. A pure impression cannot be illegitimate; it cannot be false until it pretends to represent something, and then it will have ceased to be a simple feeling, since something in it will refer to an ulterior existence, to which it ought to conform. This ulterior existence (since intelligence is life understanding its own conditions) can be nothing in the end but what produced that impression. Sensuous life, however, has its value within itself; its pleasures are not significant. Representative art is accordingly in a sense secondary; beauty and expression begin farther back. They are present whenever the outer stimulus agreeably strikes an organ and thereby arouses a sustained image, in which the consciousness of both stimulation and reaction is embodied. An abstract design in outline and colour will amply fulfil these conditions, if sensuous and motor harmonies are preserved in it, and if a sufficient sweep and depth of reaction is se-

cured. Stained-glass, tapestry, panelling, and in a measure all objects, by their mere presence and distribution, have a decorative function. When sculpture and painting cease to be representative they pass into the same category. Decoration in turn merges in construction; and so all art, like the whole Life of Reason, is joined together at its roots, and branches out from the vital processes of sensation and reaction. Diversity arises centrifugally, according to the provinces explored and the degree of mutual checking and control to which the various extensions are subjected.

Organisation, both internal and adaptive, marks the dignity and authority which each art may have **Sensuous values are primordial and so indispensable.** attained; but this advantage, important as it must seem to a philosopher or a legislator, is not what the artist chiefly considers. His privilege is to remain capricious in his response to the full-blown universe of science and passion, and to be still sensuous in his highest imaginings. He cares for structure only when it is naturally decorative. He thinks gates were invented for the sake of triumphal arches, and forests for the sake of poets and deer. Representation, with all it may represent, means to him simply what it says to his emotions. In all this the artist, though in one sense foolish, in another way is singularly sane; for, after all, everything must pass through the senses, and life, whatever its complexity, remains always primarily a feeling.

To render this feeling delightful, to train the senses to their highest potency and harmony in operation, is to begin life well. Were the foundations defective and subject to internal strain there could be little soundness in the superstructure. Æsthetic activity is far from being a late or adventitious ornament in human economy; it is an elementary factor, the perfection of an indispensable vehicle. Whenever science or morals have done violence to sense they have decreed their own dissolution. To sense a rebellious appeal will presently be addressed, and the appeal will go against rash and empty dogmas. A keen æsthetic sensibility and a flourishing art mark the puberty of reason. Fertility comes later, after a marriage with the practical world. But a sensuous ripening is needed first, such as myth and ornament betray in their exuberance. A man who has no feeling for feeling and no felicity in expression will hardly know what he is about in his further undertakings. He will have missed his first lesson in living spontaneously and well. Not knowing himself, he will be all hearsay and pedantry. He may fall into the superstition of supposing that what gives life value can be something external to life. Science and morals are themselves arts that express natural impulses and find experimental rewards. This fact, in betraying their analogy to æsthetic activity, enables them also to vindicate their excellence

CHAPTER IX

JUSTIFICATION OF ART

It is no longer the fashion among philosophers to decry art. Either its influence seems to them

Art is subject to moral censorship. too slight to excite alarm, or their systems are too lax to subject anything to censure which has the least glamour or

ideality about it. Tired, perhaps, of daily resolving the conflict between science and religion, they prefer to assume silently a harmony between morals and art. Moral harmonies, however, are not given; they have to be made. The curse of superstition is that it justifies and protracts their absence by proclaiming their invisible presence. Of course a rational religion could not conflict with a rational science; and similarly an art that was wholly admirable would necessarily play into the hands of progress. But as the real difficulty in the former case lies in saying what religion and what science would be truly rational, so here the problem is how far extant art is a benefit to mankind, and how far, perhaps, a vice or a burden.

That art is *prima facie* and in itself a good cannot be doubted. It is a spontaneous activity,

166

and that settles the question. Yet the function
of ethics is precisely to revise *prima facie* judg-
ments of this kind and to fix the ulti-
Its initial or specific excellence is not enough. mate resultant of all given interests,
in so far as they can be combined. In
the actual disarray of human life and
desire, wisdom consists in knowing what goods to
sacrifice and what simples to pour into the supreme
mixture. The extent to which æsthetic values are
allowed to colour the resultant or highest good is
a point of great theoretic importance, not only
for art but for general philosophy. If art is ex-
cluded altogether or given only a trivial rôle, per-
haps as a necessary relaxation, we feel at once
that a philosophy so judging human arts is ascetic
or post-rational. It pretends to guide life from
above and from without; it has discredited human
nature and mortal interests, and has thereby under-
mined itself, since it is at best but a partial ex-
pression of that humanity which it strives to
transcend. If, on the contrary, art is prized as
something supreme and irresponsible, if the poetic
and mystic glow which it may bring seems its own
complete justification, then philosophy is evidently
still prerational or, rather, non-existent; for the
beasts that listened to Orpheus belong to this
school.

To be bewitched is not to be saved, though all
the magicians and æsthetes in the world should
pronounce it to be so. Intoxication is a sad busi-
ness, at least for a philosopher; for you must either

drown yourself altogether, or else when sober again you will feel somewhat fooled by yesterday's joys and somewhat lost in to-day's vacancy. The man who would emancipate art from discipline and reason is trying to elude rationality, not merely in art, but in all existence. He is vexed at conditions of excellence that make him conscious of his own incompetence and failure. Rather than consider his function, he proclaims his self-sufficiency. A way foolishness has of revenging itself is to excommunicate the world.

It is in the world, however, that art must find its level. It must vindicate its function in the human commonwealth. What direct acceptable contribution does it make to the highest good? What sacrifices, if any, does it impose? What indirect influence does it exert on other activities? Our answer to these questions will be our apology for art, our proof that art belongs to the Life of Reason.

When moralists deprecate passion and contrast it with reason, they do so, if they are themselves rational, only because passion is so often "guilty," because it works havoc so often in the surrounding world and leaves, among other ruins, "a heart high-sorrowful and cloyed." Were there no danger of such after-effects within and without the sufferer, no passion would be reprehensible. Nature is innocent, and so are all her impulses and moods when taken in isolation; it is only on meet-

All satisfactions, however hurtful, have an initial worth.

ing that they blush. If it be true that matter is sinful, the logic of this truth is far from being what the fanatics imagine who commonly propound it. Matter is sinful only because it is insufficient, or is wastefully distributed. There is not enough of it to go round among the legion of hungry ideas. To embody or enact an idea is the only way of making it actual; but its embodiment may mutilate it, if the material or the situation is not propitious. So an infant may be maimed at birth, when what injures him is not being brought forth, but being brought forth in the wrong manner. Matter has a double function in respect to existence; essentially it enables the spirit to be, yet chokes it incidentally. Men sadly misbegotten, or those who are thwarted at every step by the times' penury, may fall to thinking of matter only by its defect, ignoring the material ground of their own aspirations. All flesh will seem to them weak, except that forgotten piece of it which makes their own spiritual strength. Every impulse, however, had initially the same authority as this censorious one, by which the others are now judged and condemned.

If a practice can point to its innocence, if it can absolve itself from concern for a world with which it does not interfere, it has justified itself to those who love it, though it may not yet have recommended itself to those who do not. Now art, more than any other considerable pursuit, more even than speculation, is abstract and inconsequential.

But, on the whole, artistic activity is innocent.

Born of suspended attention, it ends in itself. It
encourages sensuous abstraction, and nothing con-
cerns it less than to influence the world. Nor
does it really do so in a notable degree. Social
changes do not reach artistic expression until after
their momentum is acquired and their other col-
lateral effects are fully predetermined. Scarcely is
a school of art established, giving expression to
prevailing sentiment, when this sentiment changes
and makes that style seem empty and ridiculous.
The expression has little or no power to maintain
the movement it registers, as a waterfall has little
or no power to bring more water down. Currents
may indeed cut deep channels, but they can-
not feed their own springs—at least not until
the whole revolution of nature is taken into
account.

In the individual, also, art registers passions
without stimulating them; on the contrary, in stop-
ping to depict them it steals away their life; and
whatever interest and delight it transfers to their
expression it subtracts from their vital energy.
This appears unmistakably in erotic and in religi-
ous art. Though the artist's avowed purpose here
be to arouse a practical impulse, he fails in so
far as he is an artist in truth; for he then will
seek to move the given passions only through
beauty, but beauty is a rival object of passion in
itself. Lascivious and pious works, when beauty
has touched them, cease to give out what is wil-
ful and disquieting in their subject and become

altogether intellectual and sublime. There is a high breathlessness about beauty that cancels lust and superstition. The artist, in taking the latter for his theme, renders them innocent and interesting, because he looks at them from above, composes their attitudes and surroundings harmoniously, and makes them food for the mind. Accordingly it is only in a refined and secondary stage that active passions like to amuse themselves with their æsthetic expression. Unmitigated lustiness and raw fanaticism will snarl at pictures. Representations begin to interest when crude passions recede, and feel the need of conciliating liberal interests and adding some intellectual charm to their dumb attractions. Thus art, while by its subject it may betray the preoccupations among which it springs up, embodies a new and quite innocent interest.

This interest is more than innocent, it is liberal. Not being concerned with material reality **It is liberal,** so much as with the ideal, it knows neither ulterior motives nor quantitative limits; the more beauty there is the more there can be, and the higher one artist's imagination soars the better the whole flock flies. In æsthetic activity we have accordingly one side of rational life; sensuous experience is dominated there as mechanical or social realities ought to be dominated in science and politics. Such dominion comes of having faculties suited to their conditions and consequently finding an inherent satisfaction

in their operation. The justification of life must be ultimately intrinsic; and wherever such self-justifying experience is attained, the ideal has been in so far embodied. To have realised it in a measure helps us to realise it further; for there is a cumulative fecundity in those goods which come not by increase of force or matter, but by a better organisation and form.

Art has met, on the whole, with more success than science or morals. Beauty gives men the best hint of ultimate good which their experience as yet can offer; and the most lauded geniuses have been poets, as if people felt that those seers, rather than men of action or thought, had lived ideally and known what was worth knowing. That such should be the case, if the fact be admitted, would indeed prove the rudimentary state of human civilisation. The truly comprehensive life should be the statesman's, for whom perception and theory might be expressed and rewarded in action. The ideal dignity of art is therefore merely symbolic and vicarious. As some people study character in novels, and travel by reading tales of adventure, because real life is not yet so interesting to them as fiction, or because they find it cheaper to make their experiments in their dreams, so art in general is a rehearsal of rational living, and recasts in idea a world which we have no present means of recasting in reality. Yet this rehearsal reveals the glories of a possible performance better than do the

miserable experiments until now executed on the reality.

When we consider the present distracted state of government and religion, there is much relief in turning from them to almost any art, where what is good is altogether and finally good, and what is bad is at least not treacherous. When we consider further the senseless rivalries, the vanities, the ignominy that reign in the " practical " world, how doubly blessed it becomes to find a sphere where limitation is an excellence, where diversity is a beauty, and where every man's ambition is consistent with every other man's and even favourable to it! It is indeed so in art; for we must not import into its blameless labours the bickerings and jealousies of criticism. Critics quarrel with other critics, and that is a part of philosophy. With an artist no sane man quarrels, any more than with the colour of a child's eyes. As nature, being full of seeds, rises into all sorts of crystallisations, each having its own ideal and potential life, each a nucleus of order and a habitation for the absolute self, so art, though in a medium poorer than pregnant matter, and incapable of intrinsic life, generates a semblance of all conceivable beings. What nature does with existence, art does with appearance; and while the achievement leaves us, unhappily, much where we were before in all our efficacious relations, it entirely renews our vision and breeds a fresh world in fancy, where all form has the same inner jus-

tification that all life has in the real world. As
no insect is without its rights and every cripple
has his dream of happiness, so no artistic fact, no
child of imagination, is without its small birth-
right of beauty. In this freer element, competi-
tion does not exist and everything is Olympian.
Hungry generations do not tread down the ideal
but only its spokesmen or embodiments, that have
cast in their lot with other material things. Art
supplies constantly to contemplation what nature
seldom affords in concrete experience—the union
of life and peace.

The ideal, however, would not come down from
the empyrean and be conceived unless somebody's

**The ideal,
when incar-
nate, becomes
subject to
civil society.**
thought were absorbed in the concep-
tion. Art actually segregates classes
of men and masses of matter to serve
its special interests. This involves ex-
pense; it impedes some possible activities and im-
poses others. On this ground, from the earliest
times until our own, art has been occasionally at-
tacked by moralists, who have felt that it fostered
idolatry or luxury or irresponsible dreams. Of
these attacks the most interesting is Plato's,

**Plato's stric-
tures: he ex-
aggerates the
effect of myths.**
because he was an artist by tempera-
ment, bred in the very focus of artistic
life and discussion, and at the same
time a consummate moral philosopher.
His æsthetic sensibility was indeed so great that
it led him, perhaps, into a relative error, in that
he overestimated the influence which art can have

on character and affairs. Homer's stories about
the gods can hardly have demoralised the youths
who recited them. No religion has ever given a
picture of deity which men could have imitated
without the grossest immorality. Yet these shock-
ing representations have not had a bad effect on
believers. The deity was opposed to their own
vices; those it might itself be credited with offered
no contagious example. In spite of the theolo-
gians, we know by instinct that in speaking of the
gods we are dealing in myths and symbols. Some
aspect of nature or some law of life, expressed in
an attribute of deity, is what we really regard, and
to regard such things, however sinister they may
be, cannot but chasten and moralise us. The per-
sonal character that such a function would involve,
if it were exercised willingly by a responsible being,
is something that never enters our thoughts. No
such painful image comes to perplex the plain
sense of instinctive, poetic religion. To give
moral importance to myths, as Plato tended to do,
is to take them far too seriously and to belittle
what they stand for. Left to themselves they float
in an ineffectual stratum of the brain. They are
understood and grow current precisely by not being
pressed, like an idiom or a metaphor. The same
æsthetic sterility appears at the other end of the
scale, where fancy is anything but sacred. A
Frenchman once saw in " Punch and Judy " a
shocking proof of British brutality, destined fur-
ther to demoralise the nation; and yet the scandal

may pass. That black tragedy reflects not very pretty manners, but puppets exercise no suasion over men.

To his supersensitive censure of myths Plato added strictures upon music and the drama: to **His deeper** excite passions idly was to enervate the **moral objec-** soul. Only martial or religious strains **tions.** should be heard in the ideal republic. Furthermore, art put before us a mere phantom of the good. True excellence was the function things had in use; the horseman knew the bridle's value and essence better than the artisan did who put it together; but a painted bridle would lack even this relation to utility. It would rein in no horse, and was an impertinent sensuous reduplication of what, even when it had material being, was only an instrument and a means.

This reasoning has been little understood, because Platonists so soon lost sight of their master's Socratic habit and moral intent. They turned the good into an existence, making it thereby unmeaning. Plato's dialectic, if we do not thus abolish the force of its terms, is perfectly cogent: representative art has indeed no utility, and, if the good has been identified with efficiency in a military state, it can have no justification. Plato's Republic was avowedly a fallen state, a church militant, coming sadly short of perfection; and the joy which Plato as much as any one could feel in sensuous art he postponed, as a man in mourn-

social a disorganization is the problem

ing might, until life should be redeemed from baseness.

Never have art and beauty received a more glowing eulogy than is implied in Plato's censure. To **Their right-** him nothing was beautiful that was not **ness.** beautiful to the core, and he would have thought to insult art—the remodelling of nature by reason—if he had given it a narrower field than all practice. As an architect who had fondly designed something impossible, or which might not please in execution, would at once erase it from the plan and abandon it for the love of perfect beauty and perfect art, so Plato wished to erase from pleasing appearance all that, when its operation was completed, would bring discord into the world. This was done in the ultimate interest of art and beauty, which in a cultivated mind are inseparable from the vitally good. It is mere barbarism to feel that a thing is æsthetically good but morally evil, or morally good but hateful to perception. Things partially evil or partially ugly may have to be chosen under stress of unfavourable circumstances, lest some worse thing come; but if a thing were ugly it would *thereby* not be wholly good, and if it were *altogether* good it would perforce be beautiful.

To criticise art on moral grounds is to pay it a high compliment by assuming that it aims to be adequate, and is addressed to a comprehensive mind. The only way in which art could disallow

such criticism would be to protest its irresponsible infancy, and admit that it was a more or less amiable blatancy in individuals, and not *art* at all. Young animals often gambol in a delightful fashion, and men also may, though hardly when they intend to do so. Sportive self-expression can be prized because human nature contains a certain elasticity and margin for experiment, in which waste activity is inevitable and may be precious: for this license may lead, amid a thousand failures, to some real discovery and advance. Art, like life, should be free, since both are experimental. But it is one thing to make room for genius and to respect the sudden madness of poets through which, possibly, some god may speak, and it is quite another not to judge the result by rational standards. The earth's bowels are full of all sorts of rumblings; which of the oracles drawn thence is true can be judged only by the light of day. If an artist's inspiration has been happy, it has been so because his work can sweeten or ennoble the mind and because its total effect will be beneficent. Art being a part of life, the criticism of art is a part of morals.

Maladjustments in human society are still so scandalous, they touch matters so much more pressing than fine art, that maladjustments in the latter are passed over with a smile, as if art were at any rate an irresponsible miraculous parasite that the legislator had better not meddle with. The day

Importance of æsthetic alternatives.

may come, however, if the state is ever reduced to
a tolerable order, when questions of art will be
the most urgent questions of morals, when genius
at last will feel responsible, and the twist given
to imagination will seem the most crucial thing in
life. Under a thin disguise, the momentous char-
acter of imaginative choices has already been fully
recognised by mankind. Men have passionately
loved their special religions, languages, and man-
ners, and preferred death to a life flowering in any
other fashion. In justifying this attachment for-
ensically, with arguments on the low level of men's
named and consecrated interests, people have in-
deed said, and perhaps come to believe, that their
imaginative interests were material interests at
bottom, thinking thus to give them more weight
and legitimacy; whereas in truth material life
itself would be nothing worth, were it not, in its
essence and its issue, ideal.

It was stupidly asserted, however, that if a man
omitted the prescribed ceremonies or had unau-
thorised dreams about the gods, he would lose his
battles in this world and go to hell in the other.
He who runs can see that these expectations are
not founded on any evidence, on any observation
of what actually occurs; they are obviously a
mirage arising from a direct ideal passion, that
tries to justify itself by indirection and by false-
hoods, as it has no need to do. We all read facts
in the way most congruous with our intellectual
habit, and when this habit drives us to effulgent

creations, absorbing and expressing the whole current of our being, it not merely biasses our reading of this world but carries us into another world altogether, which we posit instead of the real one, or beside it.

Grotesque as the blunder may seem by which we thus introduce our poetic tropes into the sequence of external events or existences, the blunder is intellectual only; morally, zeal for our special rhetoric may not be irrational. The lovely Phœbus is no fact for astronomy, nor does he stand behind the material sun, in some higher heaven, physically superintending its movements; but Phœbus is a fact in his own region, a token of man's joyful piety in the presence of the forces that really condition his welfare. In the region of symbols, in the world of poetry, Phœbus has his inalienable rights. Forms of poetry are forms of human life. Languages express national character and enshrine particular ways of seeing and valuing events. To make substitutions and extensions in expression is to give the soul, in her inmost substance, a somewhat new constitution. A method of apperception is a spontaneous variation in mind, perhaps the origin of a new moral species.

The value apperceptive methods have is of course largely representative, in that they serve more or less aptly to dominate the order of events and to guide action; but quite apart from this practical value, expressions possess a character of their own, a sort of vegetative life, as languages possess

euphony. Two reports of the same fact may be equally trustworthy, equally useful as information, yet they may embody two types of mental rhetoric, and this diversity in genius may be of more intrinsic importance than the raw fact it works upon. The non-representative side of human perception may thus be the most momentous side of it, because it represents, or even constitutes, the man. After all, the chief interest we have in things lies in what we can make of them or what they can make of us. There is consequently nothing fitted to colour human happiness more pervasively than art does, nor to express more deeply the mind's internal habit. In educating the imagination art crowns all moral endeavour, which from the beginning is a species of art, and which becomes a fine art more completely as it works in a freer medium.

How great a portion of human energies should be spent on art and its appreciation is a question to be answered variously by various persons and nations. There is no ideal *à priori;* an ideal can but express, if it is genuine, the balance of impulses and potentialities in a given soul. A mind at once sensuous and mobile will find its appropriate perfection in studying and reconstructing objects of sense. Its rationality will appear chiefly on the plane of perception, to render the circle of visions which makes up its life as delightful as possible. For such a man art

The importance of æsthetic goods varies with temperaments.

will be the most satisfying, the most significant
activity, and to load him with material riches
or speculative truths or profound social loyalties
will be to impede and depress him. The irra-
tional is what does not justify itself in the end;
and the born artist, repelled by the soberer and
bitterer passions of the world, may justly call
them irrational. They would not justify them-
selves in his experience; they make grievous de-
mands and yield nothing in the end which is in-
telligible to him. His picture of them, if he be
a dramatist, will hardly fail to be satirical; fate,
frailty, illusion will be his constant themes. If
his temperament could find political expression,
he would minimise the machinery of life and dep-
recate any calculated prudence. He would trust
the heart, enjoy nature, and not frown too angrily
on inclination. Such a Bohemia he would regard
as an ideal world in which humanity might flourish
congenially.

A puritan moralist, before condemning such an
infantile paradise, should remember that a com-
monwealth of butterflies actually ex-
ists. It is not any inherent wrongness
in such an ideal that makes it unac-
ceptable, but only the fact that hu-
man butterflies are not wholly mercurial and
that even imperfect geniuses are but an extreme
type in a society whose guiding ideal is based upon
a broader humanity than the artist represents.
Men of science or business will accuse the poet of

*The æsthetic
temperament
requires tute-
lage.*

folly, on the very grounds on which he accuses
them of the same. Each will seem to the other to
be obeying a barren obsession. The statesman or
philosopher who should aspire to adjust their quar-
rel could do so only by force of intelligent sym-
pathy with both sides, and in view of the common
conditions in which they find themselves. What
ought to be done is that which, when done, will
most nearly justify itself to all concerned. Prac-
tical problems of morals are judicial and political
problems. Justice can never be pronounced with-
out hearing the parties and weighing the interests
at stake.

A circumstance that complicates such a calcu-
lation is this: æsthetic and other interests are
not separable units, to be compared ex-

**Aesthetic val-
ues every-
where inter-
fused.**
ternally; they are rather strands inter-
woven in the texture of everything.
Æsthetic sensibility colours every
thought, qualifies every allegiance, and modifies
every product of human labour. Consequently
the love of beauty has to justify itself not merely
intrinsically, or as a constituent part of life more
or less to be insisted upon; it has to justify itself
also as an influence. A hostile influence is the
most odious of things. The enemy himself, the
alien creature, lies in his own camp, and in a specu-
lative moment we may put ourselves in his place
and learn to think of him charitably; but his spirit
in our own souls is like a private tempter, a trea-
sonable voice weakening our allegiance to our own

duty. A zealot might allow his neighbours to be damned in peace, did not a certain heretical odour emitted by them infect the sanctuary and disturb his own dogmatic calm. In the same way practical people might leave the artist alone in his oasis, and even grant him a pittance on which to live, as they feed the animals in a zoological garden, did he not intrude into their inmost conclave and vitiate the abstract cogency of their designs. It is not so much art in its own field that men of science look askance upon, as the love of glitter and rhetoric and false finality trespassing upon scientific ground; while men of affairs may well deprecate a rooted habit of sensuous absorption and of sudden transit to imaginary worlds, a habit which must work havoc in their own sphere. In other words, there is an element of poetry inherent in thought, in conduct, in affection; and we must ask ourselves how far this ingredient is an obstacle to their proper development.

The fabled dove who complained, in flying, of the resistance of the air, was as wise as the philosopher who should lament the presence and influence of sense. Sense is the native element and substance of experience; all its refinements are still parts of it existentially; and whatever excellence belongs specifically to sense is a preliminary excellence, a value antecedent to any which thought or action can achieve. Science and morals have but representative authority; they are principles of ideal synthesis and

They are primordial.

safe transition; they are bridges from moment to
moment of sentience. Their function is indeed
universal and their value overwhelming, yet their
office remains derivative or secondary, and what
they serve to put in order has previously its in-
trinsic worth. An æsthetic bias is native to sense,
being indeed nothing but its form and potency;
and the influence which æsthetic habits exercise on
thought and action should not be regarded as an
intrusion to be resented, but rather as an original
interest to be built upon and developed. Sensi-
bility contains the distinctions which reason after-
ward carries out and applies; it is sensibility that
involves and supports primitive diversities, such
as those between good and bad, here and there,
fast and slow, light and darkness. There are
complications and harmonies inherent in these op-
positions, harmonies which æsthetic faculty pro-
ceeds to note; and from these we may then con-
struct others, not immediately presentable, which
we distinguish by attributing them to reason.
Reason may well outflank and transform æsthetic
judgments, but can never undermine them. Its
own materials are the perceptions which if full
and perfect are called beauties. Its function is to
endow the parts of sentience with a consciousness
of the system in which they lie, so that they may
attain a mutual relevance and ideally support one
another. But what could relevance or support be
worth if the things to be buttressed were them-
selves worthless? It is not to organise pain, ugli-

ness, and boredom that reason can be called into the world.

When a practical or scientific man boasts that he has laid aside æsthetic prejudices and is fol-

To superpose them adventitiously is to destroy them.

lowing truth and utility with a single eye, he can mean, if he is judicious, only that he has not yielded to æsthetic preference after his problem was fixed, nor in an arbitrary and vexatious fashion. He has not consulted taste when it would have been in bad taste to do so. If he meant that he had rendered himself altogether insensible to æsthetic values, and that he had proceeded to organise conduct or thought in complete indifference to the beautiful, he would be simply proclaiming his inhumanity and incompetence. A right observance of æsthetic demands does not obstruct utility nor logic; for utility and logic are themselves beautiful, while a sensuous beauty that ran counter to reason could never be, in the end, pleasing to an exquisite sense. Æsthetic vice is not favourable to æsthetic faculty: it is an impediment to the greatest æsthetic satisfactions. And so when by yielding to a blind passion for beauty we derange theory and practice, we cut ourselves off from those beauties which alone could have satisfied our passion. What we drag in so obstinately will bring but a cheap and unstable pleasure, while a double beauty will thereby be lost or obscured—first, the unlooked-for beauty which a genuine and stable system of things could not but betray, and secondly the coveted

beauty itself, which, being imported here into the wrong context, will be rendered meretricious and offensive to good taste. If a jewel worn on the wrong finger sends a shiver through the flesh, how disgusting must not rhetoric be in diplomacy or unction in metaphysics!

The poetic element inherent in thought, affection, and conduct is prior to their prosaic development and altogether legitimate. Clear, well-digested perception and rational choices follow upon those primary creative impulses, and carry out their purpose systematically. At every stage in this development new and appropriate materials are offered for æsthetic contemplation. Straightness, for instance, symmetry, and rhythm are at first sensuously defined; they are characters arrested by æsthetic instinct; but they are the materials of mathematics. And long after these initial forms have disowned their sensuous values, and suffered a wholly dialectical expansion or analysis, mathematical objects again fall under the æsthetic eye, and surprise the senses by their emotional power. A mechanical system, such as astronomy in one region has already unveiled, is an inexhaustible field for æsthetic wonder. Similarly, in another sphere, sensuous affinity leads to friendship and love, and makes us huddle up to our fellows and feel their heart-beats; but when human society has thereupon established a legal and moral edifice, this new spectacle yields new imaginative trans-

They flow naturally from perfect function.

ports, tragic, lyric, and religious. Æsthetic values everywhere precede and accompany rational activity, and life is, in one aspect, always a fine art; not by introducing inaptly æsthetic vetoes or æsthetic flourishes, but by giving to everything a form which, implying a structure, implies also an ideal and a possible perfection. This perfection, being felt, is also a beauty, since any process, though it may have become intellectual or practical, remains for all that a vital and sentient operation, with its inherent sensuous values. Whatever is to be representative in import must first be immediate in existence; whatever is transitive in operation must be at the same time actual in being. So that an æsthetic sanction sweetens all successful living; animal efficiency cannot be without grace, nor moral achievement without a sensible glory.

These vital harmonies are natural; they are neither perfect nor preordained. We often come upon beauties that need to be sacrificed, as we come upon events and practical necessities without number that are truly regrettable. There are a myriad conflicts in practice and in thought, conflicts between rival possibilities, knocking inopportunely and in vain at the door of existence. Owing to the initial disorganisation of things, some demands continually prove to be incompatible with others arising no less naturally. Reason in such cases imposes real and irreparable sacrifices, but it brings a stable consolation if its dis-

cipline is accepted. Decay, for instance, is a
moral and æsthetic evil; but being a natural ne-
cessity it can become the basis for
pathetic and magnificent harmonies,
when once imagination is adjusted to
it. The hatred of change and death
is ineradicable while life lasts, since
it expresses that self-sustaining organisation in
a creature which we call its soul; yet this hatred
of change and death is not so deeply seated in the
nature of things as are death and change them-
selves, for the flux is deeper than the ideal. Dis-
cipline may attune our higher and more adapta-
ble part to the harsh conditions of being, and the
resulting sentiment, being the only one which can
be maintained successfully, will express the great-
est satisfactions which can be reached, though not
the greatest that might be conceived or desired.
To be interested in the changing seasons is, in
this middling zone, a happier state of mind than
to be hopelessly in love with spring. Wisdom dis-
covers these possible accommodations, as circum-
stances impose them; and education ought to
prepare men to accept them.

It is for want of education and discipline that
a man so often insists petulantly on his random
tastes, instead of cultivating those which might
find some satisfaction in the world and might
produce in him some pertinent culture. Untu-
tored self-assertion may even lead him to deny
some fact that should have been patent, and

*Even in-
hibited func-
tions, when
they fall into
a new rhythm,
yield new
beauties.*

plunge him into needless calamity. His Utopias cheat him in the end, if indeed the barbarous taste he has indulged in clinging to them does not itself lapse before the dream is half formed. So men have feverishly conceived a heaven only to find it insipid, and a hell to find it ridiculous. Theodicies that were to demonstrate an absolute cosmic harmony have turned the universe into a **He who loves beauty must chasten it.** tyrannous nightmare, from which we are glad to awake again in this unintentional and somewhat tractable world. Thus the fancies of effeminate poets in violating science are false to the highest art, and the products of sheer confusion, instigated by the love of beauty, turn out to be hideous. A rational severity in respect to art simply weeds the garden; it expresses a mature æsthetic choice and opens the way to supreme artistic achievements. To keep beauty in its place is to make all things beautiful.

CHAPTER X

THE CRITERION OF TASTE

Dogmatism in matters of taste has the same status as dogmatism in other spheres. It is ini-

Dogmatism is inevitable but may be enlightened. tially justified by sincerity, being a systematic expression of a man's preferences; but it becomes absurd when its basis in a particular disposition is ignored and it pretends to have an absolute or metaphysical scope. Reason, with the order which in every region it imposes on life, is grounded on an animal nature and has no other function than to serve the same; and it fails to exercise its office quite as much when it oversteps its bounds and forgets whom it is serving as when it neglects some part of its legitimate province and serves its master imperfectly, without considering all his interests.

Dialectic, logic, and morals lose their authority and become inept if they trespass upon the realm of physics and try to disclose existences; while physics is a mere idea in the realm of poetic meditation. So the notorious diversities which human taste exhibits do not become conflicts, and raise no moral problem, until their basis or their

function has been forgotten, and each has claimed a right to assert itself exclusively. This claim is altogether absurd, and we might fail to understand how so preposterous an attitude could be assumed by anybody did we not remember that every young animal thinks himself absolute, and that dogmatism in the thinker is only the speculative side of greed and courage in the brute. The brute cannot surrender his appetites nor abdicate his primary right to dominate his environment. What experience and reason may teach him is merely how to make his self-assertion well balanced and successful. In the same way taste is bound to maintain its preferences but free to rationalise them. After a man has compared his feelings with the no less legitimate feelings of other creatures, he can reassert his own with more complete authority, since now he is aware of their necessary ground in his nature, and of their affinities with whatever other interests his nature enables him to recognise in others and to co-ordinate with his own.

A criterion of taste is, therefore, nothing but taste itself in its more deliberate and circum-

Taste gains in authority as it is more and more widely based. spect form. Reflection refines particular sentiments by bringing them into sympathy with all rational life. There is consequently the greatest possible difference in authority between taste and taste, and while delight in drums and eagle's feathers is perfectly genuine and has no cause to blush for

itself, it cannot be compared in scope or representative value with delight in a symphony or an
epic. The very instinct that is satisfied by
beauty prefers one beauty to another; and we
have only to question and purge our æsthetic feelings in order to obtain our criterion of taste.
This criterion will be natural, personal, autonomous; a circumstance that will give it authority
over our own judgment—which is all moral science is concerned about—and will extend its authority over other minds also, in so far as their
constitution is similar to ours. In that measure
what is a genuine instance of reason in us, others
will recognise for a genuine expression of reason
in themselves also.

Æsthetic feeling, in different people, may
make up a different fraction of life and vary
greatly in volume. The more nearly
insensible a man is the more incompetent he becomes to proclaim the values which sensibility might have. To
beauty men are habitually insensible,
even while they are awake and rationally active.
Tomes of æsthetic criticism hang on a few moments of real delight and intuition. It is in rare
and scattered instants that beauty smiles even on
her adorers, who are reduced for habitual comfort
to remembering her past favours. An æsthetic
glow may pervade experience, but that circumstance is seldom remarked; it figures only as an
influence working subterraneously on thoughts

**Different æsthetic endowments may
be compared
in quantity or
force.**

and judgments which in themselves take a cognitive or practical direction. Only when the æsthetic ingredient becomes predominant do we exclaim, How beautiful! Ordinarily the pleasures which formal perception gives remain an undistinguished part of our comfort or curiosity.

Taste is formed in those moments when æsthetic emotion is massive and distinct; preferences then grown conscious, judgments then put into words, will reverberate through calmer hours; they will constitute prejudices, habits of apperception, secret standards for all other beauties. A period of life in which such intuitions have been frequent may amass tastes and ideals sufficient for the rest of our days. Youth in these matters governs maturity, and while men may develop their early impressions more systematically and find confirmations of them in various quarters, they will seldom look at the world afresh or use new categories in deciphering it. Half our standards come from our first masters, and the other half from our first loves. Never being so deeply stirred again, we remain persuaded that no objects save those we then discovered can have a true sublimity. These high-water marks of æsthetic life may easily be reached under tutelage. It may be some eloquent appreciations read in a book, or some preference expressed by a gifted friend, that may have revealed unsuspected beauties in art or nature; and then, since our

Authority of vital over verbal judgments.

own perception was vicarious and obviously infe-
rior in volume to that which our mentor possessed,
we shall take his judgments for our criterion,
since they were the source and exemplar of all
our own. Thus the volume and intensity of some
appreciations, especially when nothing of the
kind has preceded, makes them authoritative
over our subsequent judgments. On those warm
moments hang all our cold systematic opinions;
and while the latter fill our days and shape our
careers it is only the former that are crucial and
alive.

A race which loves beauty holds the same place
in history that a season of love or enthusiasm
holds in an individual life. Such a race has a
pre-eminent right to pronounce upon beauty and
to bequeath its judgments to duller peoples. We
may accordingly listen with reverence to a Greek
judgment on that subject, expecting that what
might seem to us wrong about it is the expres-
sion of knowledge and passion beyond our range;
it will suffice that we learn to live in the world
of beauty, instead of merely studying its relics,
for us to understand, for instance, that imitation
is a fundamental principle in art, and that any
rational judgment on the beautiful must be a moral
and political judgment, enveloping chance æs-
thetic feelings and determining their value.
What most German philosophers, on the con-
trary, have written about art and beauty has a
minimal importance: it treats artificial problems

in a grammatical spirit, seldom giving any proof of experience or imagination. What painters say about painting and poets about poetry is better than lay opinion; it may reveal, of course, some petty jealousy or some partial incapacity, because a special gift often carries with it complementary defects in apprehension; yet what is positive in such judgments is founded on knowledge and avoids the romancing into which litterateurs and sentimentalists will gladly wander. The specific values of art are technical values, more permanent and definite than the adventitious analogies on which a stray observer usually bases his views. Only a technical education can raise judgments on musical compositions above impertinent autobiography. The Japanese know the beauty of flowers, and tailors and dressmakers have the best sense for the fashions. We ask them for suggestions, and if we do not always take their advice, it is not because the fine effects they love are not genuine, but because they may not be effects which we care to produce.

This touches a second consideration, besides the volume and vivacity of feeling, which enters

Tastes differ also in purity or consistency. into good taste. What is voluminous may be inwardly confused or outwardly confusing. Excitement, though on the whole and for the moment agreeable, may verge on pain and may be, when it subsides a little, a cause of bitterness. A thing's attractions may be partly at war with its ideal

function. In such a case what, in our haste, we call a beauty becomes hateful on a second view, and according to the key of our dissatisfaction we pronounce that effect meretricious, harsh, or affected. These discords appear when elaborate things are attempted without enough art and refinement; they are essentially in bad taste. Rudimentary effects, on the contrary, are pure, and though we may think them trivial when we are expecting something richer, their defect is never intrinsic; they do not plunge us, as impure excitements do, into a corrupt artificial conflict. So wild-flowers, plain chant, or a scarlet uniform are beautiful enough; their simplicity is a positive merit, while their crudity is only relative. There is a touch of sophistication and disease in not being able to fall back on such things and enjoy them thoroughly, as if a man could no longer relish a glass of water. Your true epicure will study not to lose so genuine a pleasure. Better forego some artificial stimulus, though that, too, has its charm, than become insensible to natural joys. Indeed, ability to revert to elementary beauties is a test that judgment remains sound.

Vulgarity is quite another matter. An old woman in a blonde wig, a dirty hand covered with jewels, ostentation without dignity, rhetoric without cogency, all offend by an inner contradiction. To like such things we should have to surrender our better intuitions and suffer a kind of dishon-

our. Yet the elements offensively combined may be excellent in isolation, so that an untrained or torpid mind will be at a loss to understand the critic's displeasure. Oftentimes barbaric art almost succeeds, by dint of splendour, in banishing the sense of confusion and absurdity; for everything, even reason, must bow to force. Yet the impression remains chaotic, and we must be either partly inattentive or partly distressed. Nothing could show better than this alternative how mechanical barbaric art is. Driven by blind impulse or tradition, the artist has worked in the dark. He has dismissed his work without having quite understood it or really justified it to his own mind. It is rather his excretion than his product. Astonished, very likely, at his own fertility, he has thought himself divinely inspired, little knowing that clear reason is the highest and truest of inspirations. Other men, observing his obscure work, have then honoured him for profundity; and so mere bulk or stress or complexity have produced a mystical wonder by which generation after generation may be enthralled. Barbaric art is half necromantic; its ascendancy rests in a certain measure on bewilderment and fraud.

To purge away these impurities nothing is needed but quickened intelligence, a keener spiritual flame. Where perception is adequate, expression is so too, and if a man will only grow sensitive to the various solicitations which any-

thing monstrous combines, he will thereby perceive its monstrosity. Let him but enact his sensations, let him pause to make explicit the confused hints that threaten to stupefy him; he will find that he can follow out each of them only by rejecting and forgetting the others. To free his imagination in any direction he must disengage it from the contrary intent, and so he must either purify his object or leave it a mass of confused promptings. Promptings essentially demand to be carried out, and when once an idea has become articulate it is not enriched but destroyed if it is still identified with its contrary. Any complete expression of a barbarous theme will, therefore, disengage its incompatible elements and turn it into a number of rational beauties.

When good taste has in this way purified and digested some turgid medley, it still has a progress to make. Ideas, like men, live in society. Not only has each a will of its own and an inherent ideal, but each finds itself conditioned for its expression by a host of other beings, on whose co-operation it depends. Good taste, besides being inwardly clear, has to be outwardly fit. A monstrous ideal devours and dissolves itself, but even a rational one does not find an immortal embodiment simply for being inwardly possible and free from contradiction. It needs a material basis, a soil and situation propitious to its growth. This basis, as it varies, makes the ideal vary

They differ, finally, in pertinence, and in width of appeal.

which is simply its expression; and therefore no
ideal can be ultimately fixed in ignorance of the
conditions that may modify it. It subsists, to be
sure, as an eternal possibility, independently of
all further earthly revolutions. Once expressed,
it has revealed the inalienable values that attach
to a certain form of being, whenever that form is
actualised. But its expression may have been only
momentary, and that eternal ideal may have no
further relevance to the living world. A crite-
rion of taste, however, looks to a social career;
it hopes to educate and to judge. In order to be
an applicable and a just law, it must represent the
interests over which it would preside.

There are many undiscovered ideals. There
are many beauties which nothing in this world
can embody or suggest. There are also many
once suggested or even embodied, which find later
their basis gone and evaporate into their native
heaven. The saddest tragedy in the world is the
destruction of what has within it no inward
ground of dissolution, death in youth, and the
crushing out of perfection. Imagination has its
bereavements of this kind. A complete mastery
of existence achieved at one moment gives no
warrant that it will be sustained or achieved
again at the next. The achievement may have
been perfect; nature will not on that account
stop to admire it. She will move on, and the
meaning which was read so triumphantly in her
momentary attitude will not fit her new posture.

Like Polonius's cloud, she will always suggest some new ideal, because she has none of her own.

In lieu of an ideal, however, nature has a constitution, and this, which is a necessary ground for ideals, is what it concerns the ideal to reckon with. A poet, spokesman of his full soul at a given juncture, cannot consider eventualities or think of anything but the message he is sent to deliver, whether the world can then hear it or not. God, he may feel sure, understands him, and in the eternal the beauty he sees and loves immortally justifies his enthusiasm. Nevertheless, critics must view his momentary ebullition from another side. They do not come to justify the poet in his own eyes; he amply relieves them of such a function. They come only to inquire how significant the poet's expressions are for humanity at large or for whatever public he addresses. They come to register the social or representative value of the poet's soul. His inspiration may have been an odd cerebral rumbling, a perfectly irrecoverable and wasted intuition; the exquisite quality it doubtless had to his own sense is now not to the purpose. A work of art is a public possession; it is addressed to the world. By taking on a material embodiment, a spirit solicits attention and claims some kinship with the prevalent gods. Has it, critics should ask, the affinities needed for such intercourse? Is it humane, is it rational, is it representative? To its inherent incommunicable charms it must add a

kind of courtesy. If it wants other approval than
its own, it cannot afford to regard no other aspi-
ration.

This scope, this representative faculty or wide
appeal, is necessary to good taste. All authority
is representative; force and inner consistency are
gifts on which I may well congratulate another,
but they give him no right to speak for me.
Either æsthetic experience would have remained
a chaos—which it is not altogether—or it must
have tended to conciliate certain general human
demands and ultimately all those interests which
its operation in any way affects. The more con-
spicuous and permanent a work of art is, the more
is such an adjustment needed. A poet or philoso-
pher may be erratic and assure us that he is in-
spired; if we cannot well gainsay it, we are at least
not obliged to read his works. An architect or a
sculptor, however, or a public performer of any
sort, that thrusts before us a spectacle justified
only in his inner consciousness, makes himself a
nuisance. A social standard of taste must assert
itself here, or else no efficacious and cumulative
art can exist at all. Good taste in such matters
cannot abstract from tradition, utility, and the
temper of the world. It must make itself an in-
terpreter of humanity and think esoteric dreams
less beautiful than what the public eye might con-
ceivably admire.

There are various affinities by which art may
acquire a representative or classic quality. It

may do so by giving form to objects which every-
body knows, by rendering experiences that are
universal and primary. The human

Art may grow
classic by
idealising the
familiar, figure, elementary passions, common
types and crises of fate—these are
facts which pass too constantly through
apperception not to have a normal æsthetic value.
The artist who can catch that effect in its fulness
and simplicity accordingly does immortal work.
This sort of art immediately becomes popular;
it passes into language and convention so that
its æsthetic charm is apparently worn down. The
old images after a while hardly stimulate unless
they be presented in some paradoxical way; but
in that case attention will be diverted to the ac-
cidental extravagance, and the chief classic ef-
fect will be missed. It is the honourable fate or
euthanasia of artistic successes that they pass from
the field of professional art altogether and be-
come a portion of human faculty. Every man
learns to be to that extent an artist; approved fig-
ures and maxims pass current like the words and
idioms of a mother-tongue, themselves once bril-
liant inventions. The lustre of such successes is
not really dimmed, however, when it becomes a
part of man's daily light; a retrogression from
that habitual style or habitual insight would at
once prove, by the shock it caused, how precious
those ingrained apperceptions continued to be.

Universality may also be achieved, in a more
heroic fashion, by art that expresses ultimate

truths, cosmic laws, great human ideals. Virgil
and Dante are classic poets in this sense, and a
or by report-
ing the ulti-
mate. similar quality belongs to Greek sculp-
ture and architecture. They may
not cause enthusiasm in everybody;
but in the end experience and reflection renew
their charm; and their greatness, like that of
high mountains, grows more obvious with dis-
tance. Such eminence is the reward of having
accepted discipline and made the mind a clear
anagram of much experience. There is a great
difference between the depth of expression so
gained and richness or realism in details. A su-
preme work presupposes minute study, sympathy
with varied passions, many experiments in ex-
pression; but these preliminary things are sub-
merged in it and are not displayed side by side
with it, like the foot-notes to a learned work,
so that the ignorant may know they have ex-
isted.

Some persons, themselves inattentive, imagine,
for instance, that Greek sculpture is abstract, that
it has left out all the detail and character which
they cannot find on the surface, as they might in
a modern work. In truth it contains those fea-
tures, as it were, in solution and in the resultant
which, when reduced to harmony, they would
produce. It embodies a finished humanity which
only varied exercises could have attained, for as
the body is the existent ground for all possible
actions, in which as actions they exist only po-

tentially, so a perfect body, such as a sculptor might conceive, which ought to be ready for all excellent activities, cannot present them all in act but only the readiness for them. The features that might express them severally must be absorbed and mastered, hidden like a sword in its scabbard, and reduced to a general dignity or grace. Though such immersed eloquence be at first overlooked and seldom explicitly acknowledged, homage is nevertheless rendered to it in the most unmistakable ways. When lazy artists, backed by no great technical or moral discipline, think they, too, can produce masterpieces by summary treatment, their failure shows how pregnant and supreme a thing simplicity is. Every man, in proportion to his experience and moral distinction, returns to the simple but inexhaustible work of finished minds, and finds more and more of his own soul responsive to it.

Human nature, for all its margin of variability, has a substantial core which is invariable, as the human body has a structure which it cannot lose without perishing altogether; for as creatures grow more complex a greater number of their organs become vital and indispensable. Advanced forms will rather die than surrender a tittle of their character; a fact which is the physical basis for loyalty and martyrdom. Any deep interpretation of oneself, or indeed of anything, has for that reason a largely representative truth. Other men, if they look closely, will make the same dis-

covery for themselves. Hence distinction and profundity, in spite of their rarity, are wont to be largely recognised. The best men in all ages keep classic traditions alive. These men have on their side the weight of superior intelligence, and, though they are few, they might even claim the weight of numbers, since the few of all ages, added together, may be more than the many who in any one age follow a temporary fashion. Classic work is nevertheless always national, or at least characteristic of its period, as the classic poetry of each people is that in which its language appears most pure and free. To translate it is impossible; but it is easy to find that the human nature so inimitably expressed in each masterpiece is the same that, under different circumstance, dictates a different performance. The deviations between races and men are not yet so great as is the ignorance of self, the blindness to the native ideal, which prevails in most of them. Hence a great man of a remote epoch is more intelligible than a common man of our own time.

Both elementary and ultimate judgments, then, contribute to a standard of taste; yet human life lies between these limits, and an art which is to be truly adjusted to life should speak also for the intermediate experience. Good taste is indeed nothing but a name for those appreciations which the swelling incidents of life recall

Good taste demands that art should be rational, *i.e.*, harmonious with all other interests.

and reinforce. Good taste is that taste which is a good possession, a friend to the whole man. It must not alienate him from anything except to ally him to something greater and more fertile in satisfactions. It will not suffer him to dote on things, however seductive, which rob him of some nobler companionship. To have a foretaste of such a loss, and to reject instinctively whatever will cause it, is the very essence of refinement. Good taste comes, therefore, from experience, in the best sense of that word; it comes from having united in one's memory and character the fruit of many diverse undertakings. Mere taste is apt to be bad taste, since it regards nothing but a chance feeling. Every man who pursues an art may be presumed to have some sensibility; the question is whether he has breeding, too, and whether what he stops at is not, in the end, vulgar and offensive. Chance feeling needs to fortify itself with reasons and to find its level in the great world. When it has added fitness to its sincerity, beneficence to its passion, it will have acquired a right to live. Violence and self-justification will not pass muster in a moral society, for vipers possess both, and must nevertheless be stamped out. Citizenship is conferred only on creatures with human and co-operative instincts. A civilised imagination has to understand and to serve the world.

The great obstacle which art finds in attempting to be rational is its functional isolation.

Sense and each of the passions suffers from a similar independence. The disarray of human instincts lets every spontaneous motion run too far; life oscillates between constraint and unreason. Morality too often puts up with being a constraint and even imagines such a disgrace to be its essence. Art, on the contrary, as often hugs unreason for fear of losing its inspiration, and forgets that it is itself a rational principle of creation and order. Morality is thus reduced to a necessary evil and art to a vain good, all for want of harmony among human impulses. If the passions arose in season, if perception fed only on those things which action should be adjusted to, turning them, while action proceeded, into the substance of ideas—then all conduct would be voluntary and enlightened, all speculation would be practical, all perceptions beautiful, and all operations arts. The Life of Reason would then be universal.

To approach this ideal, so far as art is concerned, would involve diffusing its processes and no longer confining them to a set of dead and unproductive objects called works of art.

Why art, the most vital and generative of activities, should produce a set of abstract images, monuments to lost intuitions, is a curious mystery. Nature gives her products life, and they are at least equal to their sources in dignity. Why should mind, the actualisation of nature's powers,

A mere " work of art " a baseless artifice.

produce something so inferior to itself, reverting
in its expression to material being, so that its wit-
nesses seem so many fossils with which it strews
its path? What we call museums—mausoleums,
rather, in which a dead art heaps up its remains
—are those the places where the Muses intended
to dwell? We do not keep in show-cases the coins
current in the world. A living art does not pro-
duce curiosities to be collected but spiritual
necessaries to be diffused.

Artificial art, made to be exhibited, is some-
thing gratuitous and sophisticated, and the great-
er part of men's concern about it is affectation.
There is a genuine pleasure in planning a work,
in modelling and painting it; there is a pleasure
in showing it to a sympathetic friend, who asso-
ciates himself in this way with the artist's tech-
nical experiment and with his interpretation of
some human episode; and there might be a satis-
faction in seeing the work set up in some appro-
priate space for which it was designed, where its
decorative quality might enrich the scene, and the
curious passer-by might stop to decipher it. The
pleasures proper to an ingenuous artist are spon-
taneous and human; but his works, once deliv-
ered to his patrons, are household furniture for
the state. Set up to-day, they are outworn and
replaced to-morrow, like trees in the parks or of-
ficers in the government. A community where
art was native and flourishing would have an unin-
terrupted supply of such ornaments, furnished by

its citizens in the same modest and cheerful spirit in which they furnish other commodities. Every craft has its dignity, and the decorative and monumental crafts certainly have their own; but such art is neither singular nor pre-eminent, and a statesman or reformer who should raise somewhat the level of thought or practice in the state would do an infinitely greater service.

The joys of creating are not confined, moreover, to those who create things without practical uses. The merely æsthetic, like rhyme and fireworks, is not the only subject that can engage a playful fancy or be planned with a premonition of beautiful effects. Architecture may be useful, sculpture commemorative, poetry reflective, even music, by its expression, religious or martial. In a word, practical exigencies, in calling forth the arts, give them moral functions which it is a pleasure to see them fulfil. Works may not be æsthetic in their purpose, and yet that fact may be a ground for their being doubly delightful in execution and doubly beautiful in effect. A richer plexus of emotions is concerned in producing or contemplating something humanly necessary than something idly conceived. What is very rightly called a *sense* for fitness is a vital experience, involving æsthetic satisfactions and æsthetic shocks. The more numerous the rational harmonies are which are present to the mind, the more sensible movements will be going

Human uses give to works of art their highest expression and charm.

on there to give immediate delight; for the perception or expectation of an ulterior good is a present good also. Accordingly nothing can so well call forth or sustain attention as what has a complex structure relating it to many complex interests. A work woven out of precious threads has a deep pertinence and glory; the artist who creates it does not need to surrender his practical and moral sense in order to indulge his imagination.

The truth is that mere sensation or mere emotion is an indignity to a mature human being. When we eat, we demand a pleasant vista, flowers, or conversation, and failing these we take refuge in a newspaper. The monks, knowing that men should not feed silently like stalled oxen, appointed some one to read aloud in the refectory; and the Fathers, obeying the same civilised instinct, had contrived in their theology intelligible points of attachment for religious emotion. A refined mind finds as little happiness in love without friendship as in sensuality without love; it may succumb to both, but it accepts neither. What is true of mere sensibility is no less true of mere fancy. The Arabian Nights—futile enough in any case—would be absolutely intolerable if they contained no Oriental manners, no human passions, and no convinced epicureanism behind their miracles and their tattle. Any absolute work of art which serves no further purpose than to stimulate an emotion has about it a cer-

tain luxurious and visionary taint. We leave it
with a blank mind, and a pang bubbles up from
the very fountain of pleasures. Art, so long
as it needs to be a dream, will never cease to prove
a disappointment. Its facile cruelty, its narcotic
abstraction, can never sweeten the evils we return
to at home; it can liberate half the mind only by
leaving the other half in abeyance. In the mere
artist, too, there is always something that falls
short of the gentleman and that defeats the man.

Surely it is not the artistic impulse in itself
that involves such lack of equilibrium. To im-

The sad values of appearance.
press a meaning and a rational form
on matter is one of the most masterful of actions. The trouble lies in the
barren and superficial character of this imposed
form: fine art is a play of appearance. Appearance, for a critical philosophy, is distinguished
from reality by its separation from the context of
things, by its immediacy and insignificance. A
play of appearance is accordingly some little
closed circle in experience, some dream in which
we lose ourselves by ignoring most of our interests, and from which we awake into a world in
which that lost episode plays no further part and
leaves no heirs. Art as mankind has hitherto
practised it falls largely under this head and too
much resembles an opiate or a stimulant. Life
and history are not thereby rendered better in
their principle, but a mere ideal is extracted out
of them and presented for our delectation in

some cheap material, like words or marble. The only precious materials are flesh and blood, for these alone can defend and propagate the ideal which has once informed them.

Artistic creation shows at this point a great inferiority to natural reproduction, since its product is dead. Fine art shapes inert matter and peoples the mind with impotent ghosts. What influence it has—for every event has consequences—is not pertinent to its inspiration. The art of the past is powerless even to create similar art in the present, unless similar conditions recur independently. The moments snatched for art have been generally interludes in life and its products parasites in nature, the body of them being materially functionless and the soul merely represented. To exalt fine art into a truly ideal activity we should have to knit it more closely with other rational functions, so that to beautify things might render them more useful and to represent them most imaginatively might be to see them in their truth. Something of the sort has been actually attained by the noblest arts in their noblest phases. A Sophocles or a Leonardo dominates his dreamful vehicle and works upon the real world by its means. These small centres, where interfunctional harmony is attained, ought to expand and cover the whole field. Art, like religion, needs to be absorbed in the Life of Reason.

What might help to bring about this consummation would be, on the one side, more knowl-

edge; on the other, better taste. When a mind is
filled with important and true ideas and sees the

**They need to
be made pro-
phetic of prac-
tical goods,**

actual relations of things, it cannot rel-
ish pictures of the world which wan-
tonly misrepresent it. Myth and meta-
phor remain beautiful so long as they
are the most adequate or graphic means availa-
ble for expressing the facts, but so soon as they
cease to be needful and sincere they become false
finery. The same thing happens in the plastic
arts. Unless they spring from love of their sub-
ject, and employ imagination only to penetrate
into that subject and interpret it with a more in-
ward sympathy and truth, they become conven-
tional and overgrown with mere ornament. They
then seem ridiculous to any man who can truly
conceive what they represent. So in putting an-
tique heroes on the stage we nowadays no longer
tolerate a modern costume, because the externals
of ancient life are too well known to us; but in the
seventeenth century people demanded in such
personages intelligence and nobleness, since these
were virtues which the ancients were clothed with
in their thought. A knowledge that should be
at once full and appreciative would evidently de-
mand fidelity in both matters. Knowledge, where
it exists, undermines satisfaction in what does
violence to truth, and it renders such representa-
tions grotesque. If knowledge were general and
adequate the fine arts would accordingly be
brought round to expressing reality.

At the same time, if the rendering of reality is to remain artistic, it must still study to satisfy the senses; but as this study would now accompany every activity, taste would grow vastly more subtle and exacting. Whatever any man said or did or made, he would be alive to its æsthetic quality, and beauty would be a pervasive ingredient in happiness. No work would be called, in a special sense, a work of art, for all works would be such intrinsically; and even instinctive mimicry and reproduction would themselves operate, not when mischief or idleness prompted, but when some human occasion and some general utility made the exercise of such skill entirely delightful. Thus there would need to be no division of mankind into mechanical blind workers and half-demented poets, and no separation of useful from fine art, such as people make who have understood neither the nature nor the ultimate reward of human action. All arts would be practised together and merged in the art of life, the only one wholly useful or fine among them.

which in turn would be suffused with beauty.

CHAPTER XI

ART AND HAPPINESS

The greatest enemy harmony can have is a premature settlement in which some essential force is wholly disregarded. This excluded element will rankle in the flesh; it will bring about no end of disorders until it is finally recognised and admitted into a truly comprehensive regimen. The more numerous the interests which a premature settlement combines the greater inertia will it oppose to reform, and the more self-righteously will it condemn the innocent pariah that it leaves outside.

Æsthetic harmonies are parodies of real ones,

Art has had to suffer much Pharisaical opposition of this sort. Sometimes political systems, sometimes religious zeal, have excluded it from their programme, thereby making their programme unjust and inadequate. Yet of all premature settlements the most premature is that which the fine arts are wont to establish. A harmony in appearance only, one that touches the springs of nothing and has no power to propagate itself, is so partial and momentary a good that we may justly call it an illusion. To gloat on rhythms and declama-

216

tions, to live lost in imaginary passions and his-
trionic woes, is an unmanly life, cut off from prac-
tical dominion and from rational happiness. A
lovely dream is an excellent thing in itself, but
it leaves the world no less a chaos and makes it
by contrast seem even darker than it did. By
dwelling in its mock heaven art may inflict on men
the same kind of injury that any irresponsible
passion or luxurious vice might inflict. For this
reason it sometimes passes for a misfortune in a
family if a son insists on being a poet or an actor.
Such gifts suggest too much incompetence and
such honours too much disrepute. A man does not
avoid real evils by having visionary pleasures, but
besides exposing himself to the real evils quite un-
protected, he probably adds fancied evils to them
in generous measure. He becomes supersensitive,
envious, hysterical; the world, which was perhaps
carried away at first by his ecstasies, at the next
moment merely applauds his performance, then
criticises it superciliously, and very likely ends by
forgetting it altogether.

Thus the fine arts are seldom an original factor
in human progress. If they express moral and po-
litical greatness, and serve to enhance it, they ac-
quire a certain dignity; but so soon as this expres-
sive function is abandoned they grow meretricious.
The artist becomes an abstracted trifler, and the
public is divided into two camps: the dilettanti,
who dote on the artist's affectations, and the rab-
ble, who pay him to grow coarse. Both influences

degrade him and he helps to foster both. An atmosphere of dependence and charlatanry gathers about the artistic attitude and spreads with its influence. Religion, philosophy, and manners may in turn be infected with this spirit, being reduced to a voluntary hallucination or petty flattery. Romanticism, ritualism, æstheticism, symbolism are names this disease has borne at different times as it appeared in different circles or touched a different object. Needless to say that the arts themselves are the first to suffer. That beauty which should have been an inevitable smile on the face of society, an overflow of genuine happiness and power, has to be imported, stimulated artificially, and applied from without; so that art becomes a sickly ornament for an ugly existence.

Nevertheless, æsthetic harmony, so incomplete in its basis as to be fleeting and deceptive, is most yet prototypes complete in its form. This so partial of true perfec- synthesis is a synthesis indeed, and just tions. because settlements made in fancy are altogether premature, and ignore almost everything in the world, in type they can be the most perfect settlements. The artist, being a born lover of the good, a natural breeder of perfections, clings to his insight. If the world calls his accomplishments vain, he can, with better reason, call vain the world's cumbrous instrumentalities, by which nothing clearly good is attained. Appearances, he may justly urge, are alone actual. All forces, substances, realities, and principles are inferred and

potential only and in the moral scale mere instruments to bring perfect appearances about. To have grasped such an appearance, to have embodied a form in matter, is to have justified for the first time whatever may underlie appearance and to have put reality to some use. It is to have begun to live. As the standard of perfection is internal and is measured by the satisfaction felt in realising it, every artist has tasted, in his activity, what activity essentially is. He has moulded existence into the likeness of thought and lost himself in that ideal achievement which, so to speak, beckons all things into being. Even if a thousand misfortunes await him and a final disappointment, he has been happy once. He may be inclined to rest his case there and challenge practical people to justify in the same way the faith that is in them.

That a moment of the most perfect happiness should prove a source of unhappiness is no paradox to any one who has observed the **Pros and cons of detached indulgences.** world. A hope, a passion, a crime, is a flash of vitality. It is inwardly congruous with the will that breeds it, yet the happiness it pictures is so partial that even while it is felt it may be overshadowed by sinister forebodings. A certain unrest and insecurity may consciously harass it. With time, or by a slight widening in the field of interest, this submerged unhappiness may rise to the surface. If, as is probable, it is caused or increased by the indulgence which preceded,

then the only moment in which a good was tasted, the only vista that had opened congenially before the mind, will prove a new and permanent curse. In this way love often misleads individuals, ambition cities, and religion whole races of men. That art, also, should often be an indulgence, a blind that hides reality from ill-balanced minds and ultimately increases their confusion, is by no means incompatible with art's ideal essence. On the contrary, such a result is inevitable when ideality is carried at all far upon a narrow basis. The more genuine and excellent the vision the greater havoc it makes if, being inadequate, it establishes itself authoritatively in the soul. Art, in the better sense, is a condition of happiness for a practical and labouring creature, since without art he remains a slave; but it is one more source of unhappiness for him so long as it is not squared with his necessary labours and merely interrupts them. It then alienates him from his world without being able to carry him effectually into a better one.

The artist is in many ways like a child. He seems happy, because his life is spontaneous, yet he is not competent to secure his own good. To be truly happy he must be well bred, reared from the cradle, as it were, under propitious influences, so that he may have learned to love what conduces to his development. In that rare case his art will expand as his understanding ripens; he will not need to repent and begin again on a lower key.

The happy imagination is one initially in line with things,

The ideal artist, like the ideal philosopher, has all time and all existence for his virtual theme. Fed by the world he can help to mould it, and his insight is a kind of wisdom, preparing him as science might for using the world well and making it more fruitful. He can then be happy, not merely in the sense of having now and then an ecstatic moment, but happy in having light and resource enough within him to cope steadily with real things and to leave upon them the vestige of his mind.

One effect of growing experience is to render what is unreal uninteresting. Momentous alternatives in life are so numerous and the possibilities they open up so varied that imagination finds enough employment of a historic and practical sort in trying to seize them. A child plans Towers of Babel; a mature architect, in planning, would lose all interest if he were bidden to disregard gravity and economy. The conditions of existence, after they are known and accepted, become conditions for the only pertinent beauty. In each place, for each situation, the plastic mind finds an appropriate ideal. It need not go afield to import something exotic. It need make no sacrifices to whim and to personal memories. It rather breeds out of the given problem a new and singular solution, thereby exercising greater invention than would be requisite for framing an arbitrary ideal and imposing it at all costs on every occasion.

and brought always closer to them by experience.

In other words, a happy result can be secured in art, as in life, only by intelligence. Intelligence

Reason is the principle of both art and happiness. consists in having read the heart and deciphered the promptings latent there, and then in reading the world and deciphering its law and constitution, to see how and where the heart's ideal may be embodied. Our troubles come from the colossal blunders made by our ancestors (who had worse ancestors of their own) in both these interpretations, blunders which have come down to us in our blood and in our institutions. The vices thus transmitted cloud our intelligence. We fail in practical affairs when we ignore the conditions of action and we fail in works of imagination when we concoct what is fantastic and without roots in the world.

The value of art lies in making people happy, first in practising the art and then in possessing its product. This observation might seem needless, and ought to be so; but if we compare it with what is commonly said on these subjects, we must confess that it may often be denied and more often, perhaps, may not be understood. Happiness is something men ought to pursue, although they seldom do so; they are drawn away from it at first by foolish impulses and afterwards by perverse laws. To secure happiness conduct would have to remain spontaneous while it learned not to be criminal; but the fanatical attachment of men, now to a fierce liberty, now to a false regimen, keeps them barbarous and wretched. A rational pur-

suit of happiness—which is one thing with prog-
ress or with the Life of Reason—would embody
that natural piety which leaves to the episodes
of life their inherent values, mourning death,
celebrating love, sanctifying civic traditions, en-
joying and correcting nature's ways. To dis-
criminate happiness is therefore the very soul of
art, which expresses experience without distort-
ing it, as those political or metaphysical tyrannies
distort it which sanctify unhappiness. A free
mind, like a creative imagination, rejoices at the
harmonies it can find or make between man and
nature; and, where it finds none, it solves the con-
flict so far as it may and then notes and endures
it with a shudder.

A morality organised about the human heart in
an ingenuous and sincere fashion would involve
every fine art and would render the world perva-
sively beautiful—beautiful in its artificial prod-
ucts and beautiful in its underlying natural terrors.
The closer we keep to elementary human needs and
to the natural agencies that may satisfy them, the
closer we are to beauty. Industry, sport, and
science, with the perennial intercourse and pas-
sions of men, swarm with incentives to ex-
pression, because they are everywhere creating
new moulds of being and compelling the eye to
observe those forms and to recast them ideally.
Art is simply an adequate industry; it arises when
industry is carried out to the satisfaction of all
human demands, even of those incidental sen-

suous demands which we call æsthetic and which a brutal industry, in its haste, may despise or ignore.

Arts responsive in this way to all human nature would be beautiful according to reason and might remain beautiful long. Poetic beauty touches the world whenever it attains some unfeigned harmony either with sense or with reason; and the more unfeignedly human happiness was made the test of all institutions and pursuits, the more beautiful they would be, having more numerous points of fusion with the mind, and fusing with it more profoundly. To distinguish and to create beauty would then be no art relegated to a few abstracted spirits, playing with casual fancies; it would be a habit inseparable from practical efficiency. All operations, all affairs, would then be viewed in the light of ultimate interests, and in their deep relation to human good. The arts would thus recover their Homeric glory; touching human fate as they clearly would, they would borrow something of its grandeur and pathos, and yet the interest that worked in them would be warm, because it would remain unmistakably animal and sincere.

The principle that all institutions should subserve happiness runs deeper than any cult for art and lays the foundation on which the latter might rest safely. If social structure were rational its free expression would be so too. Many observers, with no particular philosophy to adduce, feel that

Only a rational society can have sure and perfect arts.

the arts among us are somehow impotent, and
they look for a better inspiration, now to ancient
models, now to the raw phenomena of life.
A dilettante may, indeed, summon inspiration
whence he will; and a virtuoso will never lack
some material to keep him busy; but if what
is hoped for is a genuine, native, inevitable art,
a great revolution would first have to be worked
in society. We should have to abandon our
vested illusions, our irrational religions and
patriotisms and schools of art, and to discover
instead our genuine needs, the forms of our pos-
sible happiness. To call for such self-examina-
tion seems revolutionary only because we start
from a sophisticated system, a system resting on
traditional fashions and superstitions, by which
the will of the living generation is misinterpreted
and betrayed. To shake off that system would
not subvert order but rather institute order for
the first time; it would be an *Instauratio Magna*,
a setting things again on their feet.

We in Christendom are so accustomed to arti-
ficial ideals and to artificial institutions, kept up
to express them, that we hardly conceive how
anomalous our situation is, sorely as we may
suffer from it. We found academies and mu-
seums, as we found missions, to fan a flame that
constantly threatens to die out for lack of natural
fuel. Our overt ideals are parasites in the body
politic, while the ideals native to the body
politic, those involved in our natural struc-

ture and situation, are either stifled by that
alien incubus, leaving civic life barbarous, or else
force their way up, unremarked or not justly
honoured as ideals. Industry and science and
social amenities, with all the congruous comforts
and appurtenances of contemporary life, march
on their way, as if they had nothing to say
to the spirit, which remains entangled in a cobweb
of dead traditions. An idle pottering of the fancy
over obsolete forms—theological, dramatic, or plas-
tic—makes that by-play to the sober business of
life which men call their art or their religion; and
the more functionless and gratuitous this by-play
is the more those who indulge in it think they are
idealists. They feel they are champions of what
is most precious in the world, as a sentimental lady
might fancy herself a lover of flowers when she
pressed them in a book instead of planting their
seeds in the garden.

It is clear that gratuitous and functionless hab-
its cannot bring happiness; they do not constitute
Why art is an activity at once spontaneous and
now empty beneficent, such as noble art is an
and unstable. instance of. Those habits may indeed
give pleasure; they may bring extreme excitement,
as madness notably does, though it is in the high-
est degree functionless and gratuitous. Nor is
such by-play without consequences, some of which
might conceivably be fortunate. What is function-
less is so called for being worthless from some ideal
point of view, and not conducing to the particu-

lar life considered. But nothing real is dissociated
from the universal flux; everything—madness and
all unmeaning cross-currents in being—count in
the general process and discharge somewhere, not
without effect, the substance they have drawn for
a moment into their little vortex. So our vain arts
and unnecessary religions are not without real ef-
fects and not without a certain internal vitality.
When life is profoundly disorganised it may well
happen that only in detached episodes, only in mo-
ments snatched for dreaming in, can men see the
blue or catch a glimpse of something like the ideal.
In that case their esteem for their irrelevant vis-
ions may be well grounded, and their thin art and
far-fetched religion may really constitute what is
best in their experience. In a pathetic way these
poor enthusiasms may be justified, but only be-
cause the very conception of a rational life lies
entirely beyond the horizon.

It is no marvel, when art is a brief truancy from
rational practice, that the artist himself should be
a vagrant, and at best, as it were, an infant prodi-
gy. The wings of genius serve him only for an
escapade, enabling him to skirt the perilous edge
of madness and of mystical abysses. But such an
erratic workman does not deserve the name of ar-
tist or master; he has burst convention
only to break it, not to create a new
convention more in harmony with na-
ture. His originality, though it may
astonish for a moment, will in the end be despised

Anomalous character of the irrational artist.

and will find no thoroughfare. He will meantime
be wretched himself, torn from the roots of his
being by that cruel, unmeaning inspiration; or, if
too rapt to see his own plight, he will be all the
more pitied by practical men, who cannot think it
a real blessing to be lost in joys that do not
strengthen the character and yield nothing for
posterity.

Art, in its nobler acceptation, is an achievement,
not an indulgence. It prepares the world in some
sense to receive the soul, and the soul to master the
world; it disentangles those threads in each that
can be woven into the other. That the artist
should be eccentric, homeless, dreamful may almost
seem a natural law, but it is none the less a scan-
dal. An artist's business is not really to cut fan-
tastical capers or be licensed to play the fool. His
business is simply that of every keen soul to build
well when it builds, and to speak well when it
speaks, giving practice everywhere the greatest
possible affinity to the situation, the most delicate
adjustment to every faculty it affects. The wonder
of an artist's performance grows with the range of
his penetration, with the instinctive sympathy that
makes him, in his mortal isolation, considerate of
other men's fate and a great diviner of their se-
cret, so that his work speaks to them kindly, with
a deeper assurance than they could have spoken
with to themselves. And the joy of his great
sanity, the power of his adequate vision, is not
the less intense because he can lend it to others

and has borrowed it from a faithful study of the world. ✗

If happiness is the ultimate sanction of art, art in turn is the best instrument of happiness. In art more directly than in other activities man's self-expression is cumulative and finds an immediate reward; for it alters the material conditions of sentience so that sentience becomes at once more delightful and more significant. In industry man is still servile, preparing the materials he is to use in action. In action itself, though he is free, he exerts his influence on a living and treacherous medium and sees the issue at each moment drift farther and farther from his intent. In science he is an observer, preparing himself for action in another way, by studying its results and conditions. But in art he is at once competent and free; he is creative. He is not troubled by his materials, because he has assimilated them and may take them for granted; nor is he concerned with the chance complexion of affairs in the actual world, because he is making the world over, not merely considering how it grew or how it will consent to grow in future. Nothing, accordingly, could be more delightful than genuine art, nor more free from remorse and the sting of vanity. Art springs so completely from the heart of man that it makes everything speak to him in his own language; it reaches, nevertheless, so truly to the heart of nature that it co-operates with her, becomes a parcel of her creative material energy,

True art measures and completes happiness.

and builds by her instinctive hand. If the various formative impulses afoot in the world never opposed stress to stress and made no havoc with one another, nature might be called an unconscious artist. In fact, just where such a formative impulse finds support from the environment, a consciousness supervenes. If that consciousness is adequate enough to be prophetic, an art arises. Thus the emergence of arts out of instincts is the token and exact measure of nature's success and of mortal happiness.

A CATALOGUE OF
SELECTED DOVER BOOKS
IN ALL FIELDS OF INTEREST

A CATALOGUE OF SELECTED DOVER
BOOKS IN ALL FIELDS OF INTEREST

CONDITIONED REFLEXES, Ivan P. Pavlov. Full translation of most complete statement of Pavlov's work; cerebral damage, conditioned reflex, experiments with dogs, sleep, similar topics of great importance. 430pp. 5⅜ x 8½.
60614-7 Pa. $4.50

NOTES ON NURSING: WHAT IT IS, AND WHAT IT IS NOT, Florence Nightingale. Outspoken writings by founder of modern nursing. When first published (1860) it played an important role in much needed revolution in nursing. Still stimulating. 140pp. 5⅜ x 8½.
22340-X Pa. $3.00

HARTER'S PICTURE ARCHIVE FOR COLLAGE AND ILLUSTRATION, Jim Harter. Over 300 authentic, rare 19th-century engravings selected by noted collagist for artists, designers, decoupeurs, etc. Machines, people, animals, etc., printed one side of page. 25 scene plates for backgrounds. 6 collages by Harter, Satty, Singer, Evans. Introduction. 192pp. 8⅞ x 11¾.
23659-5 Pa. $5.00

MANUAL OF TRADITIONAL WOOD CARVING, edited by Paul N. Hasluck. Possibly the best book in English on the craft of wood carving. Practical instructions, along with 1,146 working drawings and photographic illustrations. Formerly titled Cassell's Wood Carving. 576pp. 6½ x 9¼.
23489-4 Pa. $7.95

THE PRINCIPLES AND PRACTICE OF HAND OR SIMPLE TURNING, John Jacob Holtzapffel. Full coverage of basic lathe techniques—history and development, special apparatus, softwood turning, hardwood turning, metal turning. Many projects—billiard ball, works formed within a sphere, egg cups, ash trays, vases, jardiniers, others—included. 1881 edition. 800 illustrations. 592pp. 6⅛ x 9¼. 23365-0 Clothbd. $15.00

THE JOY OF HANDWEAVING, Osma Tod. Only book you need for hand weaving. Fundamentals, threads, weaves, plus numerous projects for small board-loom, two-harness, tapestry, laid-in, four-harness weaving and more. Over 160 illustrations. 2nd revised edition. 352pp. 6½ x 9¼.
23458-4 Pa. $6.00

THE BOOK OF WOOD CARVING, Charles Marshall Sayers. Still finest book for beginning student in wood sculpture. Noted teacher, craftsman discusses fundamentals, technique; gives 34 designs, over 34 projects for panels, bookends, mirrors, etc. "Absolutely first-rate"—E. J. Tangerman. 33 photos. 118pp. 7¾ x 10⅝.
23654-4 Pa. $3.50

THE SENSE OF BEAUTY, George Santayana. Masterfully written discussion of nature of beauty, materials of beauty, form, expression; art, literature, social sciences all involved. 168pp. 5⅜ x 8½. 20238-0 Pa. $3.00

ON THE IMPROVEMENT OF THE UNDERSTANDING, Benedict Spinoza. Also contains *Ethics, Correspondence*, all in excellent R. Elwes translation. Basic works on entry to philosophy, pantheism, exchange of ideas with great contemporaries. 402pp. 5⅜ x 8½. 20250-X Pa. $4.50

THE TRAGIC SENSE OF LIFE, Miguel de Unamuno. Acknowledged masterpiece of existential literature, one of most important books of 20th century. Introduction by Madariaga. 367pp. 5⅜ x 8½.
20257-7 Pa. $4.50

THE GUIDE FOR THE PERPLEXED, Moses Maimonides. Great classic of medieval Judaism attempts to reconcile revealed religion (Pentateuch, commentaries) with Aristotelian philosophy. Important historically, still relevant in problems. Unabridged Friedlander translation. Total of 473pp. 5⅜ x 8½. 20351-4 Pa. $6.00

THE I CHING (THE BOOK OF CHANGES), translated by James Legge. Complete translation of basic text plus appendices by Confucius, and Chinese commentary of most penetrating divination manual ever prepared. Indispensable to study of early Oriental civilizations, to modern inquiring reader. 448pp. 5⅜ x 8½. 21062-6 Pa. $5.00

THE EGYPTIAN BOOK OF THE DEAD, E. A. Wallis Budge. Complete reproduction of Ani's papyrus, finest ever found. Full hieroglyphic text, interlinear transliteration, word for word translation, smooth translation. Basic work, for Egyptology, for modern study of psychic matters. Total of 533pp. 6½ x 9¼. (Available in U.S. only) 21866-X Pa. $5.95

THE GODS OF THE EGYPTIANS, E. A. Wallis Budge. Never excelled for richness, fullness: all gods, goddesses, demons, mythical figures of Ancient Egypt; their legends, rites, incarnations, variations, powers, etc. Many hieroglyphic texts cited. Over 225 illustrations, plus 6 color plates. Total of 988pp. 6⅛ x 9¼. (Available in U.S. only)
22055-9, 22056-7 Pa., Two-vol. set $16.00

THE STANDARD BOOK OF QUILT MAKING AND COLLECTING, Marguerite Ickis. Full information, full-sized patterns for making 46 traditional quilts, also 150 other patterns. Quilted cloths, lame, satin quilts, etc. 483 illustrations. 273pp. 6⅞ x 9⅝. 20582-7 Pa. $4.95

CORAL GARDENS AND THEIR MAGIC, Bronsilaw Malinowski. Classic study of the methods of tilling the soil and of agricultural rites in the Trobriand Islands of Melanesia. Author is one of the most important figures in the field of modern social anthropology. 143 illustrations. Indexes. Total of 911pp. of text. 5⅝ x 8¼. (Available in U.S. only)
23597-1 Pa. $12.95

THE PHILOSOPHY OF HISTORY, Georg W. Hegel. Great classic of Western thought develops concept that history is not chance but a rational process, the evolution of freedom. 457pp. 5⅜ x 8½. 20112-0 Pa. $4.50

LANGUAGE, TRUTH AND LOGIC, Alfred J. Ayer. Famous, clear introduction to Vienna, Cambridge schools of Logical Positivism. Role of philosophy, elimination of metaphysics, nature of analysis, etc. 160pp. 5⅜ x 8½. (Available in U.S. only) 20010-8 Pa. $2.00

A PREFACE TO LOGIC, Morris R. Cohen. Great City College teacher in renowned, easily followed exposition of formal logic, probability, values, logic and world order and similar topics; no previous background needed. 209pp. 5⅜ x 8½. 23517-3 Pa. $3.50

REASON AND NATURE, Morris R. Cohen. Brilliant analysis of reason and its multitudinous ramifications by charismatic teacher. Interdisciplinary, synthesizing work widely praised when it first appeared in 1931. Second (1953) edition. Indexes. 496pp. 5⅜ x 8½. 23633-1 Pa. $6.50

AN ESSAY CONCERNING HUMAN UNDERSTANDING, John Locke. The only complete edition of enormously important classic, with authoritative editorial material by A. C. Fraser. Total of 1176pp. 5⅜ x 8½.
20530-4, 20531-2 Pa., Two-vol. set $16.00

HANDBOOK OF MATHEMATICAL FUNCTIONS WITH FORMULAS, GRAPHS, AND MATHEMATICAL TABLES, edited by Milton Abramowitz and Irene A. Stegun. Vast compendium: 29 sets of tables, some to as high as 20 places. 1,046pp. 8 x 10½. 61272-4 Pa. $14.95

MATHEMATICS FOR THE PHYSICAL SCIENCES, Herbert S. Wilf. Highly acclaimed work offers clear presentations of vector spaces and matrices, orthogonal functions, roots of polynomial equations, conformal mapping, calculus of variations, etc. Knowledge of theory of functions of real and complex variables is assumed. Exercises and solutions. Index. 284pp. 5⅝ x 8¼. 63635-6 Pa. $5.00

THE PRINCIPLE OF RELATIVITY, Albert Einstein et al. Eleven most important original papers on special and general theories. Seven by Einstein, two by Lorentz, one each by Minkowski and Weyl. All translated, unabridged. 216pp. 5⅜ x 8½. 60081-5 Pa. $3.50

THERMODYNAMICS, Enrico Fermi. A classic of modern science. Clear, organized treatment of systems, first and second laws, entropy, thermodynamic potentials, gaseous reactions, dilute solutions, entropy constant. No math beyond calculus required. Problems. 160pp. 5⅜ x 8½.
60361-X Pa. $3.00

ELEMENTARY MECHANICS OF FLUIDS, Hunter Rouse. Classic undergraduate text widely considered to be far better than many later books. Ranges from fluid velocity and acceleration to role of compressibility in fluid motion. Numerous examples, questions, problems. 224 illustrations. 376pp. 5⅝ x 8¼. 63699-2 Pa. $5.00

TONE POEMS, SERIES II: TILL EULENSPIEGELS LUSTIGE STREICHE, ALSO SPRACH ZARATHUSTRA, AND EIN HELDEN-LEBEN, Richard Strauss. Three important orchestral works, including very popular *Till Eulenspiegel's Marry Pranks,* reproduced in full score from original editions. Study score. 315pp. 9⅜ x 12¼. (Available in U.S. only)
23755-9 Pa. $8.95

TONE POEMS, SERIES I: DON JUAN, TOD UND VERKLARUNG AND DON QUIXOTE, Richard Strauss. Three of the most often per-formed and recorded works in entire orchestral repertoire, reproduced in full score from original editions. Study score. 286pp. 9⅜ x 12¼. (Avail-able in U.S. only)
23754-0 Pa. $7.50

11 LATE STRING QUARTETS, Franz Joseph Haydn. The form which Haydn defined and "brought to perfection." (*Grove's*). 11 string quartets in complete score, his last and his best. The first in a projected series of the complete Haydn string quartets. Reliable modern Eulenberg edition, otherwise difficult to obtain. 320pp. 8⅜ x 11¼. (Available in U.S. only)
23753-2 Pa. $7.50

FOURTH, FIFTH AND SIXTH SYMPHONIES IN FULL SCORE, Peter Ilyitch Tchaikovsky. Complete orchestral scores of Symphony No. 4 in F Minor, Op. 36; Symphony No. 5 in E Minor, Op. 64; Symphony No. 6 in B Minor, "Pathetique," Op. 74. Bretikopf & Hartel eds. Study score. 480pp. 9⅜ x 12¼.
23861-X Pa. $10.95

THE MARRIAGE OF FIGARO: COMPLETE SCORE, Wolfgang A. Mozart. Finest comic opera ever written. Full score, not to be confused with piano renderings. Peters edition. Study score. 448pp. 9⅜ x 12¼. (Available in U.S. only)
23751-6 Pa. $11.95

"IMAGE" ON THE ART AND EVOLUTION OF THE FILM, edited by Marshall Deutelbaum. Pioneering book brings together for first time 38 groundbreaking articles on early silent films from *Image* and 263 illustra-tions newly shot from rare prints in the collection of the International Museum of Photography. A landmark work. Index. 256pp. 8¼ x 11.
23777-X Pa. $8.95

AROUND-THE-WORLD COOKY BOOK, Lois Lintner Sumption and Marguerite Lintner Ashbrook. 373 cooky and frosting recipes from 28 countries (America, Austria, China, Russia, Italy, etc.) include Viennese kisses, rice wafers, London strips, lady fingers, hony, sugar spice, maple cookies, etc. Clear instructions. All tested. 38 drawings. 182pp. 5⅜ x 8.
23802-4 Pa. $2.50

THE ART NOUVEAU STYLE, edited by Roberta Waddell. 579 rare photographs, not available elsewhere, of works in jewelry, metalwork, glass, ceramics, textiles, architecture and furniture by 175 artists—Mucha, Seguy, Lalique, Tiffany, Gaudin, Hohlwein, Saarinen, and many others. 288pp. 8⅜ x 11¼.
23515-7 Pa. $6.95

THE AMERICAN SENATOR, Anthony Trollope. Little known, long un-available Trollope novel on a grand scale. Here are humorous comment on American vs. English culture, and stunning portrayal of a heroine/villainess. Superb evocation of Victorian village life. 561pp. 5⅜ x 8½.
23801-6 Pa. $6.00

WAS IT MURDER? James Hilton. The author of *Lost Horizon* and *Good-bye, Mr. Chips* wrote one detective novel (under a pen-name) which was quickly forgotten and virtually lost, even at the height of Hilton's fame. This edition brings it back—a finely crafted public school puzzle resplendent with Hilton's stylish atmosphere. A thoroughly English thriller by the creator of Shangri-la. 252pp. 5⅜ x 8. (Available in U.S. only)
23774-5 Pa. $3.00

CENTRAL PARK: A PHOTOGRAPHIC GUIDE, Victor Laredo and Henry Hope Reed. 121 superb photographs show dramatic views of Central Park: Bethesda Fountain, Cleopatra's Needle, Sheep Meadow, the Blockhouse, plus people engaged in many park activities: ice skating, bike riding, etc. Captions by former Curator of Central Park, Henry Hope Reed, provide historical view, changes, etc. Also photos of N.Y. landmarks on park's periphery. 96pp. 8½ x 11.
23750-8 Pa. $4.50

NANTUCKET IN THE NINETEENTH CENTURY, Clay Lancaster. 180 rare photographs, stereographs, maps, drawings and floor plans recreate unique American island society. Authentic scenes of shipwreck, light-houses, streets, homes are arranged in geographic sequence to provide walking-tour guide to old Nantucket existing today. Introduction, captions. 160pp. 8⅞ x 11¾.
23747-8 Pa. $6.95

STONE AND MAN: A PHOTOGRAPHIC EXPLORATION, Andreas Feininger. 106 photographs by *Life* photographer Feininger portray man's deep passion for stone through the ages. Stonehenge-like megaliths, forti-fied towns, sculpted marble and crumbling tenements show textures, beau-ties, fascination. 128pp. 9¼ x 10¾.
23756-7 Pa. $5.95

CIRCLES, A MATHEMATICAL VIEW, D. Pedoe. Fundamental aspects of college geometry, non-Euclidean geometry, and other branches of mathe-matics: representing circle by point. Poincare model, isoperimetric prop-erty, etc. Stimulating recreational reading. 66 figures. 96pp. 5⅝ x 8¼.
63698-4 Pa. $2.75

THE DISCOVERY OF NEPTUNE, Morton Grosser. Dramatic scientific history of the investigations leading up to the actual discovery of the eighth planet of our solar system. Lucid, well-researched book by well-known historian of science. 172pp. 5⅜ x 8½.
23726-5 Pa. $3.50

HISTORY OF BACTERIOLOGY, William Bulloch. The only comprehensive history of bacteriology from the beginnings through the 19th century. Special emphasis is given to biography-Leeuwenhoek, etc. Brief accounts of 350 bacteriologists form a separate section. No clearer, fuller study, suitable to scientists and general readers, has yet been written. 52 illustrations. 448pp. 5⅝ x 8¼. 23761-3 Pa. $6.50

THE COMPLETE NONSENSE OF EDWARD LEAR, Edward Lear. All nonsense limericks, zany alphabets, Owl and Pussycat, songs, nonsense botany, etc., illustrated by Lear. Total of 321pp. 5⅜ x 8½. (Available in U.S. only) 20167-8 Pa. $3.95

INGENIOUS MATHEMATICAL PROBLEMS AND METHODS, Louis A. Graham. Sophisticated material from Graham Dial, applied and pure; stresses solution methods. Logic, number theory, networks, inversions, etc. 237pp. 5⅜ x 8½. 20545-2 Pa. $4.50

BEST MATHEMATICAL PUZZLES OF SAM LOYD, edited by Martin Gardner. Bizarre, original, whimsical puzzles by America's greatest puzzler. From fabulously rare Cyclopedia, including famous 14-15 puzzles, the Horse of a Different Color, 115 more. Elementary math. 150 illustrations. 167pp. 5⅜ x 8½. 20498-7 Pa. $2.75

THE BASIS OF COMBINATION IN CHESS, J. du Mont. Easy-to-follow, instructive book on elements of combination play, with chapters on each piece and every powerful combination team—two knights, bishop and knight, rook and bishop, etc. 250 diagrams. 218pp. 5⅜ x 8½. (Available in U.S. only) 23644-7 Pa. $3.50

MODERN CHESS STRATEGY, Ludek Pachman. The use of the queen, the active king, exchanges, pawn play, the center, weak squares, etc. Section on rook alone worth price of the book. Stress on the moderns. Often considered the most important book on strategy. 314pp. 5⅜ x 8½. 20290-9 Pa. $4.50

LASKER'S MANUAL OF CHESS, Dr. Emanuel Lasker. Great world champion offers very thorough coverage of all aspects of chess. Combinations, position play, openings, end game, aesthetics of chess, philosophy of struggle, much more. Filled with analyzed games. 390pp. 5⅜ x 8½. 20640-8 Pa. $5.00

500 MASTER GAMES OF CHESS, S. Tartakower, J. du Mont. Vast collection of great chess games from 1798-1938, with much material nowhere else readily available. Fully annotated, arranged by opening for easier study. 664pp. 5⅜ x 8½. 23208-5 Pa. $7.50

A GUIDE TO CHESS ENDINGS, Dr. Max Euwe, David Hooper. One of the finest modern works on chess endings. Thorough analysis of the most frequently encountered endings by former world champion. 331 examples, each with diagram. 248pp. 5⅜ x 8½. 23332-4 Pa. $3.75

SECOND PIATIGORSKY CUP, edited by Isaac Kashdan. One of the greatest tournament books ever produced in the English language. All 90 games of the 1966 tournament, annotated by players, most annotated by both players. Features Petrosian, Spassky, Fischer, Larsen, six others. 228pp. 5⅜ x 8½. 23572-6 Pa. $3.50

ENCYCLOPEDIA OF CARD TRICKS, revised and edited by Jean Hugard. How to perform over 600 card tricks, devised by the world's greatest magicians: impromptus, spelling tricks, key cards, using special packs, much, much more. Additional chapter on card technique. 66 illustrations. 402pp. 5⅜ x 8½. (Available in U.S. only) 21252-1 Pa. $4.95

MAGIC: STAGE ILLUSIONS, SPECIAL EFFECTS AND TRICK PHO-TOGRAPHY, Albert A. Hopkins, Henry R. Evans. One of the great classics; fullest, most authoritative explanation of vanishing lady, levitations, scores of other great stage effects. Also small magic, automata, stunts. 446 illus-trations. 556pp. 5⅜ x 8½. 23344-8 Pa. $6.95

THE SECRETS OF HOUDINI, J. C. Cannell. Classic study of Houdini's incredible magic, exposing closely-kept professional secrets and revealing, in general terms, the whole art of stage magic. 67 illustrations. 279pp. 5⅜ x 8½. 22913-0 Pa. $4.00

HOFFMANN'S MODERN MAGIC, Professor Hoffmann. One of the best, and best-known, magicians' manuals of the past century. Hundreds of tricks from card tricks and simple sleight of hand to elaborate illusions involving construction of complicated machinery. 332 illustrations. 563pp. 5⅜ x 8½. 23623-4 Pa. $6.00

MADAME PRUNIER'S FISH COOKERY BOOK, Mme. S. B. Prunier. More than 1000 recipes from world famous Prunier's of Paris and London, specially adapted here for American kitchen. Grilled tournedos with anchovy butter, Lobster a la Bordelaise, Prunier's prized desserts, more. Glossary. 340pp. 5⅜ x 8½. (Available in U.S. only) 22679-4 Pa. $3.00

FRENCH COUNTRY COOKING FOR AMERICANS, Louis Diat. 500 easy-to-make, authentic provincial recipes compiled by former head chef at New York's Fitz-Carlton Hotel: onion soup, lamb stew, potato pie, more. 309pp. 5⅜ x 8½. 23665-X Pa. $3.95

SAUCES, FRENCH AND FAMOUS, Louis Diat. Complete book gives over 200 specific recipes: bechamel, Bordelaise, hollandaise, Cumberland, apri-cot, etc. Author was one of this century's finest chefs, originator of vichyssoise and many other dishes. Index. 156pp. 5⅜ x 8.

23663-3 Pa. $2.75

TOLL HOUSE TRIED AND TRUE RECIPES, Ruth Graves Wakefield. Authentic recipes from the famous Mass. restaurant: popovers, veal and ham loaf, Toll House baked beans, chocolate cake crumb pudding, much more. Many helpful hints. Nearly 700 recipes. Index. 376pp. 5⅜ x 8½.

23560-2 Pa. $4.50

THE CURVES OF LIFE, Theodore A. Cook. Examination of shells, leaves, horns, human body, art, etc., in *"the* classic reference on how the golden ratio applies to spirals and helices in nature "—Martin Gardner.. 426 illustrations. Total of 512pp. 5⅜ x 8½. 23701-X Pa. $5.95

AN ILLUSTRATED FLORA OF THE NORTHERN UNITED STATES AND CANADA, Nathaniel L. Britton, Addison Brown. Encyclopedic work covers 4666 species, ferns on up. Everything. Full botanical information, illustration for each. This earlier edition is preferred by many to more recent revisions. 1913 edition. Over 4000 illustrations, total of 2087pp. 6⅛ x 9¼. 22642-5, 22643-3, 22644-1 Pa., Three-vol. set $25.50

MANUAL OF THE GRASSES OF THE UNITED STATES, A. S. Hitchcock, U.S. Dept. of Agriculture. The basic study of American grasses, both indigenous and escapes, cultivated and wild. Over 1400 species. Full descriptions, information. Over 1100 maps, illustrations. Total of 1051pp. 5⅜ x 8½. 22717-0, 22718-9 Pa., Two-vol. set $15.00

THE CACTACEAE,, Nathaniel L. Britton, John N. Rose. Exhaustive, definitive. Every cactus in the world. Full botanical descriptions. Thorough statement of nomenclatures, habitat, detailed finding keys. The one book needed by every cactus enthusiast. Over 1275 illustrations. Total of 1080pp. 8 x 10¼. 21191-6, 21192-4 Clothbd., Two-vol. set $35.00

AMERICAN MEDICINAL PLANTS, Charles F. Millspaugh. Full descriptions, 180 plants covered: history; physical description; methods of preparation with all chemical constituents extracted; all claimed curative or adverse effects. 180 full-page plates. Classification table. 804pp. 6½ x 9¼. 23034-1 Pa. $12.95

A MODERN HERBAL, Margaret Grieve. Much the fullest, most exact, most useful compilation of herbal material. Gigantic alphabetical encyclopedia, from aconite to zedoary, gives botanical information, medical properties, folklore, economic uses, and much else. Indispensable to serious reader. 161 illustrations. 888pp. 6½ x 9¼. (Available in U.S. only) 22798-7, 22799-5 Pa., Two-vol. set $13.00

THE HERBAL or GENERAL HISTORY OF PLANTS, John Gerard. The 1633 edition revised and enlarged by Thomas Johnson. Containing almost 2850 plant descriptions and 2705 superb illustrations, Gerard's *Herbal* is a monumental work, the book all modern English herbals are derived from, the one herbal every serious enthusiast should have in its entirety. Original editions are worth perhaps $750. 1678pp. 8½ x 12¼. 23147-X Clothbd. $50.00

MANUAL OF THE TREES OF NORTH AMERICA, Charles S. Sargent. The basic survey of every native tree and tree-like shrub, 717 species in all. Extremely full descriptions, information on habitat, growth, locales, economics, etc. Necessary to every serious tree lover. Over 100 finding keys. 783 illustrations. Total of 986pp. 5⅜ x 8½. 20277-1, 20278-X Pa., Two-vol. set $11.00

ART FORMS IN NATURE, Ernst Haeckel. Multitude of strangely beautiful natural forms: Radiolaria, Foraminifera, jellyfishes, fungi, turtles, bats, etc. All 100 plates of the 19th-century evolutionist's *Kunstformen der Natur* (1904). 100pp. 9⅜ x 12¼. 22987-4 Pa. $5.00

CHILDREN: A PICTORIAL ARCHIVE FROM NINETEENTH-CENTURY SOURCES, edited by Carol Belanger Grafton. 242 rare, copyright-free wood engravings for artists and designers. Widest such selection available. All illustrations in line. 119pp. 8⅜ x 11¼.
23694-3 Pa. $4.00

WOMEN: A PICTORIAL ARCHIVE FROM NINETEENTH-CENTURY SOURCES, edited by Jim Harter. 391 copyright-free wood engravings for artists and designers selected from rare periodicals. Most extensive such collection available. All illustrations in line. 128pp. 9 x 12.
23703-6 Pa. $4.50

ARABIC ART IN COLOR, Prisse d'Avennes. From the greatest ornamentalists of all time—50 plates in color, rarely seen outside the Near East, rich in suggestion and stimulus. Includes 4 plates on covers. 46pp. 9⅜ x 12¼. 23658-7 Pa. $6.00

AUTHENTIC ALGERIAN CARPET DESIGNS AND MOTIFS, edited by June Beveridge. Algerian carpets are world famous. Dozens of geometrical motifs are charted on grids, color-coded, for weavers, needleworkers, craftsmen, designers. 53 illustrations plus 4 in color. 48pp. 8¼ x 11. (Available in U.S. only) 23650-1 Pa. $1.75

DICTIONARY OF AMERICAN PORTRAITS, edited by Hayward and Blanche Cirker. 4000 important Americans, earliest times to 1905, mostly in clear line. Politicians, writers, soldiers, scientists, inventors, industrialists, Indians, Blacks, women, outlaws, etc. Identificatory information. 756pp. 9¼ x 12¾. 21823-6 Clothbd. $40.00

HOW THE OTHER HALF LIVES, Jacob A. Riis. Journalistic record of filth, degradation, upward drive in New York immigrant slums, shops, around 1900. New edition includes 100 original Riis photos, monuments of early photography. 233pp. 10 x 7⅞. 22012-5 Pa. $7.00

NEW YORK IN THE THIRTIES, Berenice Abbott. Noted photographer's fascinating study of city shows new buildings that have become famous and old sights that have disappeared forever. Insightful commentary. 97 photographs. 97pp. 11⅜ x 10. 22967-X Pa. $5.00

MEN AT WORK, Lewis W. Hine. Famous photographic studies of construction workers, railroad men, factory workers and coal miners. New supplement of 18 photos on Empire State building construction. New introduction by Jonathan L. Doherty. Total of 69 photos. 63pp. 8 x 10¾.
23475-4 Pa. $3.00

GEOMETRY, RELATIVITY AND THE FOURTH DIMENSION, Rudolf Rucker. Exposition of fourth dimension, means of visualization, concepts of relativity as Flatland characters continue adventures. Popular, easily followed yet accurate, profound. 141 illustrations. 133pp. 5⅜ x 8½.
23400-2 Pa. $2.75

THE ORIGIN OF LIFE, A. I. Oparin. Modern classic in biochemistry, the first rigorous examination of possible evolution of life from nitrocarbon compounds. Non-technical, easily followed. Total of 295pp. 5⅜ x 8½.
60213-3 Pa. $4.00

PLANETS, STARS AND GALAXIES, A. E. Fanning. Comprehensive introductory survey: the sun, solar system, stars, galaxies, universe, cosmology; quasars, radio stars, etc. 24pp. of photographs. 189pp. 5⅜ x 8½. (Available in U.S. only)
21680-2 Pa. $3.75

THE THIRTEEN BOOKS OF EUCLID'S ELEMENTS, translated with introduction and commentary by Sir Thomas L. Heath. Definitive edition. Textual and linguistic notes, mathematical analysis, 2500 years of critical commentary. Do not confuse with abridged school editions. Total of 1414pp. 5⅜ x 8½.
60088-2, 60089-0, 60090-4 Pa., Three-vol. set $18.50